ONE WRITTEN WORD IS WORTH

A THOUSAND PIECES OF GOLD

一字千金

ALSO BY ADELINE YEN MAH

Falling Leaves

Watching the Tree

Chinese Cinderella

A THOUSAND PIECES OF GOLD

Growing Up Through China's Proverbs

ADELINE YEN MAH

 HarperSanFrancisco
A Division of HarperCollinsPublishers

FIRST HARPERCOLLINS PAPERBACK EDITION PUBLISHED IN 2003

Designed by Lindgren/Fuller Design

Library of Congress Cataloging-in-Publication Data
Mah, Adeline Yen.
 A thousand pieces of gold : a memoir of China's past through its proverbs / Adeline Yen Mah.
 p. cm.
 Includes bibliographical references.
 ISBN 978-0-06-000641-9
 1. Proverbs, Chinese. 2. Sima, Quian, ca. 145-86 B.C. Shi ji. I. Title: My discovery of China's character in its proverbs. II. Title.
PN6519. C5 M26 2002
398.9'951—dc21 2002068718

03 04 05 06 07 ❖ RRD(H) 10 9 8 7 6 5 4 3 2 1

To my husband, Bob, who knows me better than I know myself
(zhi ji) *and makes everything worthwhile*

一字千金

My Grandfather Ye Ye told me that when he was a boy growing up in Shanghai, he saw many large red boxes placed at major street corners. Each had four gilded characters written on its surface: jing xi zi zhi, *"respect and cherish written words." Workmen with bamboo poles patrolled the streets picking up any stray pieces of paper with writing. The contents of these boxes were burned at regular intervals at a special shrine in the Temple of Confucius. These paper-burning ceremonies were solemn occasions resembling high mass at a Catholic cathedral, with music and incense. Candidates who had successfully passed the imperial examination were the only ones allowed to participate. They would prostrate themselves in worship and pray to Heaven until all the paper had been reduced to ashes. On their way out, they would further show their respect by placing a donation into a separate red box labeled*

Yi Zi Qian Jing
One Written Word Is Worth a Thousand Pieces of Gold

Ye Ye said, "Let these proverbs I've taught you and the stories behind these proverbs be your most precious treasure. Cherish them and carry them with you wherever you go. Always keep in mind that life is short, riches come and go, but written words are immortal."

Contents

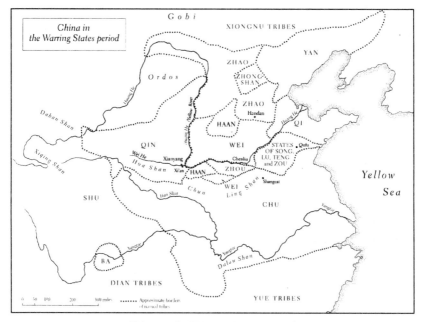

China in the Warring States period.

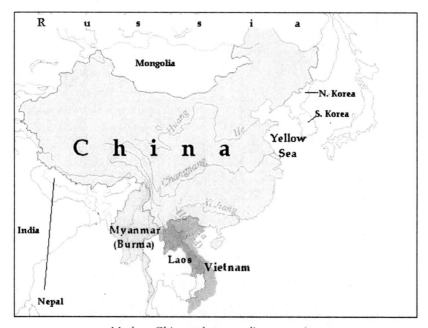

Modern China and surrounding countries.

Pronunciation Guide

Chinese is a pictorial, not a phonetic, language. Words are pronounced differently in different provinces, even though they are written in the same way and have the same meaning. This was true even during the time of the Warring States (475-221 B.C.E.). The historian Sima Qian began the biography of the assassin Jing Ke with these words: "Jing Ke was born in the state of Wei [present-day Henan Province]. The natives of Wei knew him as Master Qing, but those from the State of Yan [present-day Hebei Province] called him Master Jing."

After the Communists conquered China in 1949, they standardized the phonetic spelling of Chinese characters throughout China according to the Beijing dialect (or Mandarin) and called it *pinyin*. Pinyin is defined as "the phonetic alphabetic spelling of Chinese writing."

I would like to introduce a few famous figures from Chinese history to Western readers using pinyin. Chinese surnames come at the beginning, before the given name. Thus Deng Xiaoping's surname is Deng and his given name is Xiaoping.

INTRODUCTION

Deng Xiaoping is pronounced *Dung Shiaoping* because *x* is pronounced *sh*.
Zhuang Zi is pronounced *Jwaang Tze* because *zh* is pronounced *j*.
King Zheng is pronounced King *Jung*.
Qin is pronounced *Chin* because *q* is pronounced *ch*.
Zhao is pronounced *Jow* because *zh* is pronounced *j*.
Qi is pronounced *Chee*.

CHAPTER I

Sima Qian is pronounced *Sima Chien*.
Ren is pronounced *Run* because *en* is pronounced *un*.

Li Si is pronounced *Lee Ss* (like the hissing sound of a snake).
Zhou dynasty is pronounced *Jo* dynasty.

CHAPTER 2

Xianyang is pronounced *Shianyoung* because *x* is pronounced *sh*.
Zhong Kui is pronounced *Jong Kwei*.

CHAPTER 3

Xi is pronounced *She*.

CHAPTER 5

Han Feizi is pronounced *Haan Faytze*.
Jiang Qing is pronounced *Jiang Ching*.

CHAPTER 7

Xu Fu is pronounced *Shü Foo*.
Zhang Liang is pronounced *Jaan Liang*.
Qin Shihuang is pronounced *Chin Shihwang*. The name means
 "Founding Emperor of the Qin Dynasty" or "First Emperor."

CHAPTER 8

Zhao Gao is pronounced *Jow Gow*.
Meng Yi is pronounced *Mung Yee*.
Hu Hai is pronounced *Who Hi*.
Meng Tian is pronounced *Mung Tien*.
Fu Su is pronounced *Foo Soo*.

CHAPTER 9

Xiang Yu is pronounced *Shiang Yü*.
Liu Bang is pronounced *Liu Baang*.
Zhang Han is pronounced *Jaang Haan*.
Sima Xin is pronounced *Sima Sheen*.

CHAPTER 12

Xiao He is pronounced *Shiao Huh*.

CHAPTER 13
Fan Kuai is pronounced *Faan Kwai.*

CHAPTER 14
Hahn Xin is pronounced *Hahn Shin.*

CHAPTER 16
Kuai Tung is pronounced *Kwai Tung.*

The word *Haan* in the State of Haan during the Warring States period is the same character as the surname of General-in-chief Hahn Xin. The word *Han* in the Han dynasty is an entirely different word from the other two. However, all three are pronounced Han and are spelled identically—as Han—in the Chinese-English pinyin dictionary and in history books. To distinguish them and avoid confusion, I have chosen to spell them differently in this book.

State of Haan	Haan
General Hahn Xin	Hahn
Han dynasty	Han

Unlike in the Western world, Chinese surnames are pronounced first, to be followed by the given names. For instance, my maiden surname is Yen and my given name is Junling. Thus my Chinese name is Yen Junling.

My husband Bob's surname is Mah. When I married Bob, my Chinese name became Mah Yen Junling, whereas my English name became Adeline Yen Mah.

In a similar vein, Deng Xiaoping's surname was Deng. His given name was Xiaoping.

Mao Tse-tung's surname was Mao, and his given name was Tse-tung. Sima Qian's surname was Sima, and his given name was Qian.

A Thousand Pieces of Gold

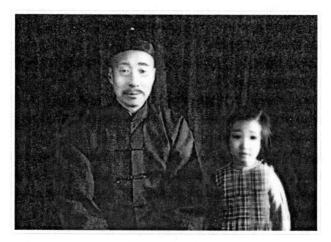

Ye Ye and Adeline.

As a little girl in Shanghai, I remember coming home from school in the afternoons and running up the stairs. The first thing I did was to dash into Grandfather Ye Ye's room to see what he was doing. His room was next to mine, which I shared with Aunt Baba, Ye Ye's daughter and the older sister of my father. When Ye Ye was in a good mood, he would be practicing calligraphy and humming a tune from Beijing opera.

One day I asked him, "Ye Ye, what are these words that you are writing?"

"They are proverbs."

"Why do you write proverbs when you practice calligraphy?"

He rested his brush on his inkstand and looked at me. "That is an excellent question!" he answered. "Tell me, what is a proverb?"

"A wise saying," I replied.

"Where do proverbs come from?" he asked.

"I don't know."

"The best proverbs," he explained, "come from our history. History describes the behavior of people who lived in the past. Those people were our ancestors. We Chinese probably revere our ancestors and our history more than any other people. To us, history is not only a record of what has happened before, it is also a guide to educate children like yourself, giving you examples that will teach you how to live your life. Proverbs mirror the past to benefit the present.

"Now, do you recognize the four characters that I am practicing today? If you do, you can have a choice: a piece of candy from my jar or the legend behind these four words."

With some difficulty, I read aloud the four characters: "*Jiu niu yi mao,* 'one hair from nine oxen.'"

Ye Ye was delighted. "Since I've never told you stories from history before, today you get both the story and the candy. But only today! From now on, you'll have to choose between the two."

I nodded eagerly, sat on the floor by his chair, and put the candy in my mouth as he began. The narrative he related was so fascinating that soon I forgot about the candy. From then on, I often chose to listen rather than satisfy my longing for sweets.

My Ye Ye passed away many years ago, but his proverbs and the history behind them have remained with me. On one of the last occasions we were together, he said to me, "No matter what else people may steal from you, they will never be able to take away the knowledge of these proverbs from your mind."

In this book, I would like to share my knowledge, as well as my love of proverbs, with you.

When I first wrote the story of my Chinese family, I chose my grandfather's favorite proverb for its title. *Falling Leaves (return to their roots)* is actually the second half of a couplet first published during the Song dynasty (960–1279 C.E.).

Shu gao qian zhang	*Luo ye gui gen*
Even if a tree reaches the height of ten thousand feet	Falling leaves return to their roots

Nowadays, the first half of the couplet is seldom used and only the second half is cited. "Falling leaves return to their roots" symbolizes the return of the wandering child to her ancestral home. Grandfather used to tell me that this proverb is a reminder that as a person gets older, he tends to go back to his beginnings.

In the 1980s, when Britain's Margaret Thatcher and China's Deng Xiaoping signed the agreement that would return Hong Kong to China in 1997, Deng was asked by reporters to make a public statement. Instead

of a lengthy speech, Deng righted the wrongs of 150 years of Chinese humiliation by uttering the four simple words *luo ye gui gen,* "falling leaves return to their roots."

On that historic occasion, at a moment when the future of Hong Kong was decided, Deng Xiaoping chose to express his sentiments, as well as the sentiments of over one billion Chinese, through an evocative proverb.

On many other occasions it is recorded that Chinese leaders have based their decisions on lessons learned from proverbs.

In the 1930s China was ruled by Chiang Kai-shek, leader of the Nationalist Party. Instead of fighting the Japanese who had invaded China, Chiang was preoccupied with annihilating the fledgling Communists led by Mao Tse-tung. Pressured by the United States to drive out the Japanese before tackling the Communists, Chiang refused, saying, "The Japanese are only *xuan jie zhi ji,* 'a disease of the skin,' but the Communists are *xin fu zhi huan,* 'a malady of the heart.'"

In America, Chiang was much admired for his poetic eloquence. What his Western audience did not realize was that Chiang's statements were not original. He was merely quoting an ancient proverb.

When the Vietnam War escalated and Ho Chi Minh asked for aid from Communist China, Mao Tse-tung agreed to do so and quoted the proverb *chun wang chi han,* "when the lips are gone, the teeth are cold." The proverb stems from an incident during the early Warring States period when China was divided into many states. One state wished to invade another state and asked for safe passage through a third one in order to do so. The prime minister of the third state advised his king not to grant the request, warning him that if the second state were conquered, they themselves would be the next target because *chun wang chi han,* "when the lips are gone, the teeth are cold." The proverb signifies interdependence between two parties and was first written by Zhuang Zi (born 330 B.C.E.)

While doing research for this book, I was amazed to come across the same proverb quoted in a memorial written 2200 years ago by Li Si, a high-ranking official in the government of King Zheng of Qin. In the year 233 B.C.E., Li Si was sent by his sovereign to the neighboring state of Haan. At that time the state of Zhao was planning to attack Qin and was asking for safe passage through Haan. Like Mao Tse-tung, Li Si quoted

the proverb "when the lips are gone, the teeth are cold" in an attempt to dissuade the King of Haan from granting the army of Zhao safe passage. He added in his memorial, "Qin and Haan suffer the same perils. The misfortune of one is the misfortune of the other. This is an obvious fact."

Substitute the state of Zhao for the United States, Qin for Vietnam, and Haan for Communist China, and we have Mao Tse-tung in 1963 thinking the same thoughts and using the same language as Li Si twenty-two centuries earlier.

In September 2000 I read of the execution of two high-ranking Chinese officials for corruption: one was the vice chair of China's National People's Congress, and the other was the deputy governor of a large province. The Chinese newspaper reported that before their crimes were discovered, both had already prepared escape routes in the tradition of the proverb *jiao tu san ku*. However, they were caught before they could put their flight plans into action.

That proverb *jiao tu san ku* means "a cunning rabbit has three warrens." It originates from an ancient history book titled *Intrigues Between the Warring States,* written over two thousand years ago. The proverb relates the story of a man named Meng who was prime minister to the King of Qi during the fourth century B.C.E. Meng sent his advisor Feng to his fief to collect debts. Instead of doing so, Feng forgave all the loans, telling the villagers that he was doing this on the prime minister's orders. Meng was displeased, but the deed was done. A year later, Meng fell from favor and had to return to his native village. When he was still one hundred *li* away, the local people, young and old, all came out to welcome him. Meng was greatly moved and praised Feng for his far-sightedness, but the latter said, "*Jiao tu san ku,* 'a cunning rabbit has three warrens.' You have only one. I am going to build you two more." Feng then obtained a fallback offer for Meng as prime minister of the Kingdom of Wei. Hearing of this, the King of Qi reinstated Meng as his prime minister. Feng told Meng, "Now that all three warrens are in place, you may relax and live in peace."

Commenting on the behavior of the two corrupt officials, the Chinese newspapers reported that two common "rabbit warrens" for corrupt politicians were obtaining foreign passports for themselves and moving family members, loved ones, and money overseas. The executed vice chairman

had secretly deposited 5 million American dollars in bribes in a Hong Kong bank account for himself and his mistress, whereas the executed deputy governor was quoted as having advised his son to get a green card in the United States so that "you'll have permanent residence there and I'll have somewhere to go when I emigrate there myself."

This true story illustrates the importance of proverbs in influencing behavior and forming opinions in China today.

How do the Chinese think? Why do we think that way? Do people in the West think in a different way?

All of us think with words. Therefore, every form of thought is related to the language, culture, and history of a particular thinker, conditioned since birth in his or her own national category. Westerners and Chinese have different views of the world that sometimes differ or even contradict each other, and yet both may be right.

For example, to an English person, Israel is the Middle East and China the Far East, whereas to a Chinese, Israel is the West and England the Far West. Depending on the viewpoint, the conclusions are different but both parties are correct.

For Westerners to understand Chinese reasoning, it is essential to realize that more than any other nation, China takes its rationale from the roots of its lengthy and well-documented past. A Chinese view of the world is highly dependent on the lessons learned from our forebears. Traditionally, this wisdom of the ages is often encapsulated in the form of four characters and is presented as a proverb.

Many Chinese proverbs originate from ancient history, literature, poetry, letters, and other writings. Based on actual events, they carry philosophical or moral implications that make them significant in contemporary life. At best, they radiate a glow that mirrors the Chinese mind, recalling incidents from bygone eras that define the Chinese way of thinking. They keep alive the memory of fabled legends and, following centuries of repetition, have evolved into coded messages that are integrated into routine speech. Used correctly, these proverbs illustrate aspects of human behavior that capture the essence of everyday existence. They link past and present, providing a stay against chaos. There is no doubt that ancient proverbs still shape the thoughts and behavior of Chinese people today. Lessons learned from conflicts and battles that happened hundreds if not

thousands of years ago continue to serve as a backdrop for many Chinese decisions.

Written Chinese is a pictorial language. Most of the words originated from pictures of actual objects, not mental concepts. Because of this, the Chinese are used to viewing life in terms of concrete examples, using specific incidents to illustrate abstract concepts. Historical precedents act as illustrations of different types of human behavior. The citation of proverbs summarizing legends has a particularly emotive appeal for the Chinese and plays a large part in the expression of Chinese thought.

Everyday conversation between ordinary Chinese people is studded with quotes from ancient historians, poets, and philosophers. The use of proverbs is often viewed as a barometer of a Chinese person's knowledge of history, level of education, and depth of wisdom. In the psyche of many Chinese lurks the conviction that scholarship is more admirable than money. Nothing impresses a Chinese more than to hear someone quote an appropriate proverb in a timely fashion.

The Chinese language has no alphabet and there is no connection between speech and writing. A person may be capable of understanding written Chinese without knowing how to read aloud or speak a single word. Each word is a different symbol and must be memorized separately. As the Chinese language developed, metaphors (figures of speech) and proverbs (short sayings based on previous experience) became increasingly important in the expression of Chinese thought.

In America and Britain, new metaphors are also being born daily before our very eyes, just as in China. Some examples are *hot seat* (for the electric chair), *gun moll* (for the gangster's girlfriend), *Pearl Harbor* (for sneak attack), *meeting one's Waterloo* (for defeat), *jousting windmills* (for fighting useless battles), *paydirt* (for reward), and *pan out* (for successful result). The last two terms came from the California Gold Rush.

Walt Whitman once said, "Into the English language are woven the sorrows, joys, loves, needs, and heartbreaks of the common people." The same can be said regarding Chinese proverbs and metaphors.

Whereas Shakespeare has been hailed for the last four hundred years by most English-speaking people as the greatest English writer who ever lived, very few Westerners have heard of Sima Qian (145-90 B.C.E.), a Chi-

nese historian who lived during the Han dynasty. In his lifetime he wrote only one book, a book of history called *Shiji (Historical Record)*. Published a few decades after his death, *Shiji* has been a bestseller in China since that time and is still in print. Many Chinese feel that it is the greatest book ever written. Its influence on Chinese thought has been immense throughout the last two millennia. Many of the proverbs we use today came from this ancient tome.

Westerners too have been captivated by the charm of Chinese proverbs. When I was a medical intern at the London Hospital in the 1960s, I had the privilege of looking after the renowned British poet Philip Larkin. He once described Chinese proverbs as "white dwarfs" of literature because each was so densely compacted with thoughts and ideas. He told me that white dwarfs are tiny stars whose atoms are packed so closely together that their weight is huge in relation to their size. He said that the enormous heat radiated by these small stars is equivalent to the vast knowledge and profound wisdom contained in certain sayings gleaned from China.

Recently, as I was reading the book *Who Moved My Cheese,* by Spencer Johnson, my husband, Bob, pointed out that the message in that book is essentially the same as one stated 2200 years ago by Li Si, who eventually became prime minister to the first emperor of China.

As a young man, Li Si worked as a petty clerk in his district. In the lavatory attached to his office, he observed many scrawny rats lurking around and eating the excrement, but they would scurry off at the first approach of man or dog. Visiting the granary one day, he noticed that the rats there not only were sleek and fat, but they also calmly helped themselves to the sacks of grain. They squatted comfortably beneath the galleries and hardly stirred when disturbed. Thereupon he sighed and thought to himself, "A man's ability or lack of ability resembles the behavior of these rats. Everything depends on where he locates himself."

The point made by the American writer is the same as that mentioned by the Chinese clerk: a person must be willing to move to another location in response to change. Otherwise the cheese (or grain) will run out regardless of one's ability. Dr. Johnson and Li Si came to the same conclusion, separated by an interval of 2200 years.

In this book I have chosen commonly used proverbs gleaned from the writings of Sima Qian, combined them with my personal reflection, and related the history behind them to provide a window into the Chinese mind. It is an honor and a privilege for me to introduce the work of this ancient Chinese writer. I hope you will find Sima's words as fascinating as I did when I first heard them from my Ye Ye all those many years ago.

The Loss of One Hair from Nine Oxen

九牛一毛

Jiu Niu Yi Mao

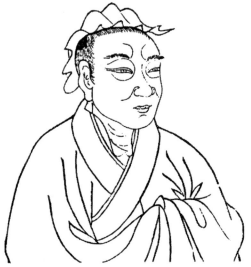

Sima Qian, historian and author of *Shiji*.

*W*hen I was thirteen years old, my parents told me that I was to leave school at fourteen and get a job because they no longer wished to pay for my education. Desperate to go to university, I begged Grandfather Ye Ye to intercede on my behalf. One evening after dinner on one of my rare visits home from boarding school, Ye Ye cornered Father, and they had a private conversation. Afterward, Ye Ye refused to elaborate but merely related that Father had been unsympathetic. Further schooling would only strain their budget because a daughter should never be too well educated.

9

It would spoil any slim chance I might have of making a suitable marriage. "No sane man," according to Father, "would ever want a bride with a Ph.D." Therefore, as far as he and my stepmother were concerned, my education was a matter as trivial as jiu niu yi mao, *"the loss of one hair from nine oxen." They had made their decision, and the subject was closed.*

◆

"The loss of one hair from nine oxen" is a phrase taken from a poignant letter written by the historian Sima Qian (145-90 B.C.E.) to his friend Ren An. The letter was written in 93 B.C.E., three years before Sima Qian's death.

Sima Qian was the *taishi* (Grand Minister of History or Grand Historian) during the reign of Emperor Wu (157-87 B.C.E.) of the Early Han dynasty. As such, he was responsible not only for keeping historical records but also for regulating the calendar and doing research on astronomy. Such positions were handed from father to son, and the Sima family had been Grand Historians for many generations. Sima Qian's father, Sima Tan, had also been Grand Minister of History. Even as a boy, Sima Qian was groomed to step into his father's shoes one day.

It had been Sima Tan's dream to write a comprehensive history of China. With that in mind, he collected many ancient tales and historical writings, which he shared with his son. He encouraged the young Sima Qian to embark on three separate journeys to explore the length and breadth of China. Like the Greek historian-traveler Herodotus, with whom he has often been compared, Sima Qian apparently also traveled far and wide; he reached the Kundong Mountains of Gansu Province in the west, the battlegrounds of Julu in Hebei Province in the north, Confucius's birthplace of Qufu in Shandong Province in the east, and the Yangtze River in the south. While lying on his deathbed in 110 B.C.E., Sima Tan extracted a promise from his son that he would one day fulfill his father's unrequited dream of writing a comprehensive history of China.

Sima Qian was appointed Grand Minister of History in 107 B.C.E. Three years later he finally assembled enough material to begin the laborious writing process. In those days paper had not yet been invented. Characters were written with a brush or carved vertically with a knife onto narrow strips of bamboo (or wood). He began writing in 105 B.C.E., but disaster struck six years later.

At that time China was frequently troubled by raids from nomadic tribes (called Xiongnu or Huns) living in the desert areas northwest of China (present-day Mongolia). In retaliation, Emperor Wu would dispatch military expeditions into the desert to harass them. In 99 B.C.E. the young, dashing, and usually victorious Han commander Li Ling led a force of 5000 men in a daring raid deep into enemy territory in an attempt to capture the Hun ruler. Vastly outnumbered, Li Ling was defeated and finally surrendered after he ran out of food and arrows. On hearing this, Emperor Wu became furious. In the case of defeat, the monarch expected his military officers either to die in battle or to commit suicide and avoid capture. Surrendering to the enemy was considered cowardly and despicable. He proposed punishing Li Ling by confiscating his property and imposing death sentences on his family members to the third degree (parents, siblings and wife, and children).

Sima Qian, who knew and admired Li Ling, tried to defend him in court. By doing so, he enraged Emperor Wu even further. The monarch cast Sima Qian into prison for daring to speak up on behalf of a "traitor" who had surrendered to the enemy. Then, a year later, he accused the historian of trying to deceive the ruler and sentenced him to death. In those days it was possible for disgraced officials either to buy their way out of their death penalty or to voluntarily submit to castration. For those with insufficient funds, tradition dictated that death was far preferable to mutilation, and only the most cowardly chose to live under such shame.

Unable to come up with the money to redeem himself, Sima Qian chose castration over death in order to complete the writing of his book, *Shiji.* After the procedure was done, he became tormented by guilt for having selected this "lowest of all punishment." Not wishing to appear spineless and unmanly, he wrote to his friend Ren An to justify himself and to explain the rationale behind his decision.

Ren An was the governor of Yizhou, now called Sichuan Province. In Sima Qian's famous letter, which may never have been sent to its intended recipient, the ancient historian mentions that Governor Ren himself had recently also fallen out of favor with the emperor and was being accused of major crimes. The entire letter is composed of 2401 Chinese characters and was probably written in 93 B.C.E. Below are four segments, which I have selected and translated.

If I were to die now as befits my punishment, my death would be as insignifi-
cant as jiu niu yi mao, *"the loss of one hair from nine oxen." How would it*
differ from the demise of a cricket or an ant?

Besides, posterity will never consider such a death to be comparable to that
of someone who perishes out of a sense of honor. They would say that it came
about only because I had exhausted all other avenues of expiating for my crime,
yet found it impossible to forgive myself.

So why should I confirm their condemnation by carrying out this deed?

A person dies but once. That death may be as monolithic as the Tai Moun-
tain or as trivial as a goose feather. It all depends on him. . . .

Further on he wrote,

It is natural for a human being to love to live and hate to die; to worry about
his parents and care for his wife and sons. But when a man's mind is stirred
by higher objectives, he becomes different. In such cases, there are things he feels
compelled to do. . . .

Having chosen castration, Sima Qian was well aware of the humiliation
and suffering awaiting him for the rest of his life. He continued,

I have incurred upon myself the derision and ridicule even of men from
my own village. I have dishonored my family name. I can never ever stand
proudly again before the tomb of my parents. Even after the passing of a hun-
dred generations, the memory of my disgrace will still linger on. This is what
grips my mind and twists my guts nine times a day. Resting at home, I am in
a daze, as if I have lost my way. I venture out, and know not what I should do
or where I should go. Every time I remember my disfigurement, the sweat pours
out and seeps through my robe. I have become no more than a slave in a harem.
How can I disappear and hide myself somewhere in a remote mountain cave?
Hence I go along with the common crowd, drifting aimlessly, gliding up and
down with the tide, sharing their illusions and craziness.

Toward the end of the letter, he concluded,

Before completing my manuscript, I encountered this monumental catastrophe.
Because my work is not yet finished, I had no choice but to submit meekly to this

most severe of punishments [castration]. When my book is finally written, I
shall place it in the Famous Mountain Archives for posterity. And should my
words one day penetrate the minds of men who will value them, allowing my
thoughts to burrow into the counties as well as great bustling cities, then even
if I should suffer ten thousand deaths by mutilations, I would have no regrets. . . .

Instead of committing suicide, he channeled his energy into writing his groundbreaking book *Shiji (Historical Record)*. Totaling just over half a million words, it chronicles events from the time of the Yellow Emperor to the reign of the emperor who condemned him, a total of 2400 years. His book records the ancient history of China, a country about half the size of present-day China with its population clustered around the Yangtze and the Yellow Rivers. From it we learn that the Shang dynasty lasted from 1765 to 1122 B.C.E. and was followed by the Zhou dynasty. A succession of Zhou kings ruled China for about 300 years through feudal vassals appointed by the king. China was vast even then, and these feudal lords were given free rein to govern their territories as they saw fit. As time went on, descendants of the local rulers became increasingly rebellious and independent. The stronger ones developed their own armies, which defied the king.

From 770 until 476 B.C.E., China was only nominally governed by the House of Zhou. This was known as the Spring and Autumn period, during which China was divided initially into as many as 170 different semi-independent principalities. Each was ruled by its own feudal lord (some called themselves kings), its own hereditary ruling caste, court, and bureaucracy. The feudal lords fought one another, with the stronger states annexing the weaker ones.

By the beginning of the Warring States period (475-221 B.C.E.), this process of annexation had accelerated to such an extent that only seven states remained in 403 B.C.E. They were Qin, Zhao, Yan, Qi, Haan, Chu, and Wei. Each state was headed by its own king. These seven states continued to wage war against one another. Gradually, it began to emerge that the state of Qin in northwest China was becoming the richest, strongest, largest, and most efficient. Qin began systematically conquering and annexing the other states, until King Zheng (259-210 B.C.E.) subdued them all and unified China in 221 B.C.E. He called himself the First Emperor of the Qin dynasty (Qin Shihuang) and planned for his dynasty to last for ten thousand generations.

The chronicle of this long period of civil war was vividly narrated by Sima Qian in his book, *Shiji*. He was innovative, bringing history alive by writing biographies of notable individuals. He wrote not only of the kings who reigned and the ministers who governed, but also of the warlords who lost as well as the words and deeds of the philosophers, writers, merchants, landlords, thieves, paid assassins, comedians, and teachers who lived and died during the reign of each ruler.

Released from prison after three years at the age of fifty, Sima regained Emperor Wu's favor and was appointed palace secretary. Despite his disgrace, he was able to arrange an advantageous marriage for his only daughter. His son-in-law, Yang Shang, was a rising young star who eventually rose to become prime minister. Sima soon had a precocious grandson, Yang Yun, who was composing poetry at a very young age.

In Sima's spare time, he continued to write, and he completed his manuscript just one year before his death. However, he never dared reveal his work during his lifetime for fear of further offending the emperor. He buried one copy in the cave of a "famous mountain." The only other copy he left to his only daughter and his talented grandson, Yang Yun.

Yang Yun became a marquis under Emperor Xuan (92-49 B.C.E.) and for a time enjoyed great favor at court. Yang judged it prudent to release *Shiji* sometime between 73 and 54 B.C.E. and promoted it assiduously. *Shiji* was immediately popular and turned into a classic on which all later official Chinese histories were modeled. It also became the first of a series of government-sponsored histories commissioned and compiled by emperors of successive dynasties. At present, there are more than 3600 volumes of official Chinese history totaling over 45 million words, describing events from the time of the Yellow Emperor to the present: the history of each dynasty systematically and continuously recorded by court-appointed historians and illustrated by biographies of notable men (and an occasional woman) of that era.

By focusing his energy into creativity rather than despair, Sima Qian became the most famous Chinese historian who ever lived. Nowadays he is certainly better known than the emperor who punished him so severely for speaking his mind.

◆

When I first heard the story of Sima Qian from Ye Ye, I was only eight years old. Even at that early age, I remember being deeply moved by the Grand Historian's plight. In those days I was living in my father's big house in Shanghai. My childhood was filled with fear and self-loathing. Although I never admitted it even to myself, I knew deep down that my stepmother despised me and wished to be rid of me. Perhaps because of this, I identified strongly and instantly with Sima Qian's depression following his mutilation, although I didn't fully understand what the term castration *implied. I only knew that it was something very bad and that he did not deserve the punishment.*

I understood Sima Qian because I too felt that I had no one to turn to for justice. Life was unfair, and I had to fend for myself. After I was bullied or beaten, my only refuge was to bury myself in books or write short stories to assuage the rankling within my heart. In time, the characters in my make-believe world became more real to me than my tormentors at home. Unlike my family members, these imaginary figures provided constant solace and consolation. Reading and writing carried me away from my real life and conveyed me to another realm. In that other kingdom, the playing field was level and I was given an even chance, just like everybody else.

In 1991, one year after my stepmother Niang's death, I received permission from my brother James to fly to Hong Kong and inspect her empty flat. As executor of Niang's will, James promised me that the contents of the flat were now mine, since other members of the family had already taken what they wanted.

At that time I was still practicing medicine full-time in California, but at the back of my mind I harbored vague thoughts of writing the book that I had always meant to write, ever since I was a child. The day after my arrival in Hong Kong, I visited a bookshop in the hope of finding some Chinese proverbs to use as possible chapter headings. I actually bought a volume but was not satisfied with its contents.

Later that afternoon, I secured the keys from my brother and went up to the familiar building. In Niang's empty apartment, smelling of mildew, mothballs, stale cigarette smoke, and neglect, haunted by ghosts of the past, I came across two dusty books lying in the corner of a closet amid a few discarded old photographs. The first book I picked up was in English and titled Selected Chinese Sayings *by a writer named T. C. Lai. The second was a paperback copy of* Shiji *in Chinese.*

I flipped open the cover of Selected Chinese Sayings *and, with a pang, saw my father's familiar signature at the top of the page. On the next page was printed the author's dedication, which read, "In memory of my Father."*

Quickly, I perused the contents and saw that Selected Chinese Sayings *consisted of a collection of the author's favorite Chinese proverbs. I read that the book*

was first published in 1960 but reprinted in 1973, three years before Alzheimer's disease took hold of my father's mind. As I perused the proverbs, I could not help wondering whether this was a message from my father to give up medicine and begin my writing career. For once, Niang was not there to interrupt our communication.

Next, I took Father's copy of Shiji and randomly turned the pages. This was where I first came across the letter written by Sima Qian to his friend. In one passage, I read,

> All these ancient writers had pain in their hearts, for they were not able to achieve in life what they had set out to accomplish. . . . And so they felt compelled to write about their past, in order to pass on their thoughts to posterity. . . .
>
> I, too, have dared to venture forth and commit myself to writing. I have collected all the ancient customs that were dispersed or discarded. I have investigated the affairs of the past and probed the reasons for their buoyancy or decay. I would like to discern the patterns leading from the past to the present, proffering my views as one method of interpretation.

When I read these words, it seemed as if Sima Qian himself had stepped out of the pages of his book and was speaking to me personally, urging me to be resolute and not falter in my resolve to become a full-time writer. Although we were separated by a time span of 2100 years, at that moment I understood him completely. He was telling me that there were many who had suffered unjustly in the past. A few, like him, were able to transcend their hurt through literature. Was I prepared to follow his footsteps and do the same?

As I turned eagerly to another page, I came across these lines:

> The reason I have borne this anguish and refused to die, living in shame without protest, is because I cannot bear the thought of leaving my work unfinished. I am still burdened with things in my heart that I have not had a chance to express. . . .

I placed my father's two books with the old photographs in the large bag I brought and prepared to leave. There appeared to be no other items worth taking. Niang's flat was scheduled to be remodeled, and everything was to be thrown away. Looking through her closets for the very last time, I suddenly saw another item abandoned by my siblings. Quickly, I retrieved it from a pile of yellowed newspaper cuttings. It was a large, framed photo of our Grandfather Ye Ye taken a few months before his death at the age of seventy-four.

CHAPTER 2

Precious Treasure
Worth Cherishing

奇貨可居

Qi Huo Ke Ju

Jade box, Western Han dynasty, second century B.C.E.

*A*lthough my grandfather used to be a businessman before his retirement, he was
always more interested in books than in money. When the Communists
were taking over China in 1949, my family fled from Shanghai to Hong Kong, and
I was sent to boarding school. On the rare occasions when I was allowed to go home
during the holidays, Niang told me to sleep on a cot in Ye Ye's room.

Ye Ye and I never discussed it, but I knew in my heart that we were both happy
about this arrangement. Although I was young and he was old, we shared a special
rapport and I loved being with him. He would ask me to read the Chinese news-
papers aloud to teach me new characters, or he would show me the proper way of
writing calligraphy with a brush. Sometimes we played Chinese chess, but what I
liked best of all were the stories he told about legendary figures from Chinese history.

Once I asked him what sort of businesses my father was involved with.

"Your father is very talented," Ye Ye answered. "He has import-export, manufacturing, and real estate businesses."

"What is the most profitable business, Ye Ye?"

"It all depends on your definition of profit," he answered. "If your chief consideration is money, then the best investment is probably real estate. Houses and apartments in good locations will always go up in value if they are well managed. Keep that in mind."

"Is there any other consideration more important than money?"

"Of course!" Ye Ye answered. "Relationships, morality, and education are all much more important than money. Many people make the mistake of thinking that cash, material goods, and real estate are the only precious things in life. They forget about education and knowledge. To me, a sharp, ethical, and cultivated mind is a much worthier asset than anything else and is truly a qi huo ke ju, 'precious treasure worth cherishing.' Let the proverbs I've taught you and the stories behind these proverbs be your most precious treasure. Cherish them, and carry them with you wherever you go."

◆

Because of their influence on history, Confucius, the First Emperor of China, and Mao Tse-tung are regarded by many Chinese as the three most influential figures who ever lived. Confucius molded Chinese thinking, and his teaching still affects Chinese life on every level. The First Emperor unified China, abolished feudalism, and established a form of government that has remained virtually unchanged until the twentieth century. Mao Tse-tung ended the civil war, unleashed the Cultural Revolution, and radically altered China's political system and ideology. Whereas the lives of Confucius and Mao Tse-tung have been well documented, that of the First Emperor remains relatively unknown to Western readers.

In *Shiji*, Sima Qian wrote extensively about that period of history when a divided China was united by the First Emperor, as well as the tumultuous years immediately following his death. Many of the phrases written by the Grand Historian to describe the intrigues and conflicts of that time have come down to us as proverbs. They have survived for over 2000 years and are still frequently quoted in everyday conversation.

During that restless era of brutal strife and constant warfare 2200 years ago, the population of China already numbered over 40 million. However,

battlefield casualties were enormous. According to *Shiji*, 1,500,000 soldiers were slaughtered in fifteen major military campaigns waged by the state of Qin between 363 and 234 B.C.E. The average peasant led a life of misery and uncertainty. Armed soldiers would arbitrarily march across the fields, appropriate the crops, draft all the sons, or rape the women while the seven states fought for supremacy. Between wars, there were diplomatic maneuvers, accords, intrigues, and treaties. Women had no rights and were used as pawns to secure strategic marriage alliances and sexual favors. The life of an average woman was at the complete mercy of her husband or father.

But it was not only peasants who suffered. Royal princes too were sometimes used as pawns. At the conclusion of a peace treaty between two states, it was customary to exchange hostages as guarantees of good faith. These hostages were usually princes of royal birth. One of these was Prince Zi Chu of Qin. He was sent to Zhao as a hostage after Qin lost a major battle against Zhao in 270 B.C.E., and there he remained for the next thirteen years.

In 265 B.C.E. a merchant named Lu Buwei traveled to Handan, the capital city of Zhao, in search of fresh business opportunities. Annexation of the weaker states by the stronger ones resulted in only seven states remaining at that time. Of these seven, the state of Zhao was the most cultured and sophisticated, Chu had the largest land area, and Qin possessed the greatest military power.

There were two main reasons for Qin's military might. First and foremost was the hardiness of the people. Living in the far west corner of ancient China, the people of Qin had been responsible for centuries for defending their western frontier against the fierce nomadic Huns who roamed the adjacent desert wastelands. In time they adopted many of the savage fighting methods of their enemy and developed military practices more ruthless than those of any other state. Their children were taught to ride from a young age, given bows and arrows, and taught to shoot birds and animals from the saddle. When a war was declared, they conscripted every citizen. They seldom used chariots but would swoop down upon their enemies on fast horses, moving like swarms of locusts across the plains and destroying all in their paths with their spears, halberds, dagger axes, crossbows, and arrows. Flight or surrender was considered cowardly,

and desertion was punishable by death. Qin soldiers were promoted according to the number of heads of enemy troops they brought back to their officers. All military personnel were expected to fight to the death.

According to *Shiji*, there was a second reason for Qin's military prowess. Sima Qian wrote,

> *The country of Qin was so situated that its geographical position almost guaranteed its military might. Access was irksome because the state was surrounded by a girdle consisting of the Yellow River and the mountains. Suspended one thousand feet above the neighboring states, its lofty location was so advantageous that a million attackers could be held off by fewer than twenty thousand men. When a Qin general sent his troops to descend on the enemy, it was like a giant emptying a pail of water from the pinnacle of a tall building.*

Merchant Lu Buwei was born in the state of Wei but lived and prospered in the state of Haan for a few years before moving to Zhao. Like many traders, he traveled frequently from state to state while buying cheap and selling dear. By the year 265 B.C.E. he had already made a fortune and was known to be a very wealthy man.

At that time Qin was governed by King Zao, whose reign would last for fifty-five years. Between 275 and 270 B.C.E. Qin defeated the armies of Wei and Chu so convincingly that both states were forced to deed over large tracts of land during the peace negotiations. Flushed with victory, King Zao turned his attention north and attacked Zhao in 270 B.C.E. This time the Qin troops were defeated by the well-disciplined Zhao army. Qin sued for peace, and as was the custom, the two states exchanged royal princes to act as hostages in each other's countries to guarantee the peace treaty.

Instead of sending his oldest son, the crown prince, as a hostage, King Zao dispatched Prince Zi Chu, who was one of his grandsons and the son of Prince An Guo, his second son. Like many princes of royal blood, Prince An Guo had a favorite wife and many concubines. His favorite wife was barren, but he had more than twenty sons by his other wives. When Prince An Guo was commanded by his father to send one of his sons to the state of Zhao, it was easy for him to dispatch Prince Zi Chu because Zi Chu's mother was one of his least favorite concubines.

Life as a hostage in an alien state was a precarious affair much dreaded by the princes. Should hostilities resume between the two states, the

hostage prince would be an easy and convenient target on whom the people could vent their anger. There was even the likelihood of being murdered or executed.

After arriving in Zhao, Prince Zi Chu was forgotten by his royal family back home. He was provided with a very modest residence in the Guest House district of Handan, capital city of Zhao. The other aristocrats in the city held him in contempt, noting that he lived shabbily under straitened circumstances, without even a decent carriage.

As time went by, the relationship between the two states (Qin and Zhao) gradually worsened. Skirmishes were frequent, with aggressive posturing on both sides. After each dispute, Zi Chu's privileges were further curtailed. He had no choice but to endure in silence the mounting insults, deplorable living conditions, diminished rations, reduced allowance, and other forms of abuse. Ignored by his own family and ostracized by the people of Zhao, Prince Zi Chu was destitute. But then Merchant Lu Buwei came into his life.

After migrating from the state of Haan to Zhao, Merchant Lu had prospered even further. Now immensely wealthy, he decided to settle down in Handan, which at that time enjoyed the reputation of being the most cultured and sophisticated capital city of the seven states. The city was so renowned it even had its own proverb. Taken from the book of Zhuang Zi (written ?300 B.C.E.), *Handan xue bu* translates like this: "Handan's women are so beautiful and its music so superb that youths everywhere try to simulate the elegance of the natives, even imitating the way they walk." It refers to those who lose their original self by slavishly imitating the ways of others.

By sheer chance, Merchant Lu heard that Prince Zi Chu was being held hostage in the same city and was in straitened circumstances. More important, he learned that Zi Chu's father, Prince An Guo, had just been proclaimed (the year before, in 266 B.C.E.) as crown prince of Qin following the death of his older brother. It dawned on the merchant that Prince Zi Chu himself now stood a chance of becoming heir to the throne of the most powerful state under Heaven.

Merchant Lu asked his own father, "What is the rate of return if one invests in farming?"

"The return can be as high as ten times your investment."

"How about the buying and selling of jewelry and pearls?"

"Much more profitable. A hundred times your capital."

"How about helping to place a king on the throne?"

"Oh!" his father exclaimed. "That can lead to the sort of wealth that is incalculable."

Merchant Lu laughed. "In that case, Prince Zi Chu should be regarded as *qi huo ke ju,* 'a precious treasure worth cherishing'! If we invest in him, we might reap enormous riches one day. Father, you have made up my mind for me. I am going to contact him."

After this conversation, Merchant Lu set about making a business plan. First he paid a visit to Prince Zi Chu and was shocked at his modest surroundings and poverty-stricken appearance. Moved to pity, he said to the prince, "I know how to open the gate of your house wider for you."

Prince Zi Chu laughed and said, "Why don't you open your own gate wider before worrying about mine?"

Lu replied, "You don't understand. The width of my opening depends on the width of yours."

Xin zhi suo wei, "grasping the essence of what he was alluding to," the prince led the merchant to a mat in an inner room. They sat opposite each other and were soon deep in conversation.

Lu said, "Your grandfather, King Zao, is getting on in years. Although your father is now crown prince and is next in line to the throne, he has not yet designated his own successor. Your chances of being your father's heir are not great because not only are you a middle son, you also have more than twenty brothers. What do you say if the two of us put our heads together and come up with a plan to seat you on the throne one day?"

Prince Zi Chu could hardly believe his ears. "My mother and I have never been favored by my father. Besides, I have been a hostage and away from home for a long time. At present, I have no chance of competing with my brothers who are there in person waiting upon my father day and night. If you can accomplish this miracle, I will make you my guardian and share everything with you. In addition, I'll remain grateful to you for the rest of my life. But the real question is, how do we achieve this?"

"I have made some inquiries and thought it out very carefully," the wily merchant replied. "You are poor and living in a foreign state. You have no money to buy gifts for members of your family or to cultivate people here in Handan. I too am poor, but I'm willing to take out a thousand pieces of

gold and use them on your behalf. As everyone knows, your father is very much in love with his favorite wife, Princess Hua Yang, who happens to be barren and has no son of her own. I think that is the reason your father has not yet named his successor. Princess Hua Yang's influence on your father is enormous, and it will help greatly if she should adopt you as her son.

"I hear that Princess Hua Yang is fond of jewelry. Tomorrow let us go and purchase for her the rarest gems and brightest jade. I shall travel to Xianyang, the capital of Qin, next month and give them to her as a special gift from you. Hopefully, she will be persuaded to put in a good word to your father on your behalf."

"But you don't even know Princess Hua Yang. How will you make her acquaintance?"

Lu laughed, "That is no problem at all! I have contacts who know Princess Hua Yang's older sister and brother. I hear that the princess and her siblings are very close and see each other regularly. In any case, leave all that to me and don't worry. First let me present you with five hundred pieces of gold for living expenses and for entertaining the noble lords here at Handan. Make some good contacts. I'll be back soon, and everything will be arranged for you."

Prince Zi Chu knelt on the ground and kowtowed to Lu. Then he said, "Should you succeed in making me King of Qin, I shall rule my kingdom together with you."

A few months later Lu returned from Xianyang in the best of spirits and immediately sought out Zi Chu. "Congratulations!" he began. "I met Princess Hua Yang's sister and asked her to present some gifts to the princess, telling her that they are from you. Then I said to her, 'King Zao is getting old. When he dies, your sister's husband, Prince An Guo, will be king. At present, Prince An Guo loves your sister deeply even though she is barren. Princess Hua Yang is a beautiful woman, but I have heard that when a woman ages, her husband's love vanishes along with her beauty. Since she has no son, the loss of Prince An Guo will mean that there will be no one left to protect her after his death. Her position will become more and more precarious as she gets older and feebler. Who will be there to look after her at that stage of her life?'

"I could see that she was getting interested. Now I brought out the jewelry and said, 'All this jewelry was specially purchased for Princess Hua

Yang by Prince Zi Chu. Please give them to her. Prince Zi Chu is a worthy and filial son and loves your sister like his second mother. Life is hard for him, and the people of Qin have largely forgotten Prince Zi Chu, who has languished in the foreign state of Zhao as a hostage for over five years. In spite of this, he remains good-hearted and honest. What a fine young man! He is worthy and filial, and everyone in Zhao holds him in the highest esteem!

'When I think of it, since Princess Hua Yang has no son of her own, why doesn't she adopt Zi Chu as her heir and persuade Prince An Guo to make Zi Chu his successor? This way, your sister, you, and your family will always be protected and honored, even after Prince An Guo's death. When Zi Chu ascends the throne, Princess Hua Yang will be the queen mother. Even after her death, Prince Zi Chu will honor your sister's memory and the memory of her family. This is called *yi yan er wan shi zhi li,* "speaking one sentence that results in ten thousand generations of gain." '

"I'm glad to report that Princess Hua Yang became convinced of the truth of my advice. She praised you to your father, saying what a worthy man you are. Then, with tears in her eyes, she begged your father to allow her to adopt you as her son and set you up as his rightful heir so that her own future would be secure. Your father gave his consent and even had a jade tally engraved with words to this effect. He broke the tally in two and gave one half to Princess Hua Yang while retaining the other half for himself. That means you are now your father's rightful heir! Congratulations!"

"What you've done is incredible!" Prince Zi Chu exclaimed. "But why did my father not make a public announcement that I am now his heir?"

"How can he do that? Remember, your grandfather is still very much alive and sits on the throne at this very moment. Your father is only the crown prince, not yet the king. But the fact that he had a jade tally engraved to this effect and divided it with Princess Hua Yang means that he has made a solemn promise. Here! I almost forgot! Your father and Princess Hua Yang also asked me to be your tutor and entrusted me to bring you all these rich gifts. Just look at them! I have no doubt that all the noble lords in Handan will soon look at you with different eyes, and your fame will spread far and wide from now on."

"I shall always be grateful to you," Zi Chu exclaimed. "How can I ever repay you?"

"Don't even think of it!" Merchant Lu replied. "Why don't you come to my house tonight to celebrate? I have many concubines who can entertain us. Tonight they will sing for us while we dine."

Over the next five years the two men became best friends and spent much time together. Though Merchant Lu had many concubines, he was particularly fond of one named Zhao Ji, who was very beautiful and had great skill in dancing. One day in 260 B.C.E., Prince Zi Chu happened to catch sight of her. As Zhao Ji danced and sang, Prince Zi Chu could not take his eyes off her. Throughout the dinner he thought of her. Finally, when it came time for him to leave, he stood up and proposed a toast.

"I drink to your long life!" Prince Zi Chu said to Merchant Lu. "You have done so much for me. May I ask for one more favor?"

"Of course! Whatever I have also belongs to you. Just ask and it will be yours."

"In the last five years, I have been to your house many times and seen many of your concubines," Prince Zi Chu began. "Even though they are all very pretty, I have never been tempted. But tonight I have met someone who is the most beautiful woman I have ever seen. Please, will you give Zhao Ji to me?"

Lu was outraged. But instead of lashing out, he took a long drink of wine and thought deeply. By now he had invested all his wealth in Prince Zi Chu and could no longer afford to break with him. And unknown to anyone else, Zhao Ji had just told him that morning that she was pregnant. If they concealed her pregnancy and Prince Zi Chu married her, his son would be King of Qin one day.

He forced a laugh and said to Prince Zi Chu, "I would not do it for anyone else but you! You are my best friend, and I can refuse you nothing. Give her a few days to pack her belongings, and I will send her to you."

Zhao Ji successfully concealed her pregnancy from the prince. When she delivered a son some months later in 259 B.C.E., Prince Zi Chu assumed the child was his and promoted her to the level of a proper wife. He named the boy Prince Zheng.

Two years later hostilities between Qin and Zhao escalated to such an extent that the Qin army laid siege to the city of Handan. This infuriated

the men of Zhao, and they wanted to kill Prince Zi Chu. With the help of Merchant Lu, the prince successfully bribed the officers acting as his guards with 600 catties of gold, and the two friends managed to escape. They made their way outside the city gates of Handan to the Qin army and were escorted back to Qin.

Back in Xianyang, Prince Zi Chu was hailed as a war hero. Since his adoptive mother, Princess Hua Yang, was originally from Chu, Lu urged Prince Zi Chu to dress in the costume worn by Chu noblemen when he went to pay his respects to her and his father, Prince An Guo. Princess Hua Yang was very much impressed by this thoughtful gesture and advised Prince An Guo to grant Zi Chu even greater riches.

Meanwhile, in Handan, Prince Zi Chu's wife, Zhao Ji, and son, Prince Zheng, were threatened. Over the years, however, through the assistance of Merchant Lu, Zhao Ji's parents had become wealthy in their own right. They paid heavy bribes for Zhao Ji and Prince Zheng to go into hiding. Mother and son lived quietly by themselves for a number of years close to the home of another royal hostage, a prince from Yan. This prince had a baby son, Prince Dan, who was approximately the same age as Prince Zheng. The two princelings often played together and developed a close friendship as they grew into boyhood.

◆

In reading Shiji, *I am repeatedly struck by the extensive role that close friendships, family ties, and personal commitments played on the course of Chinese history, leading to consequences undreamed of by the perpetrators. By "giving" his pregnant mistress to Prince Zi Chu without the latter's knowledge of her pregnancy and "guiding" Zi Chu into becoming King of Qin, Merchant Lu created a train of events that would eventually explode completely out of his control. We will follow the story further in the next chapter.*

For now, we may note that the proverb has a striking parallel in our own time. During the 1940s in China, almost all the leaders of the Chinese Communist Party were special friends of Mao Tse-tung. They actively participated in the promotion of Mao's image, claiming him to be a qi huo ke ju, *"precious treasure worth cherishing" and "the highest ideal of mankind." While deifying Mao, they rode on the coattail of his success and developed a total and blind commitment to him.*

After driving out the Nationalists in 1949, Mao became more powerful than any previous monarch. To challenge him was to dispute the party and its legitimacy to

rule. In Chinese folklore we read of a mythical figure named Zhong Kui, who possesses the power to expel ghosts and evil spirits. Mao himself described his role in these words: "The Communist Party needed someone to get rid of Chiang Kai-shek and the other bad elements in order to personify its claim to power. I became the party's Zhong Kui of the twentieth century."

As the years went by, Mao identified more and more with his own press. Twenty years after he came to power, the idealistic and fiery revolutionary had turned into an autocratic, paranoid, and frustrated old despot clinging to his throne. At one point in the early 1960s, he was heard lamenting that his comrades were treating him with the same attention paid to the corpse at their father's funeral.

Mao unleashed the Cultural Revolution in 1966 to reassert his dominance, purging his most loyal colleagues, many of whom were veteran cadres who had been with him for over thirty years. These were the same men who had originally deified Mao in the 1940s. Because of their previous assiduous promotion of Mao, they created the Mao dynasty and identified Mao so closely with the Chinese Communist Party that the two became synonymous in the eyes of the Chinese people. Never did they expect that the "precious treasure" they had helped transform into a demigod would turn against them and plunge the country into chaos.

Although China still considers itself to be Communist, it is a very different sort of Communism from that envisioned by Marx, Engels, Lenin, or even Mao himself. Since Mao's death in 1976, China has been radically transformed culturally, economically, and politically. Some consider China to be Communist in name only, retaining that name solely because of its Maoist legacy.

Even today, criticizing Mao for his actions during the Cultural Revolution is still perceived as challenging the Communist Party's right to rule. This issue remains unresolved and continues to haunt the present leadership.

One Written Word Is Worth a Thousand Pieces of Gold

一字千金

Yi Zi Qian Jing

Bamboo slips, Warring States period (c. mid-fourth century B.C.E.).

For the first ten years of my life, my Aunt Baba and I shared a room. We knew in our hearts that we were both viewed with contempt by the rest of our family, even though we never dared verbalize this, not even to ourselves. I was the lowest of the low because I was a girl and the youngest of five stepchildren. In addition, everyone considered me to be a source of bad luck because my mother had died giving birth to me. My Aunt Baba was also despised because she was a spinster and financially dependent upon my father.

Aunt Baba was always like a mother to me. After the death of my grandmother we grew even closer. She paid the greatest attention to everything about me: my health, my appearance, and my personality. Most of all, she cared about my education and checked my homework every evening. Whenever I got a good report card, she would lock it in her safe deposit box and wear the key around her neck, as if my grades were so many precious jewels impossible to replace.

29

In those days I already loved to write. On the evenings when I had no home-work, I used to scribble kung fu stories in a special notebook and take them to school the next morning. It thrilled me to show my stories to my giggling classmates and watch them pass my writing illicitly from desk to desk during class.

When she was in a good mood, Aunt Baba read them too. She would pour her-self a cup of tea, put on her glasses, and chuckle over my narratives. If she came across one she particularly liked, she would smile and say, "Yi zi qian jing! 'One writ-ten word is worth a thousand pieces of gold—a literary gem!' "

It was only when I was doing research for this book that I learned the origin of this proverb. The phrase was first used under unique circumstances (in 241 B.C.E.) to describe a book of essays collected by the true father of the First Emperor of China: the wily and immensely rich merchant, Lu Buwei.

◆

In 251 B.C.E. old King Zao of Qin finally passed away after a reign of fifty-six years. His son, Crown Prince An Guo, succeeded him as King of Qin. Princess Hua Yang became queen, and Prince Zi Chu was officially named crown prince. By that time the political climate had changed so much that when Prince Zi Chu requested the return of his wife and son, the King of Zhao obliged by sending them to Qin under official escort. King An Guo was already fifty-one years old, and he ruled for only one year before succumbing to illness and dying.

An Guo's son, Prince Zi Chu, became King of Qin. Merchant Lu Buwei was ecstatic that his dream of investing in a future King of Qin was ful-filled. Far from forgetting his mentor, Prince Zi Chu made the former mer-chant his prime minister. Queen Hua Yang, whom Zi Chu had come to treat as a mother, was named queen dowager. The former courtesan Zhao Ji was named queen of Qin, and her son, Prince Zheng, became crown prince and successor to the throne.

As his father had predicted, Merchant Lu became richer and more pow-erful than he had ever thought possible. His financial reward was certainly greater than what he might have reaped from any other investment. Zi Chu addressed him as "brother," ennobled him as a marquis, and allowed him to keep the revenues of 100,000 households in Luoyang in Henan Province. It was recorded that Lu Buwei employed 10,000 servants and engaged them in handicrafts, industry, and commerce, thus further increasing his wealth.

After Zi Chu's death from illness only three years later, thirteen-year-old Prince Zheng ascended the throne. He made Merchant Lu his regent as well as his prime minister and honored him by giving him the title of *zhong fu,* or "second father."

Merchant Lu's authority over the affairs of state was absolute during King Zheng's teenage years. He resumed his sexual relationship with his former concubine, the beautiful Zhao Ji (now the queen mother), but kept it a secret from their son, the boy king. For the next eight years he was the de facto ruler of Qin.

Ashamed of his merchant background, he emulated the practice of the four most renowned and cultured kings of that era (those of Zhao, Chu, Qi, and Wei) by opening his home to visiting scholars regardless of their family background or origin. At the height of his fame and power, Merchant Lu maintained a household of 3000 guest-scholars, many of whom came from places outside Qin. Among them was the scholar Li Si, who had emigrated recently from the state of Chu. Merchant Lu introduced Li Si to King Zheng, who took an instant liking to the well-educated scholar.

Merchant Lu assembled the best articles written by the scholars under his roof and compiled them into a book of twenty-six chapters, comprising 160 essays and 20,000 words. According to *Shiji,*

> *He claimed it to be an encyclopedia of current knowledge, encompassing all matters pertaining to Heaven, the earth, natural phenomena, the past and the present.*

He titled it *Spring and Autumn Annals of the House of Lu* and had the words carved in stone and the tablets displayed at the city gate of Xianyang. One thousand pieces of gold were suspended above the text along with a notice proclaiming that the sum would be rewarded to anyone who could improve the literary value of his book by adding or deleting a single word. Naturally, no one dared risk the displeasure of someone as powerful as the prime minister by challenging his writing. Merchant Lu's book is still in print. The phrase *yi zi qian jin,* "one written word is worth a thousand pieces of gold," has become a proverb, used nowadays to describe any literary work of exceptional merit.

During the eight years that he ruled the country, Merchant Lu success-
fully waged war and annexed various territories from Haan, Wei, and Zhao,
thereby increasing the size, wealth, and prestige of Qin.

As Zheng approached manhood, Merchant Lu became fearful that the
boy king would discover his liaison with the queen mother. So he decided
to distance himself and look for someone who would take his place. He
searched about until he found a man named Lao Ai, who had the reputa-
tion of being very well endowed, and made him his servant. *Shiji* tells us
that in order to arouse the queen mother's interest, Merchant Lu ordered
Lao Ai to parade around with a cartwheel made of paulowina wood bal-
anced on his phallus while sensual music was being played. Hearing of this,
the queen mother expressed a desire to meet him. To avoid a scandal, Mer-
chant Lu disguised Lao Ai as a eunuch by plucking his beard and eyebrows.
(After castration, eunuchs would lose their source of testosterone and typ-
ically became beardless). He then gave him to Queen Zhao Ji as her ser-
vant in her private apartments. Lao Ai got along so well with the queen
mother that they secretly had two sons together. Queen Zhao Ji lavished
gifts upon her lover and referred all decisions to him. Ennobled as a mar-
quis, he was assigned lands, palaces, parks, and hunting areas, while employ-
ing several thousand male servants.

In 238 B.C.E. King Zheng reached the age of twenty-one and began
to take the reins of government into his own hands. Meanwhile, the for-
mer servant Lao Ai was becoming increasingly boastful while the besot-
ted queen mother continued to shower him with riches and titles. At a
dinner party a drunken Lao Ai was heard openly bragging of his influence
over the queen mother and claiming to be the stepfather of the young king.
His comments were duly reported back to His Majesty.

King Zheng now heard that Lao Ai was not a eunuch at all but his
mother's lover. "Your mother has borne Lao Ai two sons who are being
kept hidden," he was told. "As soon as Your Majesty passes on, they have
agreed between themselves that one of their sons will succeed you."

The king investigated and discovered that the lovers had been brought
together by Merchant Lu. He was still uncovering evidence when he set
off to the ancient capital of Yong to undergo the capping ceremony (equiv-
alent to the coronation) and to perform ritual sacrifices to his ancestors.
While he was away from Xianyang, Lai Ai made his move. He seized the
queen mother's seal without her permission, forged the king's seal, mobi-

lized the army in the outlying counties, and ordered them to rebel in the name of the queen mother. Swiftly and resolutely, King Zheng commanded his officers to attack the rebels. At the sight of the army under the young king's flag, Lao Ai's troops from the provinces laid down their arms and refused to fight. The few who remained loyal to Lao Ai fled for their lives along with their ringleader.

King Zheng placed a price of one million copper coins on Lao Ai's head if taken alive and half a million if dead. Lao Ai and his supporters were captured while fleeing. Twenty of his fellow plotters were beheaded and their heads exposed in the marketplace. Lao Ai himself was torn in two by carriages and his entire family was executed to the third degree. The young king also put to death the queen mother's two young sons by Lao Ai.

The queen mother was at first banished into exile. Later, King Zheng brought her back to Xianyang on the advice of his ministers, who recommended that he should keep up the appearance of being a filial son to his mother. He built her a palace but placed her under house arrest until her death seventeen years later.

As for Merchant Lu, King Zheng never forgave him for his part in the plot against the throne. Although there was no direct evidence that the former merchant was involved in the rebellion, his power was such that he must have had some knowledge that he never shared with the king.

Shiji says,

> The king wished to kill the prime minister, but because he had done much for the preceding ruler, and because his retainers and scholarly supporters were numerous, the king did not allow the law to be applied.

Merchant Lu was relieved of his office and ordered to retire to his fief in Loyang (Henan Province). In no time at all, emissaries and ministers from the other six states were beating a path to Lu's door. So many came that their carriages were never out of one another's sight on the road to Loyang. They asked Lu for advice, pumped him for information, inundated him with offers of high office, and tempted him with fresh opportunities. King Zheng was not pleased when he heard this but found himself in a dilemma. He distrusted Lu and could never use him again but feared that the former prime minister knew too much that might prove useful to someone else.

After due deliberation, the king penned Merchant Lu a personal letter in 235 B.C.E. The tone of his letter was accusatory and cold:

> *What have you contributed to Qin lately? Yet you have retained your noble title and continue to receive the revenue from one hundred thousand households in the province of Henan. I order you and your family to move to Shu [presently Sichuan Province but at that time a remote farming area]* immediately.

On reading this, Lu knew that King Zheng would never forgive him. Fearful of involving the other members of his family (who would also be punished if he were given the death penalty to the third degree) but unable to reveal that he was the young king's true father, the merchant took the only path that remained. One chilly autumn morning, he drank a cup of poisoned wine and committed suicide.

<p style="text-align:center">✦</p>

Sima Qian frequently wrote a commentary at the end of his biographical sketches. In the case of Merchant Lu, he wrote,

> *Confucius said, "Famous men often give the appearance of virtue but act very differently in practice." This comment can be aptly applied to the life of Merchant Lu, can it not?*

That today we should be reading the remarks of a historian who lived 2100 years ago, making comments on the writing of Confucius who lived four hundred years before him, certainly puts things in perspective. It also brings home the concept that writing is immortal.

Among ancient tombs discovered in Shuihudi, Hubei Province, in 1975 C.E. was one coffin from the third century B.C.E. that differed from the rest. Besides the usual assortment of precious objects such as bronzes, gold, jade, silks, lacquered vessels, and pottery, this tomb also contained a number of bamboo "books" next to the skeleton. Over the centuries the silk threads binding the books together had rotted away, and the deceased was found covered by a tangle of narrow bamboo slips, numbering over one thousand. The writing on them was still clearly legible, and the books ranged from legal texts to historical writings.

I find it poignant that even during the Warring States period there was already someone who refused to be parted from his beloved books even at death. What was this man's motivation? Rolled up like a pillow under his head was a separate bundle of bamboo slips, which contained brief biographical notices of a man named Xi (probably the deceased). These notices were interspersed with a chronological table of yearly events in the state of Qin between 306 and 217 B.C.E. Xi was born in 262 B.C.E. and died in 217 B.C.E. He worked as a bureaucrat and legal expert in the Qin government, and was forty-five years old when he died. At his death Xi chose to make sense of his own life by recording his personal milestones in the context of Qin's history. Apparently, history was his anchor as well as his source of life's meaning.

Approximately one hundred years later, the Grand Historian Sima Qian also chose to safeguard his book by burying it in the "famous mountain archives." Shiji was Sima's attempt to bring order out of chaos to All Under Heaven by means of history. It became the most influential and widely read book in China and continues to exert a profound impact on the cultural consciousness of the Chinese, having maintained its eminence for over 2000 years.

Since ancient times, it has been a Chinese tradition to revere zi (the written word). Erudition is still considered the epitome of virtue in China. Xi was not alone in choosing to be buried with his books. Well-known classics such as the Art of War, Book of Tao, *and the* Analects of Confucius *written on silk or bamboo slips have been found subsequently in other tombs from the Han dynasty onward.*

My grandfather told me that when he was a boy growing up in Shanghai he saw many large red boxes placed at major street corners. Each had four gilded characters written on its surface: jing xi zi zhi, *"respect and cherish written words." Workmen with bamboo poles patrolled the streets picking up any stray pieces of paper with writing, and painstakingly placed them in the red containers. The contents of these boxes were burned at regular intervals at a special shrine in the Temple of Confucius. These paper-burning ceremonies were solemn occasions resembling high mass at a Catholic cathedral, with music and incense. Candidates who had successfully passed the imperial examination were the only ones allowed to participate. They would prostrate themselves in worship and pray to Heaven until all the paper had been reduced to ashes. On their way out, they would further show their respect by placing a donation into a separate red box labeled* yi zi qian jing, *"one written word is worth a thousand pieces of gold."*

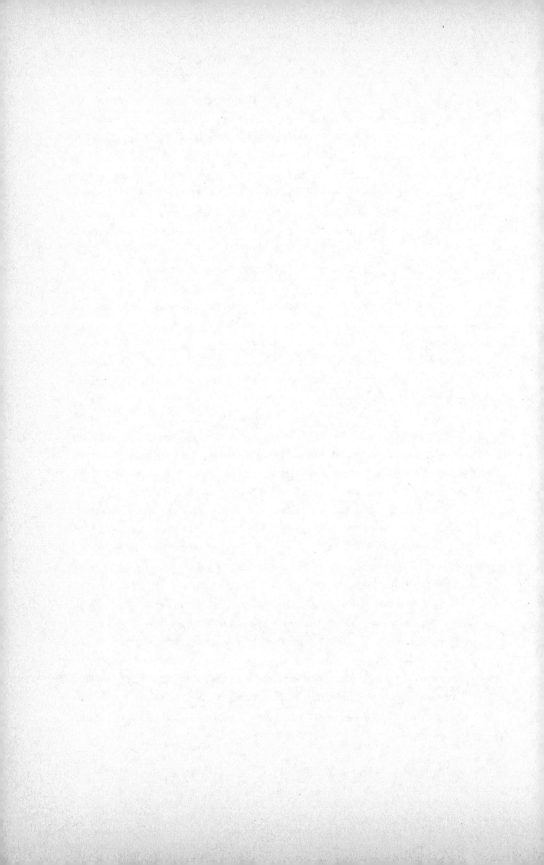

CHAPTER 4

Binding Your Feet to Prevent Your Own Progress

裹足不前
Guo Zu Bu Qian

Li Si, Prime Minister to the First Emperor, Qin Shihuang.

*I*n 1949 many Shanghai entrepreneurs fled south to Hong Kong to escape the Communists. Like Prime Minister Li Si 2200 years earlier, my father also left his home and traveled to a distant place in search of better opportunities and a fresh start. My siblings and I did not realize it then, but my father's move destined us to become part of the 55 million Chinese living and working outside of China. From then on, we became itinerant immigrants.

At the age of fourteen, I won an international writing competition, which convinced my father to send me from Hong Kong to London for higher education. Three years later, while waiting for medical school to begin, I applied for a summer accounting job advertised in the evening newspaper. Over the phone the manager sounded eager to hire me. He gave me directions to his firm and asked if I was ready to start work that day. As soon as he saw my Chinese face, however, his attitude changed. Avoiding my eyes, he told me that the position had just been filled. He was a nice man because I could hear the embarrassment in his voice as he repeated the lie. One part of him knew that I would be a good worker and was reluctant to let me go. Nevertheless, he sent me away.

Throughout the long period of my training at medical school in London, I knew in my heart that if I were to remain in England after graduation, I would never be given the same opportunities as my British classmates. In order to secure a decent career, I realized I had to go elsewhere after graduation. Because of my dismal childhood, the feeling of being discriminated against was only too familiar. I had decided long ago that life was unfair and that a person needed to find ways of overcoming adversity herself. Even so, the bias I was encountering in Britain was far less than the blatant prejudice I had endured for so many years at my own home under my stepmother.

After graduating from medical school, I went back to Hong Kong. To my shock and dismay, I came across more prejudice. My colleagues resented me because I was not Cantonese and was a graduate of an English (rather than Hong Kong) medical school. The fact that we were all Chinese simply meant that they could be more open in their intolerance. They nicknamed me "Imported Goods" and told me to my face that I was a "foreigner." No matter how hard I tried to please, I remained an outsider.

My last refuge was America. Even before I set foot on American soil, I was already being helped by an American who was a total stranger. The medical secretary of the Philadelphia hospital where I had applied for a job turned out to be kinder to me than my own parents. As soon as I wrote to her, she immediately advanced me the airfare from Hong Kong to New York against my future earnings, whereas my millionaire father and stepmother simply turned down my request for a loan. In America I found that my gender and ethnic origin were still a hindrance, but the country was large and the people were generous. However, despite these favorable considerations, I did come across one instance of ugliness.

In the 1970s there were few board-qualified and fully trained physicians specializing in anesthesia. Therefore, my services were in demand. A Catholic order that owned a large and prestigious private hospital in Los Angeles encouraged me to apply for a position in obstetric anesthesia. In due course, I was interviewed. As

soon as I sat in front of the white, male, and arrogant head of the department of anesthesia, that familiar childhood feeling of being picked on came flooding back.

"Despite what you have been told by the nuns who own this hospital," he began, "our medical group is not looking for more anesthesiologists."

Taken aback, I said somewhat lamely, trying to please the godlike figure in front of me, "I thought I might be given a chance to fill in during sick leaves and vacations."

"Look!" he replied icily. "No one in our group ever gets sick or takes a vacation. Do you understand?"

I stared back at him in silence, and he added, "Have I made myself perfectly clear?"

I nodded and prepared to leave. In those days anesthesia jobs were plentiful. His rejection did not devastate me because I knew that I would be able to find a position elsewhere. As I bade him good-bye, however, I was seized by a sudden impulse. With my hand on the doorknob, I turned to him and asked, "Have you ever heard of the Chinese proverb 'binding your feet to prevent your own progress'?"

◆

That proverb, *guo zu bu qian,* was a phrase first used by the King of Qin's minister, Li Si, in the third century B.C.E. Like the brain drain into the United States today, a similar flow of talent was happening 2200 years ago. Qin was the richest state of that era, and talented scholars from all the other states flocked there to seek employment. Their success caused such resentment among Qin's native people that they eventually persuaded the king to expel all non-Qin scholar-officials. Reluctant to relinquish his post, Li Si wrote a letter to the King of Qin protesting his deportation. He complained that Qin's new exclusionary policy was akin to "binding your feet to prevent your own progress."

Li Si was a commoner from a humble family from southern Chu (present-day southeastern Henan Province). During that time of constant warfare, talented young men would seek out famous writers and philosophers to be their teachers. After a period of study, the young scholars would travel from state to state and try to attach themselves as advisers to the rulers. These scholar-bureaucrats were called *shih.* Their functions were comparable to the tasks performed by political scientists and cabinet ministers today.

As a teenager, Li Si worked as a petty district clerk for a few years. He wanted to save up enough money to study under Xun Zi, an outstanding

Confucian scholar who lived about 600 *li* (200 miles) away, at that time considered a great distance. Even at that early stage of his life, Li Si had the foresight to conclude from observing the behavior of the rats around him that a man's fate (like that of the rat) depended very much on where he chose to live.

After completing his studies, Li Si did not wish to go back to his native state of Chu. Recognizing that Qin was becoming increasingly powerful, Li Si, like many gifted scholars from the other states, decided that he would travel there to seek employment. On leaving, he said to his teacher, Xun Zi,

> *"I have heard that one should not hesitate when the right moment dawns. Now is the time. The King of Qin wishes to devour the other states and rule them. This is the opportunity for the common man to rise. It is the golden period of the wandering scholar. One who does not move and decides to remain passive at this juncture is like a bird or deer that will merely look at a tempting morsel of meat but not touch it. There is no greater ignominy than lowness of position, nor deeper pain than penury. Therefore, I shall go west to give advice to the King of Qin."*

Xun Zi, knowing that he himself was a Confucian moralist whereas his pupil was a realist, said to him,

> *"You and I think at cross-purposes. What you consider an advantage is a disadvantageous advantage. The true advantage is what I call benevolence and righteousness. These are the two essential qualities with which to conduct a government. Under such a government, the people have affection for their ruler. They celebrate their prince and are willing to die for him. Therefore it has been said: 'Of governing matters, generals and commanders should come last.' Although the state of Qin has been triumphant for four generations, it has lived in constant terror that the other states will unite and destroy it some day. Now you are seeking not for what should come at the beginning (that is, benevolence and righteousness) but what should come at the end (that is, generals and commanders). My conclusion is that your generation is confused."*

In 247 B.C.E. Li Si traveled from his village home to Xianyang, the capital of Qin. There he found that the King of Qin had just died. He sought out Prime Minister Lu Buwei and became one of Lu's 3000 houseguests. Impressed with Li Si's literary talent, Lu Buwei took him under his wing

and introduced him to thirteen-year-old King Zheng, who had just ascended the throne following the death of his father. According to *Shiji*, this was Li's advice to the boy king:

> "The little man is one who discards his opportunities, but great feats are achieved only by giants who can profit from the mistakes of others and single-mindedly complete their mission. . . .
>
> "Many feudal lords of the other six states are already paying allegiance to Your Majesty, as if they were your prefectures. With the might of Qin and Your Majesty's great ability, conquering the other states would be as easy as wiping dust from the surface of a kitchen stove. Qin possesses sufficient power at present to annihilate the other rulers, found a single empire, and rule the world. This is the chance of ten thousand generations. If you should let go of this opportunity, the various nobles might form a great alliance against you from north to south and rediscover their power. Against that union you will never prevail, even if you were the Yellow Emperor himself."

Lu Buwei as well as the boy king were impressed by Li Si's presentation, so much so that they conferred upon him the office of senior scribe. *Shiji* tells us,

> The king listened carefully to Li Si's plans and secretly recruited agents, provisioned them with gold and precious jewels, and commissioned them to go from state to state lobbying the feudal lords and ministers of note. They were instructed to reward those whose submission could be bought with gold. As for those who would not acquiesce, they were to be killed with sharp swords.

Li's advice closely echoed King Zheng's own inclinations. From then on, the young king made every effort to weaken and sever the various alliances between the different states by bribery, threats, espionage, and negotiation. Meanwhile, the other states were themselves enmeshed in a tangle of intrigue directed against one another as well as against Qin. *Shiji* records one such incident:

> The King of Haan came up with the idea of preoccupying the state of Qin with massive construction projects so as to slow its military expansion. He therefore dispatched the water engineer Zheng Guo to see King Zheng of Qin. Engineer

Zheng successfully persuaded the king to build a canal between the Jing River and the Lo River for irrigation purposes. The terrain between the two rivers was hilly and uneven. The canal was 300 li [90 miles] long and required the construction of a tunnel beneath the hills.

The massive project involved years of hard labor and hundreds of thousands of workers. It was only partially completed when the king discovered that Engineer Zheng was a spy working for the state of Haan. The king was about to execute the engineer when the latter said, "It is true that this scheme was meant to harm you. However, if you should allow the canal to be constructed, it will be of tremendous benefit to your state in the future. By this scheme, I have extended the life of the state of Haan for only a few years; but my project will benefit the state of Qin for ten thousand generations."

The king changed his mind and allowed the work to continue. When completed, the canal irrigated over 500,000 acres of previously arid land with water full of rich sediment. The interior of Qin became fertile and productive without dry years. Qin grew rich and powerful and was able to conquer all the other states. The canal was named Zheng Guo Canal after the engineer who built it.

The plot of the Zheng Guo Canal was uncovered at about the same time as the rebellion instigated against the king by Lao Ai. Members of the royal family and other Qin nobles had long been resentful of the high offices held by foreign officials from other states. Now they pointed out to the king that all the ring bearers in the recent conspiracies were not natives of Qin. They warned the king that the non-Qin scholars-officials who came ostensibly to serve Qin were mostly spies working on behalf of their own sovereigns. Their true purpose was to cause chaos within Qin. The nobles convinced the king to sign an order expelling all visiting scholars from Qin.

On finding his name on the list of those to be banished, Li Si wrote a powerful memorial to the throne pleading against the ordinance. He began by pointing out that several ancient kings in the past had profited greatly from the use of foreign scholars. According to *Shiji*, Li's letter continued:

At present, Your Majesty collects jade from the Kun Mountains, enjoys the treasures of Shui and Ho, dangles pearls bright as the moon, and wears a Tai-oh

sword on his belt. He rides horses from Xian-li and waves banners decorated with green phoenixes. He plays on drums made by stretching the skin of crocodiles. Of all these treasures, not one was produced by Qin. Yet Your Majesty delights in them. May I ask why?

If only products from Qin are allowed in Qin, then these luminous jades that brighten the night would not decorate your court; and art objects made from rhinoceros horns or elephants' tusks would no longer be available. Beautiful girls from Zheng and Wei would not fill your inner palaces; and the fastest-running horses would be absent from your stables.

The music of Qin used to consist of the beating of earthenware pitchers, pounding on jars, plucking of the strings of the zheng, *and thumping on bones while crying Wu! Wu! Such was Qin's method of pleasing the ear and the eye.*

Today, the people of Qin seem to have abandoned this ancient way of making music and adopted the lilting melodies of Zheng and Wei. Once more, may I ask the reason why?

The answer is because we choose to enjoy whatever is best and pleases us most!

However, this appears not to be the case when it comes to the selection of men. Without considering their qualifications or capability, let alone their honesty or deceitfulness, non-Qin scholars are being stripped of their office and sent away.

Can it be that feminine beauty, music, pearls, and jade are perceived as being weightier and of higher importance, while human beings are of less concern? [Note that Li Si considers women as commodities rather than human beings.] Such is not the conduct to govern that which lies within the four seas, nor the correct strategy to adopt for controlling the feudal lords. . . .

By blindly driving out all foreign officials without first determining their loyalty, you are forcing them to use their talents to serve the rulers of other states. Your policy is tantamount to guo zu bu qian, *"binding your feet to prevent your own progress." It will cause future scholars to turn away form Qin and retreat before ever thinking of turning westward. Hence you will be providing weapons to bandits and preparing banquets for robbers.*

Of products that are not produced in Qin, there are many that should be treasured. Of scholars that were not originally from Qin, there are numerous who are loyal and true. In the long run, your ordinance will harm your own people and benefit your enemies. It is definitely not the way toward stability and safety for your state.

Swayed by Li Si's eloquence and analytical logic, King Zheng rescinded his order and recalled Li Si. When His Majesty's new dictum was announced, Li Si had already left Qin's capital city and was halfway back to Chu. The king's messenger finally caught up with him hundreds of miles southeast of Qin. Li Si was delighted to hear of King Zheng's change of heart and returned to Qin immediately. Shortly afterward, Li Si was promoted to the rank of chief justice and in 221 B.C.E. became prime minister.

Unlike King Zheng, who was dictatorial, impetuous, emotional, and deeply superstitious, Li Si was rational, methodical, cold, and calculating. Twenty-one years older than the monarch, Li Si acted as a father figure to the young king, who turned to the older man increasingly for advice after the downfall and suicide of Lu Buwei. Many of the great deeds attributed to the king alone were probably carried out with the able assistance of his minister. In a memorial written shortly before he died, Li Si enumerated his manifold services:

> *I sent out secret agents, equipped them with gold and precious gems, and ordered them to travel to different states to befriend and counsel the feudal lords. Eventually, I was able to help His Majesty annex the six states, capture their kings, unite the country, realize for him the imperial heritage, and establish him to be the Son of Heaven [as the emperor was known in those times].*
>
> *I helped to drive out the Huns to the north and the Yues to the south. I reformed the policies and standardized the laws, weights, measures, and the written characters. I laid out roads and highways and inaugurated regular imperial tours of inspection for His Majesty. I relaxed the punishments and lowered the taxes.*

Li Si served the state of Qin for a total of thirty-nine years and was to play a pivotal role at the deathbed of his sovereign.

◆

With hindsight, I have come to realize that resentment of foreigners is not peculiar to Qin, London, Hong Kong, or Los Angeles but is universal. Locals everywhere wish to preserve their own turf and reserve the best jobs for themselves and their children.

In the 1960s the United States had a special visa category for visiting scholars, called an exchange visa. At the conclusion of their work contract, foreigners who

entered America on this type of visa were obliged to leave America for at least two years before reentry. One of the unstated purposes of this type of special visa may have been to prevent foreigners from competing with locals for permanent positions at prestigious universities and other desirable technical institutions.

In Hong Kong today, despite the fact that most of the domestic jobs are filled by alien maids and butlers, there is a movement pending to prevent foreigners from working as chauffeurs. Drivers traditionally receive higher wages than domestic workers, and the locals wish to keep the more lucrative jobs for themselves. Throughout history, despite the fact that particular incidents may appear to differ in specific details, the same human impulses seem to repeat themselves over and over again.

Although the desire to keep out "foreigners" has led to exclusionary policies in many countries throughout history, Li Si correctly foresaw long ago that such conduct would be counterproductive. He likened it to guo zu bu qian, "binding your feet to prevent your own progress."

"In the long run," Li Si had predicted in his famous memorial to King Zheng, "your ordinance will harm your own people and benefit your enemies. It is definitely not the way toward stability and safety for your state."

Clapping with One Hand Produces No Sound

孤掌難鳴

Gu Zhang Nan Ming

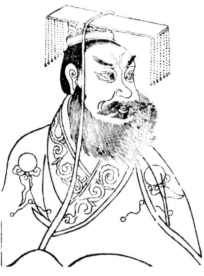

The First Emperor, Qin Shihuang.

*R*ecently, I read a wonderful example of the current use of the proverb gu zhang nan ming, *"clapping with one hand produces no sound."* President Jiang Zemin, the seventy-five-year-old leader of mainland China, was asked about China-U. S. relations. He responded by quoting, "Gu zhang nan ming, 'it takes two hands to clap, or clapping with one hand produces no sound.'"

This proverb was written by the brilliant philosopher Han Feizi, extrapolated from a couplet that says, "Regardless of how fast you do it, clapping with one hand

*will produce no sound." The Western equivalent would be "It takes two to tango"
or "One cannot negotiate alone."*

After the publication of my autobiography, Falling Leaves, *I received many letters
from readers. Among them was a Chinese psychoanalyst who wrote that my struggles
with my family members fell into a recognizable pattern:*

> *As for your brother Edgar, he was obviously jealous of you. You two were
> in the same class at medical school! Do you remember how envious Li Si
> was of his classmate Han Feizi when they were both being taught by Xun
> Zi? The best thing you did for yourself was when you cut yourself off from
> Edgar. Otherwise you would still be clapping with one hand. Remember
> that no matter how hard you do it,* gu zhang nan ming, *"clapping with
> one hand will produce only silence." For a relationship to exist between
> two parties, both have to participate. Many fail to understand this funda-
> mental fact.*

◆

Han Feizi was born a prince in Haan. Burdened with a speech impedi-
ment, he turned to writing as a means of self-expression. He and Li Si
were exactly the same age, and both studied under the Confucian philoso-
pher Xun Zi. During their time together, Li Si grew increasingly jealous
of his classmate. Li Si was born poor, whereas Han Feizi's first cousin was
the King of Haan. Although both were excellent students, Li Si recog-
nized that his fellow pupil was more talented.

When they completed their studies, Li Si traveled to Qin to seek
employment while Han Feizi went home. After losing a series of wars,
Haan pursued a policy of appeasement toward Qin and was almost bank-
rupt. Concerned over the weakness of his home state, Han Feizi repeat-
edly urged his cousin, the King of Haan, to reform the government. His
ideas were ignored. In his frustration, he wrote a book of essays outlining
his programs.

He was a proponent of the Legalist School of philosophy. As such, he
disagreed with the Confucian concept of regarding the past as the ideal and
using the past to discredit the present. He wrote,

In the state of a wise ruler, there is no need for books and bamboo slips. The law is the only creed. We do not need to quote the sayings of ancient kings as our guides. The appointed officials are our models.

In order to rule effectively, Han Feizi listed three principles that the king had to adopt. The first was *shi* (absolute power). The second was *shu* (method). In this context, it is interesting to note that some of the *shu* (governing methods), such as *hukou* (system of requiring every household to be registered with the local government in Communist China), has been handed down virtually unchanged since the time of the Warring States. The third was *fa* (law).

Surprisingly modern in some aspects, the Legalist School made the rule of law the foundation of its new philosophy of government. The law was to be universal and was to be obeyed by everyone, regardless of rank or blood. This was far different from the feudal system during the Warring States, in which the king of each state was a law unto himself. He, his family, and the nobles they appointed had unlimited powers over those under them. Han Feizi was a fierce opponent of feudal privileges and their hierarchic social structure. He wrote,

Let the laws be recorded in writing, displayed within the government offices, and made known to the people.

He taught that the laws must be kept constant. All affairs could be carried out only within the scope of the law, and the law was to be the highest standard of behavior in the world. Laws should be established so as to do away with private standards:

Private standards and private opinions tend to confuse the laws. If devious scholars should pursue their education while harboring hidden agendas, then the more intelligent ones will criticize while the lesser ones will cast doubt. What gives good government is law; but what causes chaos is private standards and private opinions. After establishing the law, no one should be allowed to question the law or to have private opinions.

His writings came into the hands of King Zheng, ruler of Qin and future First Emperor of China.

According to *Shiji*,

> *Someone sent Han Feizi's writings to the King of Qin. When he read them, he said, "Ah! If I could only meet the man who wrote this and come to know him, I would die without regret."*

Li Si replied, "These essays were written by my classmate. His name is Han Feizi." At that time, Li Si had been in Qin for fourteen years and held the high post of visiting minister. Fearing that the brilliant Han Feizi would again overshadow him if he were also to work for the King of Qin, Li Si devised a devious plan.

Not long afterward, at the urging of Li Si, Qin attacked Haan on a pretext. As part of the peace negotiation, Li Si insisted that his classmate Han Feizi be dispatched to Qin as the emissary representing the state of Haan. Therefore, in the year 233 B.C.E., Han Feizi went to Qin and was presented to King Zheng.

Shiji continues:

> *The King of Haan sent Han Feizi as an emissary to Qin. Although the King of Qin was much pleased with the brilliant scholar, he dared not trust him sufficiently yet to use him.*

While in Qin, Han Feizi submitted a petition to King Zheng. In eloquent terms, he asked Qin to desist from continuing its military campaign against Haan and to attack Zhao instead. Hearing of this, Li Si submitted a counter petition to the king, urging him not to agree to the suggestions of Han Feizi. He suggested that he himself be sent as Qin's emissary to see the King of Haan and make an attempt to lure the latter to visit Qin. In one stroke, Li Si hoped to imprison the King of Haan in Qin and place Haan at the mercy of Qin.

King Zheng duly sent Li Si to Haan, but the King of Haan would not grant him an interview. At great peril to himself, Li Si submitted a petition to the King of Haan in which he tried to dissuade the king from granting safe passage to the army of Zhao, which was threatening to invade Qin. This was the petition in which Li Si quoted the proverb

chun wan chi han, "when the lips are gone, the teeth are cold." Li Si claimed that the war of Qin would become the war of Haan because Zhao would eventually invade them both. In the 1960s Chairman Mao used the same proverb and the same argument during the Vietnam War.

Despite his best efforts, Li Si was not granted an interview and returned to Qin empty-handed. *Shiji* continues:

> *Soon after returning to Qin, Li Si grievously slandered his fellow student by saying to the king, "Han Feizi is one of the princes of the ruling House of Haan. His heart will always be with Haan and not with Qin. Such is the nature of man. If Your Majesty ignores his advice and sends him home after having detained him for such a long time, he will use what he has learned here against us and bring disaster upon us. The wisest course of action is to punish him for breaking the laws."*
>
> *King Zheng agreed and put Han Feizi in prison. Shocked and depressed, Han Feizi requested that he be allowed to see the king and plead his case in person. This was denied. At this critical juncture, Li Si sent a messenger, who brought the jailed Han Feizi poisonous wine and induced him to commit suicide.*
>
> *Later the king regretted his actions and sent a special envoy to pardon the scholar. Unfortunately, it was too late, for Han Feizi was already dead.*

Han Feizi died at the age of forty-seven as a result of his classmate's envy and treachery, but his thinking was to exert an enormous influence on the future policies of King Zheng and Li Si himself. There was a prevalent belief then that a mythical golden age had existed in the past during an indeterminate period of history. Although nobody had evidence that there ever really was such a Garden of Eden, all the great philosophers were in agreement that society had degenerated since that time. Confucius himself was always quoting the ancient sage rulers and exhorting his followers to turn back and learn from that bygone era of ideal government.

Instead of following the Confucian philosophy of using the past to criticize the present, Han Feizi believed in discounting the past, emphasizing the present, and adapting to change. He opposed feudalism and promulgated the unification of China under a single supreme ruler. Though he believed in the rule of law and taught that the law must be constant and obeyed by everyone, he made one fatal exception: he did not include the supreme ruler himself.

Because the supreme ruler wrote the laws and could arbitrarily change them, the laws were therefore designed to serve, not the people, but the supreme ruler himself. Because of this crucial omission, Han Feizi's "rule of law" became his deeply flawed "rule of the emperor." The welfare of the ruler would take precedence over the welfare of the people.

Eventually, the people came to regard the emperor's laws as an instrument of terror to keep them in subjugation for the sole benefit of the ruler. The rule of law was perceived as being established by the ruler for himself and not by the people for the people. As such, the system was destined to fail.

There was no doubt that Han Feizi was a brilliant thinker. Why, then, was he not aware that in order for the rule of law to succeed there could be no exceptions? Perhaps he was aware but could not say so. In a total dictatorship such as the state of Qin during the third century B.C.E., advocating that the king be placed under the same rule of law as everyone else would probably have resulted in punishment by death. Nevertheless, it is interesting to note that 2200 years ago, Han Feizi had already suggested that the law should be universal and be obeyed by everyone alike. It would be the highest method of conduct for "all under Heaven."

Although Han Feizi proposed the "rule of law" for "all under Heaven," everyone in China knew that this "rule of law" did not include the king. Since ancient times, an alternate name for a Chinese monarch was *tian zi,* "son of Heaven." As such, a special pronoun, *zhen,* was created and used only by the king for self-designation, in place of the common pronoun *wo* (I). The implication was that the king was not like everyone else. Both his title and name indicated that he was special and different, even supernatural.

In the West, there has been a long-standing conviction that "laws make the king; the king does not make the laws." The western Christian belief in an almighty God who was higher than the king has traditionally, by serendipity, subsumed political power under a higher framework of reference. There is no such precedence in China to provide for the sovereignty of a rule-based legal system. In China the "son of Heaven" was always above the law. He was the one mandated by Heaven to rule and was therefore accountable to no one but himself.

To have a leadership that is enlightened and responsive to the wishes of the people, China needs first to adopt a set of laws that are sovereign to the power of the ruling party. Otherwise, *gu zhang nan ming,* "clapping with

one hand will produce no sound." Unfortunately, history has taught us that it is only too easy for a supreme ruler to become corrupted by unlimited power and adulation. This was the final legacy of Mao Tse-tung.

◆

The majority of Chinese would probably agree that the most dominant figure in twentieth-century China was Mao Tse-tung. They would also draw a clear distinction between the "Great Mao" of his prime and the "tyrannical Mao" of his declining years. Before 1949, Mao was the passionate revolutionary whose vision brought about the unification of China. His achievement elevated him into becoming the supreme ruler. Mao's every word was worshiped, and he gradually turned into a despot more powerful than any previous emperor.

As he grew older, Mao became increasingly megalomaniac and paranoid. Seven years after launching the Cultural Revolution he said, in a conversation with the Egyptian ambassador, "The First Emperor [King Zheng] was the most famous emperor of China. In China, there are always two opposite viewpoints. Some people support the First Emperor. Others oppose him. I myself endorse him, but I am against Confucius."

Three years before he died, Mao encouraged his wife, Jiang Qing, to set up a group of writers to denigrate Confucius and promote the Legalist School as represented by Han Feizi. Mao claimed that he as well as the First Emperor were both Legalists who advocated reform and opposed retrogression. As soon as he seized power at the age of twenty-one, King Zheng had eliminated the Confucian prime minister, Lu Buwei. From then on, according to Mao, China's history was characterized by a series of struggles between Confucianism and the Legalist School, between progress and retrogression, between stagnation and revolution.

While advocating the rule of law and the consolidation of power within the hands of a single supreme ruler, Han Feizi never wrote about the adverse consequences of such unlimited authority on the personality of the ruler. In the case of Mao, absolute power corrupted him absolutely, and he became increasingly intolerant of the slightest disagreement with any of his wishes.

Mao carried out political persecution at an unprecedented scale during the last ten years of his life, attacking most of his closest associates. He exhibited such ambiguity and contradiction that it was impossible to foretell his intentions or predict his desires. Ever since Khrushchev's posthumous denigration of Stalin in the 1950s, Mao had been fearful of a similar revisionism in China after his own death. He was obsessed both with grooming a successor and destroying that successor as the latter's

power grew. It became extremely hazardous to assume the number two position in China.

Back in 1961, Mao confided to Field Marshal Montgomery that Liu Shaoqi was his successor and would take his place after his death. At the start of the Cultural Revolution in 1966, Liu Shaoqi was taken into custody, deprived of medical treatment, and moved to a city far away from Beijing, where he died alone in a room without any furniture. Meanwhile, Lin Biao was publicly named as Mao's designated successor. Five years later, Mao turned against Lin Biao with the help of the Gang of Four under the direction of his wife, Jiang Qing, and Premier Zhou Enlai. Three years after Lin's death, Mao began to criticize Zhou Enlai, accusing him of making unauthorized statements on the Taiwan issue during his talks with Henry Kissinger. Zhou was compared to Confucius as well as the merchant Lu Buwei, "slave owner and Confucian prime minister during the Qin dynasty, who assiduously promoted a conservative and reactionary political line in order to restore slavery." At this critical juncture, Zhou became terminally ill from prostate cancer and died in early 1976. A few months later Mao followed him to the grave, still haunted by nightmarish visions of revisionism, capitalism, and the need for eternal struggle.

To his sickbed, Mao had summoned his latest designated successor, Hua Guofeng, his wife, Jiang Qing, and her three closest collaborators and said to them, "I have done two great things in my life. The first was to drive out the Japanese and Chiang Kai-shek. The second was to initiate the Cultural Revolution, which remains unfinished. Heaven knows how you are going to handle it." Mao closed his eyes wearily and ended by quoting a proverb from a book written in the Jin dynasty (265–420 C.E.): "Gai guan lun ding, 'only when a person is dead and the lid of his coffin closed can final judgment be passed on him.' "

When the Map Is Unrolled, the Dagger Is Revealed

圖窮匕見

Tu Qiong Bi Xian

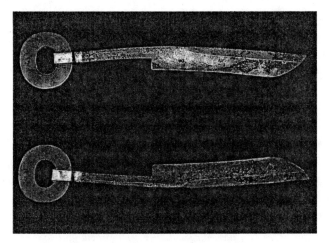

Writer's knife, Warring States period.

*O*ne day before my stepmother Niang's funeral in 1990, my brother James (the executor of her will) gave me the startling news that she had suddenly and mysteriously disinherited me. Although our father had died two years earlier, Niang had prevented all of her stepchildren from reading his will. Devastated by my stepmother's unexpected rejection and desperate to know my father's feelings toward me, I went to Niang's apartment with my husband, Bob, to search for Father's will. There, rummaging through Niang's personal belongings in her bedroom, I came across several piles of letters written by my oldest sister, Lydia, whose children we had helped to escape from Communist China and educate in America

against Niang's wishes. To my shock and dismay, I found that instead of gratitude and affection, Lydia's letters were full of lies and venom, inciting Niang to hate me. After reading them, I had no doubt that Niang had disinherited me because of Lydia's defamation.

I remember feeling nauseated and dizzy while a pain in my chest gripped me like a vice. Then Bob shouted from his side of Niang's bedroom. He had found my father's will.

Father's intentions were radically different from those of Niang. He had included me and had meant to give me the same share of his estate as two of my brothers. At that specific moment, reading Father's words soothed me as nothing else could have done. It was almost as if he had raised himself out of his grave to console me for the savage blow from my sister, whose deviousness I had just uncovered. I heard once more my father's voice, saying urgently over and over, "Tu qiong bi xian, 'when the map is unrolled, the dagger is revealed.' Now you know the reason for your disinheritance."

At certain defining moments throughout history, the consciousness of the world has been transformed by a singular horrific event. In describing such an incident, the Chinese might use the proverb tu qiong bi xian, "*when the map is unrolled, the dagger is revealed,*" especially if the upheaval involved an element of surprise. As mentioned before, while it is common for Chinese people to think in metaphors and apply lessons from history to current events, certain American sayings also embody this quality. The terms Pearl Harbor and Kennedy's assassination are two examples of metaphors that conjure images that resonate in the national consciousness, so much so that many people still recall exactly what they were doing when they first heard the news of these calamities.

On September 11, 2001, our daughter Ann called from New York to tell us of the suicide plane crashes in that city. In the days following, the images of the blazing World Trade Center did not leave our minds. My husband, Bob, noted that the words September 11 would probably evolve into a new American metaphor. For the rest of our lives, Americans will be asking one another, "What were you doing on September 11 when you heard the news?"

Ann was the first to ask me this question. I told her that I had been reading an account of a political assassination that happened 2200 years ago, and I was trying to choose an appropriate proverb for the chapter heading. On hearing this, Ann surprised me with two questions: "Why do you like proverbs so much, Mom? Do you think in proverbs?"

They were excellent questions. I told her that I would think about them before answering her by letter.

The following passage, extracted from Shiji, was the text I was working on when Ann phoned:

Following the death of Han Feizi, King Zheng of Qin stepped up his campaign to unify China. After six years of ruthless warfare, strategic alliances, and Machiavellian intrigue, he was successful in annexing Haan, and most of Zhao and Wei. Six years later, in 227 B.C.E., King Zheng began to eye Yan [the area in and around present-day Beijing].

◆

Crown Prince Dan of Yan had been born in Handan, capital of Zhao, about the same time as King Zheng. Their fathers were both political hostages and used to live close to each other. The two boys played together as children and became boyhood chums.

King Zheng returned to Qin at the age of ten when his father ascended the throne. Three years later he himself became king at the death of his father. The two boys grew into manhood, and when they were in their twenties Prince Dan was sent as a political hostage to Qin. In spite of their boyhood friendship, King Zheng was cold and cruel to Prince Dan. The latter became upset and fled back to Yan. On his return, he searched for someone who would avenge his humiliation. However, his state was small and weak while Qin was rich and powerful.

Soon after Prince Dan's return to Yan, King Zheng began moving his troops east of the mountains to invade the unconquered states. Gradually, Qin soldiers approached the borders of the state of Yan. Because the rulers and ministers of Yan were all greatly worried at the prospect of a war with Qin, Crown Prince Dan conferred with his tutor, Ju Wu, for advice. But the grand tutor was unable to provide a satisfactory solution.

Some months later, Fan Yuqi, a Qin general who had led an unsuccessful rebellion against King Zheng, defected to Yan as a fugitive and begged Prince Dan for asylum. The prince received him graciously and gave him shelter. The grand tutor protested and gave warning: "You must not do this. The King of Qin is legendary for his cruelty and vengefulness. Even if he should merely dislike you without cause, everyone in Yan would already be in danger. That thought alone is sufficient to make one shiver

in the height of summer! How much worse when he learns that you are actually harboring General Fan in our state! Your action is akin to baiting a hungry tiger by throwing meat in his path. The resulting bloodbath will be disastrous.

"Instead of keeping General Fan here, you should send him up north and hand him over to the Huns. By transferring General Fan to the barbarians, you will be sure to please the King of Qin and perhaps ward off invasion."

The crown prince refused. He said, "General Fan was in grave peril when he threw himself at me and begged for my mercy. Never, until the day I die, could I abandon the ties of compassion and surrender him to the savage and barbarian Huns simply out of fear of retaliation from King Zheng. If I should stoop so low, it would surely be time for me to die. Will you please reconsider and come up with an alternate plan?"

The grand tutor was much distressed. He sighed and said, "To bind yourself so tightly to a single desperate man without considering the consequences will certainly bring disaster to our entire state. You are inviting retribution and risking retaliation from King Zheng, the most powerful man in the world. What else is there to talk about?"

The prince was silent for so long that the grand tutor felt pity for him. As the tutor rose from his mat to take his leave, an idea suddenly struck him and he said, "Perhaps Your Highness might like to consult my friend, the scholar Tian Guang. He is old and in poor health, but he is wise and has a big heart."

The prince summoned Scholar Tian to his palace. He personally welcomed the elderly scholar at the door and led him inside. When the two were alone, the prince knelt respectfully in front of the old man and dusted off the mat for him to sit on. He moved close to him and said, "The states of Yan and Qin cannot coexist. Will you, sir, please ponder on this and give me advice?"

"Your Highness may have heard falsely that I am still in my prime. Alas! I have long ago lost the bloom of youth and become old. But that is no excuse to neglect the affairs of state that are of such urgency. I am much honored that Your Highness considers me sufficiently worthy to be consulted.

"Among my friends is a man named Jing Ke, commonly known as Master Jing. He likes to drink at the marketplace, read books, and handle

the sword. Originally he came from the state of Wei, but, as you know, that state has largely been annexed by Qin and is now mostly under the command of King Zheng. Master Jing has become stateless and wanders from place to place looking for employment. He holds little love for King Zheng.

"Although he likes to drink too much and mingles with butchers and musicians, he is a learned scholar and loves books. When he first came here I invited him to stay, and he lived at my home for some time. His friends are all talented, upright, and honest. Master Jing is not an ordinary man. It is most unusual for a scholar to be so expert at handling the sword. Your Highness should get to know him."

The crown prince listened carefully and replied, "I would like very much to meet him. Can you arrange this?"

Scholar Tian inclined his head and said, "Your wish is my command. I respectfully obey." He rose from his mat, and the prince escorted him to the gate. As they bade each other good-bye, the prince added, "What we have discussed today are important matters of state. Please do not divulge them to anyone."

Scholar Tian nodded and said, "I will not."

The old scholar summoned Master Jing and said, "Prince Dan wishes to see you in his palace. You should go there at once." As Master Jing prepared to leave, Scholar Tian added, "I have heard that when an elderly gentleman carries out a mission, he should not cause others to doubt him. But today the prince said to me, 'Please do not divulge what we have discussed.' This means that His Highness does not have full confidence in me." At this point Scholar Tian hesitated and looked at Master Jing intently. Deciding to impress upon the young man the gravity of the situation and spur him into action, he continued, "Please go quickly to the palace and inform His Highness that I have already died. That way he will be reassured that I have neither spoken nor revealed his secret." Then he slashed his own throat and died.

Master Jing was shocked and tried to save him, but it was too late. He hurried to see the prince and informed him of the old man's suicide. Prince Dan was saddened and went to pay his respects.

At the sight of Scholar Tian's body, the crown prince bowed twice, knelt, approached on his knees, and wept. Then he said, "The reason I told him not to speak was because I did not want him to jeopardize my plans.

And now he has used his suicide to show me that he obeyed my instruction. It was certainly not my intention for him to do this. I am devastated."

The two mourned the old man together. Then the prince opened up to Master Jing. "Yan is weak and has suffered greatly from war," he said. "Even if I were to conscript my entire state, our forces would not be sufficient to oppose Qin. My secret scheme is to engage one of the world's bravest and strongest men and dispatch him to Qin. There is a remote possibility that he might succeed in kidnapping King Zheng and forcing him to return all the territory of the feudal lords that he has appropriated in the past. Wouldn't that be splendid? But even if that were impossible, he could just go ahead and stab him to death. With the death of King Zheng, there would be no central commander. When Qin's armies learn that the feudal lords from all the other states are joining together and sending a mighty united force against Qin, they will become confused since they lack direction from the top. Each Qin general will want to be the supreme commander, and a power struggle will ensue. Then Qin will surely be defeated."

Master Jing was at first reluctant and protested that his capabilities were limited. But Prince Dan reminded him of the suicide of his benefactor, Scholar Tian, who had gallantly given up his life for the cause. The prince bowed humbly before the designated assassin and pressed him not to betray his old friend's trust or render his suicide meaningless. There was a long pause. Then Master Jing finally consented.

The prince was delighted and immediately gave him the title of a high dignitary. He lodged him in a well-appointed house and showered him with gold and privileges. Every day the prince visited him, giving him carriages, horses, beautiful women, jewels, rare objects, and whatever Master Jing might desire so as to satisfy his every whim.

After some days of reflection, Master Jing said to the prince, "In order to be admitted into the court of King Zheng and come face-to-face with him, we must tempt him by the promise of great profit. Now the King of Qin has offered a reward of 1000 catties of gold and the revenue from 10,000 households for the capture of General Fan. If we could find a way to get hold of General Fan's head and present it to King Zheng along with a map of Yan's District of Dukang, then His Majesty would be sure to admit me and grant me an audience. Thus will I get the opportunity to serve Your Highness and avenge the hatred you hold against him."

But the prince replied, "General Fan came to me as a last resort, in poverty and distress. I am unwilling to violate his trust merely to fulfill my selfish desires. Will you, sir, please come up with another scheme?"

Master Jing turned the matter over in his mind and made his own plans without revealing them to the prince. He sought out General Fan, and the two men met in private.

"King Zheng's treatment of you cannot be said to have been kind," Master Jing began. "I hear that your father, mother, and entire family have all been beheaded. And now there is a reward of 1000 catties of gold and the revenue of 10,000 households offered for your capture. Tell me, sir, do you intend to do anything about all this?"

General Fan heaved a great sigh and wept bitterly. "Day after day I think about this and suffer constantly. I grit my teeth, and the pain seeps into my heart and marrow. But every plan I consider seems full of fallacies. Truly, sir, I do not know what to do."

Master Jing stared at the general and said, "I hold on my tongue a single word that will accomplish all that you desire. It will free Yan from its ordeal and avenge your hatred. How about it?"

The general leaned toward him and asked, "What is that word?"

Jing Ke replied, "*Head!*" There was a long silence as the word sank in. Then Master Jing continued, "I should like to have your head in a box to present to the King of Qin. Then His Majesty will be delighted and will be sure to grant me an audience. With my left hand I will grab his left sleeve. With my right hand I will stab his chest with a dagger. That way, you will have achieved all your goals, including the repayment of your debt to the prince who is risking his own life to give you shelter."

General Fan bared his arm to show his determination and drew closer to Master Jing. "Day and night, I have been grinding my teeth and churning my heart to come up with a solution. Now that I have heard your words, I am finally satisfied." With that he took out a dagger and slit his own throat.

Though the crown prince was saddened by General Fan's suicide, he saw that the deed was done and could not be undone. He placed the head in a box, then set about a systematic search for the sharpest dagger in the world. He coated the blade with the deadliest poison and tested it on several victims. Whenever a subject was cut with the blade deeply enough to draw blood, death invariably followed at once.

Next the prince found an accomplice to accompany Master Jing on his mission. Qin Wuyang was a brash youth who held no respect for life, either his own or anyone else's. It was rumored that he enjoyed killing and committed his first murder at the age of thirteen. He was so much feared that no one dared to look at him the wrong way.

Should the two assassins be admitted into the presence of King Zheng, their chances of survival were obviously infinitesimal whatever the outcome. Master Jing knew this and delayed his departure. Day after day he drank in the marketplace with his friend the butcher and with Gao Jianli, a talented lute player. While the musician strummed his lute, the other two would sing and make merry. Afterward, all three would weep together, as if they were completely alone.

The crown prince worried that Master Jing was having regrets, so he again urged the assassin, saying, "Another day is gone, and what have you decided? Please let me send Qin Wuyang in advance of you."

At this Master Jing became angry. He rebuked the Prince and said, "This one who will go on your mission, never to come back, is but a boy. He will be entering a hostile state that is immeasurably powerful, armed only with a single dagger. The reason I have delayed my departure was to await a certain visitor and be with him for the last time. But now that you accuse me of procrastination, I shall take my leave immediately."

So the two men began their journey. The crown prince and those who were aware of their fatal mission came to see them off. They were all dressed in white robes and white caps, white being the color of mourning in China. First they offered sacrifices and prayed to their ancestors. Then they accompanied them on the high road as far as the banks of the Yi River, on their way westward to Qin. With the musician Gao strumming a haunting melody on his lute, Master Jing joined in with a song while the prince and his retinue wept.

The procession moved forward for a short distance. Then, accompanied by music from the lute, Master Jing sang again. The theme was that of his impending sacrifice.

> *The wind whispers softly,*
> *'Tis chilly on the River Yi.*
> *Once we warriors depart,*
> *We can no longer return.*

Now the musician Gao readjusted the strings of his lute and began playing an impassioned and fervent tune. Whereupon all the gentlemen courtiers gazed sternly straight ahead, and their black hair bristled against their white mourning caps.

Even before the strands of music faded, the two assassins had already entered the carriage. As their vehicle vanished in the distance and until the very end, Master Jing did not look back.

In Xianyang, the capital of Qin, Master Jing bribed certain high officials and was successful in securing an audience with King Zheng. His Majesty was delighted to hear that the King of Yan had sent two emissaries bearing the head of the rebellious General Fan as well as a map of the rich and fertile Province of Dukang to present to him. The severed head was first checked with a portrait of General Fan and verified to be authentic. Then, on a bright and sunny morning in 227 B.C.E., the two assassins were duly admitted into the inner sanctum of the royal palace.

Master Jing carried the box with the head, followed closely by his young accomplice with the map in a container. When they approached the throne, Qin Wuyang turned pale and began to tremble violently. The courtiers looked at him with amazement, but Master Jing smiled and said, "He is a simple man of northern barbarian stock and has never seen the Son of Heaven before. Therefore he trembles with fear. May it please Your Majesty to excuse him and allow me, your humble servant, to come forward instead?"

Kinz Zheng dismissed Qin Wuyang after ordering him to hand the map over to Master Jing. Then he said to Master Jing, "Show me the map."

Master Jing, therefore, stepped forward and presented the case containing the map. The King of Qin took out the map and started to unroll it. *Tu qiong bi xian*, "when the map was unrolled, the dagger was revealed," glittering brightly in the morning sun. Whereupon Master Jing immediately seized King Zheng's left sleeve with his left hand and, grasping the dagger with his right, threatened the monarch with his weapon but did not stab him.

In his terror, the king leaped backward and his left sleeve tore off in Master Jing's hand. Though he struggled mightily to draw his sword from its sheath, King Zheng was unsuccessful. The blade was too long and there was not enough room. Meanwhile, Master Jing pursued the king, who ran round and round a pillar. The courtiers looked on in amazement.

The law as practiced in Qin at that time was strict. Courtiers were for-
bidden to carry weapons into the king's upper throne room. Although the
royal guards in the lower hall were armed, they were not allowed to leave
their stations unless summoned. Master Jing's sudden attack had taken
everyone by surprise, and no one gave the order.

At this moment, a court physician named Xia, who had been awaiting
his turn to present a pouch of medicinal herbs to the king, struck Master
Jing with the pouch. While the assassin's attention was thus briefly diverted,
a guard cried out, "Draw out your sword from behind you, Your Majesty!"
By doing so, King Zheng found that he had enough room to unsheathe
the weapon and slash his attacker's left thigh. Wounded and hobbling on
one leg, Master Jing hurled his dagger at the king with all his might, but
it missed and hit a bronze pillar. The king struck out repeatedly with his
sword and cut his assailant seven more times.

Knowing that his attempt had failed, Master Jing leaned against a pil-
lar and laughed, while bright blood seeped from his clothing and dripped
onto the floor. Then he squatted down and cursed the king, saying, "I did
not succeed because I wanted to capture you alive. Someone else will now
have to take the pledge to avenge my prince." The king shouted out an
order. It was only then that the guards rushed forward from all sides and
killed the valiant assassin.

King Zheng was outraged. After executing Master Jing's assistant, Qin
Wuyang, he sent an army into Yan. Two hundred thousand Qin troops
marched across the Yan border and successfully forced the King of Yan to
execute his own son and hand over the severed head of Crown Prince
Dan. A few years later the King of Yan himself was compelled to commit
suicide after another disastrous defeat at the hands of King Zheng. Qin
annexed Yan and made it into one of its commanderies.

No one connected with the plot escaped punishment. Master's Jing's
friend, the brilliant musician Gao Jianli, was blinded for his foreknowledge
of the scheme. Filled with thoughts of revenge, he changed his name and
made his way secretly to Qin. His skills on the lute gained him access to
the court of King Zheng, who grew fond of his melodies and listened to
his lute playing daily in his private chambers. Although his true identity
was eventually revealed, he was allowed to remain after a special pardon
from the king. In 219 B.C.E. the musician loaded his lute with lead, armed

himself with a knife, and tried unsuccessfully to kill the king. He was arrested and immediately executed. But his assault had taken its toll. For the rest of his life King Zheng was fearful and was filled with the dread of dying. He kept his whereabouts a secret and allowed very few to get close to him. His paranoia and seclusion were to lead to disastrous consequences.

◆

In the days following September 11, the recurring television images of the blazing sky-scrapers disturbed me so much that I had trouble sleeping. To distract myself, I thought more about Ann's questions: "Why do you like proverbs so much, Mom? Do you think in proverbs?" Finally one night I wrote her the following reply.

A proverb is defined in Collins's English dictionary as a saying that embodies some commonplace experience, whereas a metaphor is defined as a figure of speech in which words are applied to an action that it does not literally denote. To my Chinese mind, the two are synonymous.

I grew up in China, and Chinese was my only language until the age of eleven. The Chinese language is full of metaphors. That is how we Chinese think, by metaphors. But why do we think in metaphors?

Because written Chinese is a pictorial, and not a phonetic, language, the characters denoting abstract qualities were initially derived metaphorically from word-pictures representing concrete objects. For example, the word dao *means "road" or "path," but it also means "way," "method," or "doctrine." Thus when I see the Chinese word* dao, *it suggests to my mind a whole panorama of related images, and the whole effect is rather like reading poetry.*

Everyday Chinese speech is riddled with figurative phrases (metaphors). For example:

For "boiled water" we say "opened water" or "rolling water."
For "revenge" we say "snowed hatred."
For "time" we say "light/shade."
For "stranger" we say "raw man."
For "friend" we say "cooked man."
For "teacher" we say "previously born."

A natural consequence of this type of thinking is the Chinese tendency to use proverbs, and the history behind these proverbs also, as metaphors or concrete examples to illustrate abstract ideas. Thus a proverb such as "When the map is unrolled, the dagger is revealed" would serve as a metaphor not only of "the

unraveling of a concealed plot" but also of "the exposure of a person's hidden motive" because of the history behind the proverb's origin. Add to this the Chinese respect toward the past, and we can understand the reasons proverbs have such emotive and long-lasting appeal in China.

From now on, whenever I hear the Chinese proverb "When the map is unrolled, the dagger is revealed," I will feel the shock of reading Lydia's poison letters to Niang, I will recall the horror of September 11 and the sleepless nights that followed, and I will see images of Master Jing dying on the floor of King Zheng's palace.

Your Uncle James once gave me a piece of brotherly advice after I discovered my sister Lydia's poison letters. "Your problem, Adeline" he said, "is that you're always transferring your own feelings and reasoning into others. You wanted to believe that we all shared in your dream of a united family. In fact, no one cared except for you."

Subsequently, I have often reflected on James's words. I came to realize that he was entirely correct in his analysis of my previous naïve assumptions. Just because I would never have betrayed Lydia in similar circumstances if our roles had been reversed, I assumed automatically that my sister would also be true to me. Until "the map was unrolled and the dagger revealed," I had harbored no suspicion whatsoever toward Lydia because nothing was further from my mind than treachery against a sister who was trying to help me. The thought of Lydia hatching plots to harm me simply never entered my consciousness.

In a similar vein, what happened on the morning of September 11 shocked us all with its unimaginable horror. We know that the majority of people abide by a basic, common, moral code of behavior, and we expect this behavior from them. Unfortunately, our assumptions that morning were as erroneous as my estimation of my sister Lydia. We only realized our error "when the map was unrolled and the dagger finally revealed" (tu qiong bi xian).

And now, because I was working on this passage when I heard the news from you, my daughter, another layer of meaning for me personally has been added to the proverb. This is how metaphors grow; this is why I think in proverbs.

Burning Books and
Burying Scholars

焚書坑儒
Fen Shu Keng Ru

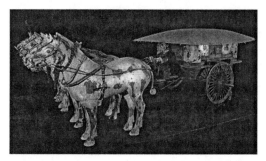

Bronze chariot found near the First Emperor's
mausoleum, Qin dynasty.

*I*n 1979 I went back to Shanghai to visit Aunt Baba after a separation of thirty-
one years. I was shocked at her dilapidated room and poverty-stricken appear-
ance. The Red Guards had driven her out of her home in 1966 and ordered her to
live in a neighbor's house. She spoke to me in a whisper, constantly on the lookout
for spies and informers, saying, "It seems incredible that we should be sitting across
from each other and speaking of everything. This would have been dangerous dur-
ing the Cultural Revolution just three years ago."

I asked her about life under Mao Tse-tung, who had ruled China from 1949
until 1976. She shook her head and nervously looked over her shoulder before uttering
the proverb, "Fen shu keng ru! 'He burned the books and buried the scholars!' "

"You mean just like the First Emperor?"

"Yes! Mao was a reincarnated First Emperor, except even more powerful."

Mao instigated the Cultural Revolution in 1966 to topple his political enemies. Once unleashed, however, the movement threw the nation into economic stagnation, factionalism, and utter chaos, adversely affecting the lives of millions of people in all levels of society for ten long years.

General Lin Biao, Mao's second in command, planned to murder Mao in 1971. Lin accused Mao of turning China into a giant meat grinder for strife and carnage, alleging that although Mao claimed to be a Marxist-Leninist, he was actually more of a dictator than was the First Emperor.

◆

In 221 B.C.E. King Zheng defeated the last surviving feudal state and finally unified China. This was a phenomenal achievement, since the various states had been at war with one another for five and a half centuries. He called a council of his ministers to advise him on choosing the appropriate title under which he would rule. Their discussion was duly recorded in the annals by the Grand Historian. After a lengthy debate, the king chose to call himself Qin Shihuang (Founding Emperor of the Qin dynasty, or First Emperor).

Soon afterward, the ministers advised the First Emperor to appoint his sons and other male relatives as new feudal lords to help rule the far-flung regions of his vast empire. Li Si, who had been appointed minister of justice, was the only one who disagreed.

He pointed out that China had last been united during the Zhou dynasty (1027-771 B.C.E.). However, because of lack of central control and regional autonomy, the House of Zhou had fallen. According to *Shiji*, he said to the emperor, "The feudal states given by the King of Zhou to his sons, younger brothers, and other male relatives were numerous. Initially these nobles obeyed the commands of their king, but as time went by, some members of the family became estranged. Each was the de facto ruler of his own territory. They began to kill and war with one another, causing discord and suffering, without the King of Zhou being able to control them. Since China has just emerged from the chaos of warring states, why not leave it as one unit under a single command? This would prevent future dissension and would lead to long-term peace and tranquillity."

After due reflection, the First Emperor replied, "Because of the system of feudal lords established during the Zhou dynasty, the whole world (that is, China) has suffered from unceasing warfare for hundreds of years. Thanks

to the help of my ancestors, the empire has finally been united and pacified for the first time. For me to create again the same system (of feudal lords) would be to reinsert warfare among us. It would then be impossible to reestablish peace and order. The minister of justice is correct."

He therefore divided his empire into thirty-six commanderies (qun), each under the rule of three ministers, selected on the basis of ability, without regard to blood or family connections. These consisted of a governor for military matters, an administrator for civil duties, and an overseer to report directly to the emperor. This was a significant development because it marked the end of feudalism. The new hierarchy was based upon merit and ability, no longer on noble birth.

To prevent rebellion, the First Emperor disarmed the nation by confiscating all the weapons of the populace. He transported them to Xianyang, now capital city of the empire, melted them, and cast the metal into twelve giant metal human figures, each weighing seventy tons. He then placed the statues in the imperial palace.

To remove the last vestiges of feudalism, he separated the rich and noble families from their ancestral homes and landholdings and compelled them to live in the capital.

Shiji reports that 120,000 wealthy families were moved from all over the empire and resettled in Xianyang.

Every time Qin conquered another feudal state, a replica of its ruler's palace was copied and rebuilt on the hills to the north of the capital overlooking the Wei River.... Connected to each other by elevated courtyards and wide boulevards, they were filled with the instruments, gadgets, and beautiful women captured from the defeated states.

Under the emperor's watchful eye, the new arrivals were encouraged to use their talents to benefit the Qin empire. This forced assemblage of ability and wealth transformed Xianyang into the premier city of China, as well as its political, cultural, military, administrative, and economic center.

The First Emperor issued an edict that extended freehold land ownership to all farmers. He looked down on commerce but encouraged agriculture and husbandry, considering them fundamental occupations. Private trade was discouraged through government monopolies of basic substances such as salt and iron. However, he increased taxes mercilessly. Tax grain amounted to half of all agricultural production. Taxes on the profits derived

from the sale of salt and iron were increased thirty times during his reign. He also initiated a poll tax.

He conscripted hundreds of thousands of men as laborers into his army and ordered them to work on his massive building projects. Besides the Great Wall and his tomb, he built canals, bridges, roads, and palaces. According to *Shiji*, the conglomeration of palaces that he built in the capital extended for a distance of seventy miles (two hundred *lis*). Of these residences, two hundred and seventy were reserved for his own use and that of his family. The enormous A Fang Palace measured 2500 feet from east to west and 500 feet from north to south and could seat ten thousand people. All the palaces were lavishly furnished with priceless furniture and art objects.

By all accounts, he was a dedicated and driven monarch, handling one hundred and twenty pounds of reports (written on bamboo slips) daily. Life was not all work, however, because *Shiji* states that the First Emperor used to keep jesters at his court to amuse him.

Like many powerful conquerors, the First Emperor was terrified of death. He filled his days with work, consulted astrologers, and became obsessed with orderliness and uniformity. Deeply superstitious, he came under the influence of Taoism and the School of Five Elements. *Shiji* relates:

> *The First Emperor believed in the theory of the cyclic rotation of the Five Elements [earth, wood, metal, fire, and water]. This school of thought claimed that each period of history is dominated by one of the five elements, which will then be succeeded by the next element in a fixed and endless cycle. For example, if metal is the dominant element at any one time, it will inevitably be replaced sooner or later by the next element in the series, which is fire [fire melts metal]. After a certain period, fire in its turn will be replaced by water, since fire is extinguished by water. This process will continue in an endless cycle, which will determine the course of history. Because the authority of the previous unifier of China [the Zhou dynasty] had been replaced by that of his Qin dynasty, the First Emperor concluded that Zhou's element was fire and Qin's was water. He considered his reign the era of the Power of Water. The New Year was changed from the first day of the First Month to the first day of the Tenth Month. Black became the chief color of court dress, banners, and pennants because black was the color of water. Condemned criminals and prisoners of war were dressed in red since red was the color of fire. The number six was his*

favorite number because it had the same pronunciation as the word current. *Official tallies and headgear were six inches long. Chariots were six feet wide. One pace was a measure of six feet, and the imperial carriage was drawn by six horses.*

He renamed the Yellow River the Powerful Water. In order to inaugurate this new era of the Power of Water, he ruthlessly repressed everything that did not conform with his laws. He believed that only the most implacable severity could harmonize the Five Elements. Thus his reign was harsh and devoid of amnesties.

The First Emperor issued a decree to his ministers, ordering them to unify all laws into a single, coherent, universally applicable system throughout his empire. He vigorously and compulsively standardized every aspect of his subjects' lives, reducing all in a uniform manner. Weights and measures, size of acreage, agricultural implements, and even the axles and wheels of wagons had to be made of a standard gauge. The "knife" money of Qi, "spade" coins of Haan, Zhao, Wei, and Yan, and the "checker" pieces of Chu were all replaced by the "round money" of Qin. Local customs and writing that did not conform to the new system were vigorously repressed.

To further clarify his laws and make them understood throughout the land, the First Emperor, with the help of Li Si, also standardized the system of writing. Previously, there was such great divergence that men from one state could hardly understand the written language of men from the other states. Besides establishing a common tie between people from all parts of the empire, it also secured a line of communication with the literature of the past.

To this day, modern Chinese writing is based on the system proposed by Li Si over 2000 years ago. The script has changed so little that I, who left China at the age of fourteen, am still able to read and understand the ancient Chinese classics with the help of a dictionary. The literature of millennia is thus open to anyone who can read Chinese. The oldest Chinese dictionary, shuo wen, *was published in 100 C.E. It is still in print, for it is the basis of every Chinese dictionary that followed. It never fails to thrill me to be able to open my copy of* Shiji *and be stirred by the same words written by a historian who lived 2100 years ago.*

Because of the First Emperor's standardization of the written Chinese language, China has maintained its cultural continuity ever since. Of all the great civilizations

that used to exist, such as Egyptian, Greek, or Roman, China's is the only one to have survived intact. Many attribute this to the immutability and universality of the written Chinese language.

Recently, my husband and I visited Vietnam. On the streets of Ho Chi Minh City (Saigon), I noticed that the billboards and shop signs were all lettered in the French alphabet but with Vietnamese spelling. I asked the young Vietnamese tour guide who was showing us around, "Mr. Nguyen, when did the French colonize Vietnam?"

"Nineteenth century," he replied.

"What was the written language of Vietnam before the French came?" I wondered.

Mr. Nguyen would not answer. He shrugged his shoulders and walked away. At first I thought he did not hear me, but after being rebuffed twice more, I finally understood that his silence was intentional. For some reason he did not wish to answer me.

Two days later we were taken by bus to visit the ancient imperial city of Hue. One of our destinations was an ancient pagoda built in the sixteenth century.

"Surely," I told Bob, "we will be shown monuments with ancient Vietnamese writing at the pagoda. I'm really curious to see some samples of Vietnamese writing before the French arrived on the scene."

The Thien Mu Pagoda was built in the style of a Ming dynasty Chinese tower. On its surface were many engraved sayings, well preserved and perfectly legible. To my astonishment, I could read every word because they were all written in Chinese. It dawned on me that before the French came the written language of Vietnam was Chinese. Our tour guide knew this. When I questioned him, he had remained silent precisely because he could see that I was Chinese. For reasons of his own, he did not wish to admit that historically, Vietnamese culture was the same as that of China's.

A brochure informed me that the very name of Vietnam was derived from two Chinese characters, yue *and* nan. *The word* yue *is pronounced "viet," and* nan *is pronounced "nam" in Vietnam, but they are written the same way and have the same meaning as Chinese. Yue means "to cross" or "climb over." Nan means "south." Thus* Vietnam *or* Yue Nan *means "to climb over the south." Alternately, it can also mean "south of the state of Yue."*

During the Warring States period, the state of Yue used to be an independent kingdom south of the Yangtze River. Later, it was absorbed into Chu, which in turn

was conquered by King Zheng in 223 B.C.E. From then on, the word Yue was used
to describe the southern coastal provinces of China such as Guangzhou (Canton).
Shiji states that after unification, the First Emperor elevated the status of farmers
but deported "merchants, vagabonds, and other useless people" to populate the dis-
tant and "barbaric" region known as Yue. Vietnam is immediately south (nam) of
Yue (Viet); hence its name.

If the First Emperor had not united the seven states, today's China would
probably be more like Europe, consisting of a collection of different countries, each
with its own government, spoken and written language, currency, laws, religious beliefs,
customs, grievances, and perhaps wars.

The First Emperor built thousands of miles of straight, tree-lined imper-
ial highways radiating from Xianyang toward the outposts of his empire.
He inaugurated regular tours of inspection, traveling over his new roads
and impressing the people by giving them a glimpse of the pomp and
majesty of his entourage.

He came under the influence of Xu Fu, a Taoist scholar-magician from
Qi, who was a skillful navigator. The seaman convinced the emperor to
finance an excursion to the three islands of Penglai. On these isles in the
Eastern Sea, according to Xu Fu, dwelled celestial beings in possession of
a magic elixir that rendered them immortal. Equipped with many ships
containing food, water, tools, and weapons, and amid high expectations,
Xu Fu set out on an expedition with thousands of virgin maidens and
youths of good family. They never returned. Historians believe that Xu
Fu and his entourage set sail for Japan and settled there.

After waiting in vain for Xu Fu, the First Emperor reluctantly began
his journey home. As he reached the Yangtze River, the weather suddenly
changed. Gale-force winds churned the river water into giant waves and
delayed his passage. Blaming the inclement weather on the river goddess
whose temple stood on a hill nearby, the infuriated monarch ordered
3000 convicts to cut down all the trees on the hillside bordering the
riverbank in retaliation. As further punishment, he demanded that the
mountain be painted red, since red was the color worn by condemned
criminals.

A year later, in 218 B.C.E., the First Emperor narrowly escaped another
assassination attempt while on his second tour of inspection.

Zhang Liang was descended from an aristocratic family from Haan. His father and grandfather had both been prime ministers of Haan at one time. In 230 B.C.E. Qin had defeated Haan and the King of Haan had been captured. Qin soldiers had killed many Haan nobles and deliberately left their bodies lying on the ground unburied. Seeking revenge, Zhang Liang had sold all the valuables he could lay his hands on and carefully made his plans.

He engaged a powerful weight lifter renowned for his strength and built for him a heavy metal cone weighing 120 *jin* (132 pounds). The two young men hid among the mountain bushes along the First Emperor's route and watched the impressive procession as it went by beneath them. At a signal from Zhang Liang, the muscular assassin hurled the cone at the First Emperor's carriage, shattering it to smithereens.

The First Emperor, however, had planned for just such an event. He was traveling in the second of two identical royal carriages, and the assassins had ambushed the wrong coach. Once again he escaped unscathed.

Despite an extensive search, the assassins were never captured, but the First Emperor did discover that Zhang Liang was the instigator. He placed a price on the young man's head, but his close brush with death troubled him. He realized that the feudal nobility of the six conquered states had not disappeared. They were lying in wait, like a many-headed hydra, to do him harm. Anger and fear deepened his paranoia and spurred him on in his search for immortality. He became increasingly reclusive, trusting no one except those who filled his mind with tales of the supernatural.

Three years later the First Emperor embarked on his third tour. Still yearning for the elixir of immortality, he dispatched a number of seafarers to search for the elusive mariner, Xu Fu. One of the search party returned and presented the monarch with a five-character message purportedly written by the immortals. The note predicted, "Qin's demise will be brought about by *hu*."

The word *hu* was another name for *Hun*. Both were collective terms for the barbarian tribes that lived beyond China's northwest frontier. Unlike the Chinese, who considered themselves civilized and lived by cultivating the land, the Huns were nomads and lived by hunting, fishing, and raiding. Before returning to his capital, the First Emperor inspected this border and saw for himself the devastation, disease, mutilation, and death inflicted on his people by the savagery of his northern neighbors.

On reaching Xianyang, the First Emperor dispatched one of his ablest generals, Meng Tian, with a force of 300,000 men to clear the Huns from the Ordos Desert. When this had been accomplished, he further ordered Meng Tian to transform his army into a labor force and build a great wall to keep out the nomads for good. He called this *wan li chang cheng* (Great Wall of Ten Thousand *Li*), "the most warlike fortification in the world."

Extending thousands of miles and visible to astronauts circling the earth from outer space, the Great Wall stretches across three main regions. The first area lies close to Beijing, climbs across convoluted mountains, and ends at the Gulf of Liaodong near Korea. The second runs across the Ordos Steppes and traverses miles of quicksand within the loop of the Yellow River. The third strides across the western edge of China separating the Tibetan frontier from the Gobi Desert. Portions of the Great Wall are twenty-five feet tall and stand at an elevation of six thousand feet.

Never in the history of humankind before or since has labor been mobilized on such a grand scale. Working conditions were deplorable. Much of the northwestern frontier was desolate and wild, with endless sand dunes, deadly quicksand, plunging chasms, and precipitous mountains. During the building of the wall, it is estimated that 400,000 people died from disease, pestilence, malnutrition, and poor working conditions. Although they were not buried within the wall but only close to the wall, the Great Wall became known as the "longest cemetery in the world."

When workers died, the labor crews were replenished by conscripts and convicts. After unification, the First Emperor posted new codified laws throughout his empire and handed out harsh retribution for those who disobeyed. Even those who deviated merely from his laws of weights and measures were sent off to work on one of his endless building projects: the Great Wall, imperial road system, canals and bridges, palaces in Xianyang, and his mausoleum.

To pay for and staff his projects, the First Emperor levied heavy taxes and instituted compulsory service. He divided families in every village into left and right halves and decreed that every man living on the left side of the village gate was to report to the frontier for work under General Meng Tian. As more and more workers perished, the remaining peasants were unable to cultivate the land as required. Villages suffered from lack of laborers, shortage of food, and general discontent.

· · ·

Shiji tells us that in the year 213 B.C.E. the First Emperor held a banquet at his palace in Xianyang to celebrate that year's bountiful harvest and Meng Tian's victory over the Huns. Led by the senior minister, all the officials rose to drink a toast to the emperor and were full of praise for His Majesty's accomplishments. Among the din of congratulations, however, was a single voice of dissent. One of the guests, a Confucian scholar named Chun from the former state of Qi, rashly and openly criticized the emperor. He started by saying that unlike the male relatives of the ancient kings, the sons and brothers of the First Emperor remained commoners without fiefs. He then sounded a warning that "no empire can endure for long unless it is modeled on antiquity."

Perceiving this to be an attack on himself, Li Si was outraged. By then, he was prime minister and enjoyed the full confidence of the emperor. He rose to rebut Chun and said accusingly, "There are some who study the past only in order to discredit the present. If this type of behavior is allowed to continue, the imperial power will decline. We must stop this at once."

Playing on the emperor's paranoia and megalomania, Li Si submitted a throne memorial. Wishing to preserve forever his sovereign's power and, by extension, his own power, he recommended the erection of a permanent barrier between past and present by destroying the past. To all future generations, the world was to begin with the First Emperor, who now issued a decree that all books in the bureau of history, save for the records of Qin, were to be burned. "These Confucian scholars," said Li Si, "use their learning to refute our laws and confuse the people. By destroying their books and all historical records except for those of Qin, dangerous thoughts would no longer exist and nobody could use the past to discredit the present anymore."

At that time paper had not yet been invented. Books were written on bamboo slips about nine inches long, tied together with silk threads, and rolled into bundles with leather thongs like the shutters of a window. Words were written with a brush or engraved vertically onto the bamboo with a knife. General Meng Tian, who built the Great Wall, supposedly first invented the writing brush by binding rabbit or camel hair to a wooden shaft with string and glue and using pine soot as ink. As more and more people chose brush and ink over the knife for writing, the script itself lost its angularity and adopted more flowing lines.

· · ·

Calligraphy is considered the mother of art in China. Accomplished calligraphers are revered, and beautiful script is cherished as great paintings are in the West. Words are written with a brush, and a writer's emotions are captured and transmitted through the direction, speed, and power of the brush strokes. My grandfather used to adorn his room with proverbs written in large black characters on rectangular sheets of paper, hung vertically. Once he told me that there is an intimate connection between Chinese words and paintings, that literature and art are inextricably linked. When I was a little girl in Shanghai 2200 years after the time of the First Emperor, my first task when I got home from school was to put water in the receptacle portion of my inkstone and make fresh ink by grinding an ink stick against the stone's moistened flat surface, probably in the same way as was done since the time of Meng Tian. Then I would start my homework by writing ten different characters into a special exercise book with brush and ink, copying each word five times in an attempt to improve my handwriting.

Since printing was also unknown during the time of the First Emperor, books were laboriously engraved (or "brushed") separately by hand. The educated treated them with reverence and treasured them above all else. Now they were suddenly told to burn the books within thirty days of the emperor's order being issued. The only exceptions were books on medicine, divination, and agriculture. "As for those who wish to learn," added Li Si, in an attempt to impose imperial control on thought as well as education, "let them learn from the state officials."

Some scholars simply could not bear to burn their books. To those who loved to read, books enshrined the wisdom and knowledge of great writers who came before them. They were not lifeless stacks of bamboo slips but fascinating minds beckoning with their magic wands. A few did hide their precious rolls of bamboo underground or between walls, but those who were discovered were killed outright or branded on the face as convicts and sent to work on the Great Wall.

According to *Shiji*,

The scholars believed that burning the works of Confucius and the other great philosophers was akin to destroying their very own heart. . . . Some refused to go along with the order and chose to die rather than betray their books. . . . But many more brought their books to Xianyang out of fear. . . . And the fires burned day and night. . . .

. . .

Over 2000 years later Mao instituted his version of fen shu keng ru, *"burning the books and burying the scholars." A seemingly minor incident took place in 1965, one year before the beginning of the Cultural Revolution. The vice mayor of Beijing was a writer-historian by the name of Wu Han. Wu had written a play that portrayed the unjust dismissal of an honest bureaucrat by a Ming dynasty emperor. Mao, who had just purged a straight-talking general named Peng Dehuai, took exception. He claimed that Wu's play was a veiled criticism of Mao's dismissal of Peng. He accused Wu of employing literature as a disguise for anti-Party activities, and he relieved him of his office. Later Wu was further condemned as an "enemy of the people" for "using the past to attack the present." He was imprisoned and died there. During the Cultural Revolution, which ensued, schooling was abolished, teachers were attacked, and millions of teenage Red Guards went on a rampage of torture, murder, and destruction throughout China.*

As time went on, the First Emperor became increasingly anxious about the possibility of dying. Although he was the most powerful man in the world, he was riddled with fear, and happiness eluded him. He consulted the Taoist magicians, who advised him to conduct his affairs in secret so as to avoid evil spirits. He was told that by withdrawing himself from other men, he could gain union with the true Tao and be transformed into a Divine Being or a True Man. As such, he would be immortal.

In 212 B.C.E. his Taoist advisers could no longer invent any more plausible excuses for not obtaining the elixir of immortality. Fearing for their lives, they fled the capital without notice.

The emperor was enraged. *Shiji* relates:

> *The First Emperor said, "I assembled this group of scholars and alchemists in a quest for peace, having been promised wonderful herbs. . . . Instead they have wasted vast sums without procuring any elixir. . . . Meanwhile their cohorts are slandering me in my own city. . . . I have made inquiries, and they are defaming me viciously. My people are becoming confused.*

In his frustration and anger, he turned against the literati in his court and ordered 460 scholars to be buried alive. His own eldest son, Prince Fu Su, protested this sentence as unnecessarily harsh, predicting that it would cause general discontent. For daring to speak out, the prince was banished

from the capital and sent to the Great Wall to oversee the work of General Meng Tian.

Meanwhile, Li Si, the prime minister, had become the second most powerful man in the country, subordinate only to the emperor. He was now in his sixties, and his children were either married or affianced to the children of the emperor. On his eldest son's return to the capital from the commandery of Sanchuan, where he was chief administrator, Li Si gave a celebratory banquet. *Shiji* reports:

> *The chief ministers of the various departments all attended to offer their congratulations, and the carriages and horses at his door numbered in the thousands. Li Si sighed and said, "My teacher, Xun Zi, always used to warn me against excessive success. I am but an ordinary clerk from a little village in Chu. His Majesty did not realize that I am only an inferior workhorse and elevated me to this august post, where I have achieved the epitome of wealth and power and am second to no other minister. When a man has reached the top, he starts to come down. I do not yet know what my ultimate fate will be."*

Chinese thinking has changed remarkably little in the last 2200 years. Whenever I brought home a good report card to show my Ye Ye, he would quote the proverb le ji sheng bei, "excessive happiness will lead to sorrow" (le ji sheng bei was a phrase first coined by Sima Qian in Shiji).

Ye Ye believed in the dualist theory of yin and yang, which teaches that happiness and sorrow (like "day and night" or "summer and winter") are complementary and interdependent and represent two faces of the same coin. Since the two are each other's counterparts, one will eventually transform into the other.

"Don't rejoice too much!" Ye Ye would say, "Be modest and content! What rises will fall and what falls will rise."

Li Si was voicing the same sentiments 2200 years ago when he wondered about his ultimate destiny during the lavish banquet he gave at the height of his happiness to celebrate the homecoming of his successful son.

Historical figures in China are frequently reinterpreted according to the politics of a given time. This is nowhere more true than in the case of the First Emperor during the rule of Mao Tse-tung.

The two had many similarities. They were both intelligent, incisive, hardworking, charismatic, and natural leaders. However, both were also autocratic, cruel, megalo-maniac, and paranoid. The First Emperor unified the empire, while Mao Tse-tung established the People's Republic of China. Their achievements were such that they both regarded themselves as superhuman.

Like the First Emperor, Qin Shihuang, Mao also became a man of infinite power, having triumphed over all his enemies, imagined or otherwise. Nicknamed "Qin Shihuang the Second," he could rewrite every law, imprison any citizen, bed the prettiest maidens, suspend the education of every Chinese youth, and uproot the entire nation by a wave of his hand.

For over 2000 years the First Emperor had been roundly condemned for being the bloodthirsty tyrant who fen shu keng ru, *"burned the books and buried the scholars." After Mao took power in 1949, however, the official view gradually changed. Articles began appearing in Communist journals such as* Red Flag, Peking Review, *and* People's Daily *praising the First Emperor. During the Cul-tural Revolution, it became dangerously incorrect in China to castigate the First Emperor in any way whatsoever. His cruelty was now considered to have been essential in crushing the "counter-revolutionaries" within his court, and he was praised for his "enlightened policies."*

As Mao's power and prestige grew in China, he identified more and more with the First Emperor. He often compared himself directly with the ancient monarch and would find him lacking. During the Communist Party's Central Committee Meeting in May of 1958, Mao made a speech in which he personally praised the First Emperor for being an authority on "emphasizing the present while discount-ing the past." Further on in the same speech, Mao said, "Who is Qin Shihuang anyway, and what did he do? So he buried 460 scholars alive. We have 'buried' at least 46,000! Haven't we silenced that many counter-revolutionary intellectuals during our anti-rightist campaigns? In discussions with members of the minor demo-cratic parties, I've said to them, 'You accuse us of being Qin Shihuangs. You are incorrect. Actually, we have outshone him a hundred times. You accuse us of being dictators. We have never denied this. You should have gone further in your accusa-tions because now we have to supplement them.' "

It was recorded in the minutes that Mao's remarks were greeted with roaring laughter.

Following the failure of Mao's economic policy known as the Great Leap For-ward, he began purging senior ministers of his cabinet, such as Liu Shaoqi and Deng Xiaoping, who criticized him. Like the First Emperor two millennia earlier,

Mao was also determined to eliminate those who dared to attack him. His method of feng shu keng ru, *"burning books and burying scholars," was to abolish education for all children and silence his opponents by condemning and persecuting them as counter-revolutionaries. All this was carried out during the Cultural Revolution.*

◆

After our tour of Vietnam, Bob and I visited the city of Qufu, in Shandong Province (ancient Qi), where Confucius (Kong Fuzi), or Master Kong, was born and buried. Inside the Confucian Temple, we saw a genealogical chart of Confucius's family. Nothing I have ever seen before or since has impressed me more than this simple document to illustrate the continuity and span of Chinese history. Starting with Confucius, the names of all his direct firstborn male descendants have been recorded, together with their years of birth and death. Confucius's descendants lived consecutively at the mansion for almost 2500 years, totaling seventy-seven generations. In 1940 C.E. the last male heir of the line fled to Taiwan to escape the Japanese and never returned. However, the surname Kong is so common in Qufu that more than one-third of the local telephone directory is dedicated to it.

Twenty-one hundred years ago, the Grand Historian Sima Qian also visited Qufu. In Shiji *he wrote,*

> *Whenever I read the writings of Confucius, I try to picture him in my mind. Once I traveled to his birthplace in the state of Lu. There I visited the temple of Confucius and saw his carriage, clothes, and sacrificial vessels with my own eyes. Scholars from all over go there to study at his house. I wandered about from room to room mesmerized, unable to leave.*

A solitary wall in a courtyard within the Confucian temple is known as the Lu Wall. During the book-burning phase of the First Emperor, a ninth-generation descendant of Confucius hid his forefather's books within this very wall. Several decades later, during the Han dynasty (206 B.C.E.–220 C.E.), the books were rediscovered when part of the wall was demolished to build an extension.

In a separate courtyard closer to the entrance is the Thirteen-Stele Pavilion, which contains many stone tablets with engraved comments from different emperors commemorating their visits. They date from the Tang dynasty (618–907 C.E.) to the first half of the twentieth century, a span of thirteen hundred years. Many of the beautiful tablets show deep cracks and scratches across their surface where Red Guards wantonly tried to destroy them. An old tour guide at the temple told us

sadly that he tried to hide and protect the slabs from the "young hooligans" but was beaten savagely for his pains. Like the First Emperor, Mao Tse-tung also wished to destroy the civilization of the past and start afresh. In many ways the Cultural Revolution was an eerie replay of fen shu keng ru, *"burning books and burying scholars." It was Mao's bid to increase his personal power at the expense of his old comrades, who had dared to challenge him.*

In his bloody purges, Mao was at first ably and wholeheartedly assisted by the war hero, General Lin Biao, who was named defense minister and Mao's designated successor. After four years Lin became increasingly powerful as he went about replacing the old veterans with his own men in key military positions. Feeling threatened, Mao tried to curtail Lin's influence in the crucial Central and Military Affairs Committees. A struggle ensued between the two, which eventually led to the notorious affair known as Project 571.

In 1971 Lin Biao entered into a conspiracy with his son to murder Mao. The younger Lin drafted a plan called Project 571 in which he accused Mao of being the worst feudal tyrant in history and named him the "contemporary First Emperor (Qin Shihuang)." Lin's coup called for the rapid seizure of military power in Shanghai, Beijing, and Canton. Mao was to be assassinated by missiles launched against his train while he was on an inspection tour.

The plot was revealed to Premier Zhou Enlai in the nick of time by Lin Biao's daughter Dou Dou, who had always felt neglected by her parents and been jealous of her brother. The premier immediately informed Mao, who aborted the scheme. While fleeing, Lin Biao, his wife, his son, and five aides were all killed in a plane crash in Mongolia. There were rumors that the plane was shot down by surface-to-air missiles.

Since Lin's Project 571 was anti-Mao and anti–Qin Shihuang, it became expedient, even mandatory, to view the First Emperor favorably from then on. There is a proverb that says, "The enemy of one's enemy is one's friend." Eminent historians throughout China began publishing articles revising their opinions of the First Emperor and conforming to the eulogistic Maoist view that has persisted up to the present.

To the Chinese, there is no rigorous distinction between ancient history and current events. Continually, analogies are drawn and identification made between historical characters and contemporary figures. History is regarded as a mirror of the human condition, a timeless parable from the past, to aid in governing lives not only here and now but for countless generations to come. It is interesting to note, however, that like his namesake, Mao too was unable to find happiness as he neared the end of his life.

Words That Would Cause a Nation to Perish

亡國之言

Wang Guo Zhi Yan

 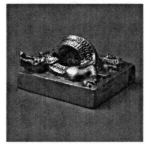

Golden seal from the Western Han dynasty,
second century B.C.E.

*A*fter visiting Qufu, the birthplace of Confucius, Bob and I flew west to Xi'an, the capital of Shaanxi Province. In ancient times, Shaanxi was called Qin because it encompassed approximately the same territory as the state of Qin. The First Emperor's ancient capital of Xianyang is located about thirty-five miles northwest of Xi'an, on the northern bank of the Wei River. It was from Xianyang that the First Emperor launched the expeditions that eliminated the six rival states, swallowing them, according to Shiji, like a silkworm devouring mulberry leaves.

Even today, we can see traces of ruins of the First Emperor's legendary palaces on the outskirts of this still-existing ancient city. They endure as earth mounds with outlines of the zigzagging corridors that linked one building to another. Relics of hollow bricks, tiles, baths, water tanks, drainage pipes, and stairways have been excavated

as well as slabs of walls decorated with images of stallions, chariots, hunting scenes, birds, and animals in various colors. These are probably the earliest palace murals to have been discovered in China. The floor tiles of the main hall of one palace were painted red. It thrilled me to imagine that the legendary assassin Master Jing might have stood on these very tiles and gazed at the same frescos we were seeing as he waited to present General Fan's head to the emperor.

The First Emperor's tomb is situated about twenty miles northeast of Xi'an. We were amazed both by its magnitude and by the fact that the tomb protruded upward like a small, grassy mountain. We had expected it to be hidden underground but were told that originally it was even higher but had weathered down after 2200 years to a height of a twenty-five-story building. So far, Chinese archeologists have not dared open the grave for fear of damage and pollution.

Shiji records that the First Emperor started constructing his mausoleum soon after ascending the throne at the age of thirteen. He chose a site for his tomb at the foot of Mount Li and immediately began digging. When he unified China twenty-six years later, he transported 700,000 men, many of them convicts, from all over the empire to work on the project. They dug through three underground springs and oriented the massive necropolis according to the four points of the compass. The underground chambers were lined with brick, but the outer coffin was lined with bronze. The tomb contained a huge relief map of China made of bronze representing the features of the earth. The Yangtze and Yellow Rivers and many others were reproduced as channels twelve feet deep and filled with mercury. Machines were installed to keep the mercury in motion. Myriad treasures were placed within the sepulchre: replicas of magnificent palaces and grand pavilions containing flocks of silver and gold animals; priceless dishes, plates, lamps, and furniture made of jade and bronze; lacquer boxes, musical instruments, weapons, money, and "books" written on bamboo or silk. Above was a huge copper dome representing the night sky with the moon and starry constellations in pearls. Lamps were fueled by whale oil, set to burn for a long time. The tomb was protected by crossbows and arrows set as booby traps to slay would-be grave robbers.

What Shiji did not record and perhaps the historian Sima Qian did not know is that there are over 500 satellite tombs and subterranean chambers in the immediate vicinity of the main tomb. In 1974 peasants digging for well water a short distance from the First Emperor's tomb accidentally stumbled upon a vast clay army contained in one of these underground chambers, undisturbed for 2000 years. Thousands of life-sized, individually crafted, terra-cotta soldiers were found in three separate vaults together with hundreds of archers and horses and chariots.

We entered the largest chamber, known as Vault One. It is rectangular in shape and is built of earth, with brick floors and timber supports. Bob and I stood on the elevated walkway erected over the site and could hardly believe what we were seeing. Called the eighth wonder of the world, it is truly a magnificent sight. Row upon row of life-sized warriors are lined up neatly in battle formation, poised to fight on behalf of their emperor. When first discovered, they were carrying real metal weapons such as swords, halberds, dagger axes, spears, and spikes, which were made of a special alloy that had not rusted after two millennia. The cavalrymen wore caps with chin straps while the officers and charioteers had on more ornately designed headgear. Their long hair was either plaited or pulled up on top of the head and tied. Their tunics were double layered and belted at the waist, with a thick roll of fabric around the neck to protect against chafing from their leather armor. Below the knee, they wore leggings and square-toed shoes. Each soldier has his own distinctive facial features; no two look alike. Their average height is five feet, ten inches, the same as Bob's.

Vault Two is L-shaped and smaller. It appears to contain an elite unit of special troops and consists of a few hundred kneeling archers, cavalrymen, horses, and charioteers as well as some infantry.

Vault Three is smaller still and resembles an army's command headquarters. Besides a chariot there are sixty-eight figures, mostly lined up as guards of honor and holding ceremonial weapons. This was the base where the general in chief would consult with his advisers in devising strategies of attack or defense. The remains of animal bones have been found in this vault, which suggests that ritual sacrifices were performed here, as was the custom before going into battle.

Adjacent to Vault Number Two is a separate chamber with two imperial bronze chariots, each drawn by four horses and driven by a charioteer.

◆

In October of 211 B.C.E., the First Emperor set off on what was to be the fifth and last tour of his empire. His entourage included the elderly prime minister Li Si, then about seventy years old, Meng Yi, the younger brother of General Meng Tian, and Zhao Gao, a palace eunuch and minor official of low rank. Just before departure, the emperor's youngest son, Prince Hu Hai, who was then twenty years old and much loved by his father, begged to tag along and was allowed to go.

The Meng family had served the Qin kings faithfully for three generations. The emperor respected their ability and held them in esteem. At

that time, General Meng Tian was supervising 300,000 troops in building the Great Wall. Prince Fu Su, the emperor's oldest son, had been banished to join Meng Tian after protesting his father's harsh policy of *fen shu keng ru,* "burning books and burying scholars." Meng Yi, the younger brother of General Meng Tian, was a high-ranking minister in charge of internal administration, sacrificial rites, and ancestor worship. The First Emperor was particularly close to Meng Yi. At court, Meng Yi was allowed to stand in the imperial presence. Outside, he often rode in the same carriage as the emperor. With Meng Tian entrusted with the bulk of the Qin army and Meng Yi constantly at the emperor's side, the Meng brothers were well regarded and treated with deference by the other ministers.

The eunuch Zhao Gao's family originally came from Zhao, distantly related to the House of Zhao. According to *Shiji,* his father had committed a crime and was punished. His mother became a slave and was imprisoned. While in prison, she had illicit relations and bore her sons, all of whom were born in prison and were made eunuchs. As a eunuch, Zhao Gao was allowed to enter into service within the palace. Intelligent and diligent, Zhao Gao rose from obscurity to become a minor official with the title of keeper of the chariots. At one time he assisted Li Si in standardizing the written script and came to know the prime minister well. Later he was put in charge of the royal seal as well as of dispatching the emperor's edicts. His knowledge and understanding of the law made a favorable impression on the emperor, who appointed him tutor to Prince Hu Hai, his youngest son. In no time at all, Zhao Gao became his student's mentor and was able to exert almost total control over the weak and sensuous young man.

Sometime in the past, Zhao Gao had committed a serious offense. His case was referred to Meng Yi, who had found him guilty and sentenced him to death. For some reason, perhaps as a result of pleading from Prince Hu Hai, the emperor had remitted his sentence and given him a special pardon. From then on, Zhao Gao had borne a secret grudge against the Meng family.

This was the background of the imperial entourage that set off on its fateful journey. Records show that the First Emperor sailed down the Yangtze River and visited his eastern territories, including present-day Hangzhou, Zhejiang, and Jiangsu. After offering sacrifices to ancient kings and erecting stone memorials to extol his own virtue, he meandered along

the coast of the Yellow Sea. One night he had a dream about a physical fight with a sea monster. He was told that a giant fish-demon was patrolling the waters and keeping him from reaching the immortals who were in possession of the magic elixir of eternal life. He went out to sea with his men and killed a whale in the waters of the former state of Qi (present-day Shandong Province) with crossbows and arrows. He then traveled westward along the seashore. Nine months went by, and it was the height of summer. One thousand miles away from home, the emperor suddenly became ill. Although no one around him was allowed to mention the word *si* (death), he knew in his heart that he was about to die.

Shiji relates that the emperor commanded Zhao Gao to appear before him and instructed the eunuch to write the following imperial edict to his oldest son, Prince Fu Su:

> *On receiving this letter, immediately proceed to Xianyang. Meet my funeral procession there. Hold the rites and bury me in my mausoleum.*

The letter was sealed but not yet given to the messenger when the emperor died in Shaqiu (Sand Hill in present-day Hebei Province) on July 20, 210 B.C.E. He was forty-nine years old and had been on the throne for thirty-six years. At that time, besides Zhao Gao, Prince Hu Hai, and Prime Minister Li Si, only five or six trusted servant-eunuchs knew of the emperor's demise. Meng Yi had been ordered to return to the capital a few days earlier to carry out sacrifices to the mountains and rivers.

Fearing unrest and rebellion because a crown prince had not been named, the prime minister deliberately concealed the emperor's sudden death. He swore everyone to secrecy and behaved as if the emperor were still alive but merely resting in his chariot. Various officers continued to submit documents and the trusted eunuchs would pretend to transmit the emperor's approvals. They also went on serving food and administering to the emperor's daily needs as before.

In China it is not unusual for a leader's death to be deliberately concealed during times of political crisis. When Mao's designated successor, Lin Biao, was killed in a plane crash on September 12, 1971, while fleeing after failing to assassinate Mao, no public announcements were made. The October 1971 issue of People's China, *China's widely read picture magazine, featured a large photo of Mao Tse-tung and*

Lin Biao on its cover. For over a month after Lin's death, big character posters con-
tinued to be pasted on the walls of Tiananmen Square exhorting readers to adhere
to Lin's words, and the people went on worshiping Lin along with Mao as before.
The grand National Day ceremony held annually at Tiananmen Square on Octo-
ber 1 was canceled at the last minute, probably because Lin's absence at Mao's side
would have drawn comments from the international press.

Although there were rumors of Lin's death within China in late October, it
was only on November 27 that the Washington Post *released the news to the rest*
of the world. "Lin Biao Believed to Be Dead" read the headline that day.

Aunt Baba, who was then living in Shanghai, was attending a political meeting
in January of 1972 when her group was instructed to tear out and destroy the first two
pages of Mao's Little Red Book, *which contained Lin Biao's foreword. Along*
with many other elderly men and women, my aunt was fearful of this new dictum.

"How is it possible," one of the old ladies finally asked the cadre in charge
after a long silence, "that Lin Biao, who was Chairman Mao's designated successor
and minister of defense, is now suddenly being called a double dealer, traitor, con-
spirator, and counter-revolutionary? By ordering us to tear out the first two pages
of Mao's Little Red Book, *are you sure you are not saying* wang guo zhi yan,
'words that would cause a nation to perish,' and giving us advice that will lead to
total disaster?"

Zhao Gao, who was in possession of the dead emperor's last letter to Prince
Fu Su as well as the imperial seal, saw his opportunity. He approached his
former student, Prince Hu Hai, and said, "Your father, the emperor, has
died without proclaiming a legitimate heir to the throne. All he left behind
is this letter to your older brother. When Prince Fu Su meets us in Xian-
yang, he will be crowned as emperor while you will be left without a foot
or even an inch of territory. Are you planning to do anything about this?"

Hu Hai replied dutifully, "I have heard that the enlightened ruler knows
his subjects and the smart father understands his sons. Since my father
died without proclaiming an heir, what can I do or say?"

"I beg to disagree," the eunuch replied. "In fact, Your Highness, at pres-
ent the fate of the empire rests in the hands of three people: you, the
prime minister, and me. Please keep this in mind. Besides, when it is a
matter of ruling others or being ruled by others, or a choice of making
others one's vassals or being the vassals of others, how can you even think
of considering them in the same instance?"

Still the young prince resisted. "It is not right to displace an older brother and install a younger one in his shoes," he protested. "It is also wrong not to pass on a father's true wishes. Such acts are against the moral obligations of a son. When a person has limited skills and capability, it is reprehensible for him to take over the assignments of another who has proven himself through his achievements. These three acts are contrary to the correct behavior of a wise ruler, and the empire will not condone them. If I were to behave in such a manner, I would fall into danger and the spirits of the land would reject my sacrifices."

But the eunuch was not so easily dissuaded. He cited two precedents: the first a minister who killed his master, and the second a son who murdered his father, both for just causes. The former received approbation from the general populace while the latter was applauded by no less a person than Confucius himself, who did not consider the son to have been unfilial. "Great men do not perform grand deeds out of prudence. Neither do virtuous acts arise from gallant denial," he said to the prince. "A person of decision and daring will carry the world before him, so much so that even spirits and ghosts dare not obstruct his way. Only then will he perform memorable feats. I beg you to consider my words. Now is the time! Now is the time! Be not afraid because fear is the only thing that can make us fail."

At this, the young prince heaved a sigh and nodded his agreement. Having had his way with his student, the eunuch now said, "For our plan to succeed, we need to involve the prime minister. I request permission to speak to him on your behalf."

Years earlier, the cunning eunuch had worked with Li Si on standardizing the script. He knew the prime minister intimately and was very much aware of his love of money and power. Besides having been ennobled as a marquis of the highest rank, Li Si had also seized for himself the greatest revenues from the government. Zhao Gao knew that he had but one chance to present his case. If he were to fail in his persuasive mission, he would be accused of treason and his life would be in jeopardy.

He now approached Li Si and said, "At this uncertain time, may I remind Your Highness of the close relationship between General Meng Tian and Prince Fu Su, the emperor's oldest son and rightful heir. For many years now, the Meng family has held the reins of power in the Qin empire.

"I beg your lordship to pose to yourself the following questions: As to talent and ability, how do you compare with Meng Tian? In resourcefulness and strategic military planning, how do you compare with Meng Tian? Regarding meritorious service, how do you compare with Meng Tian? In popularity and legendary heroism, how do you compare with Meng Tian? Last but not least, in the mind and heart of Prince Fu Su, how do you compare with Meng Tian?"

"You know very well, sir," replied old Li Si sadly, "that in all five aspects, I cannot compare with Meng Tian. Why do you question me thus?"

"I am but a lowly eunuch in His Majesty's service," said Zhao Gao humbly, "who has been fortunate enough to be admitted into the Qin palace through the writing of words. In my twenty years with the emperor, I have seen many exemplary ministers who have been dismissed. Alas! Not a single one has retained his feudal holdings to pass on to the next generation. In fact, every one has been eventually executed. . . ."

He saw Li Si's right hand trembling and knew that his warning had struck home. He cleared his throat and continued, "We both recognize that the emperor's oldest son is resolute, steadfast, brave, and trustworthy. When he ascends the throne, he is bound to appoint General Meng Tian as his prime minister. In that case, it is certain that Your Highness will not be able to sustain your present exalted position and may even have to surrender your seal of high office and go back to your village."

"What you are saying are *wang guo zhi yan,* 'words that would cause a nation to perish.' I have read our late majesty's final decree," replied Li Si feebly. "According to the sages, we should listen and obey the will of Heaven. Who am I to question or doubt the emperor's final intent?"

Zhao Gao knew that for his plan to succeed, Li Si's complicity was essential. "Do not be so sure of your own reasoning," the wily eunuch counseled. "What you consider dangerous may actually be safe. And what you consider safe may actually be dangerous. Would it not be wiser to decide first on what is dangerous and what is safe before worrying about the will of Heaven or how to honor the sages?"

"In spite of my lofty position, I began life as a commoner," Li Si replied, "having been born in the narrow lanes of the village of Shangcai. Through the grace of the emperor, I was fortunate to have attained my present post of prime minister. Hence it is my responsibility to decide on

the measures that should be taken to safeguard the integrity of our empire. Do not tempt me by advising me to ignore my duty. One who is loyal to the memory of his emperor cannot hope to do a proper job if he blanches at the thought of his own death. I beg you to say no more."

Sensing weakness in the old man's words, Zhao Gao persisted, "It has been said that sometimes even the sages do not follow the usual patterns of behavior but adapt to change as they see fit. Besides, no rule is unerring. The only thing that does not change is that everything changes. If circumstances are constantly altering, how can there be but one correct rule of conduct?

"If you would only grant me the patience to listen to my plan, you will see for yourself that it has been specifically designed for you to maintain your power and position for as long as you wish. However, if you should reject my proposal, it is equally obvious that you and your offspring will suffer disastrous consequences. The adroit minister is one who can turn calamity into opportunity and success. Your Highness, please let me know your decision."

The old minister looked up to Heaven and heaved a great sigh. Tears flowed down his cheeks as he lamented, "It seems that the fate of the great empire of Qin has fallen upon my shoulders. Why must I alone of all my family be saddled with such chaotic times? And since I am unable to face the possibility of sacrificing my life, what fate should I hope for?"

Zhao Gao continued, "Fortune is smiling on us because the conditions for carrying out my plan cannot be more perfect. The royal seal and His Late Majesty's last letter are both in the possession of Prince Hu Hai.

"I propose that we first burn the emperor's letter to Prince Fu Su. Using the emperor's seal, let us send Fu Su a new letter instead. Meanwhile, let me report back to Prince Hu Hai."

The eunuch hurried back to Hu Hai and said, "I hereby hand you the emperor's seal as well as his letter to your oldest brother, Fu Su. I humbly ask your permission to relay your commands as heir apparent to the prime minister. From now on, he will not dare disobey your orders."

The three men first prepared a false edict from the First Emperor, purportedly instructing the prime minister to establish Hu Hai as crown prince. They then forged a new letter to the eldest son, Prince Fu Su, after destroying the first letter.

The false letter read:

We are touring the empire and performing sacrifices to prolong our life. Mean-
while, Fu Su is with General Meng Tian. The latter has been stationed at the
border for more than ten years. Not only has Fu Su not been able to gain an
inch of territory after the loss of numerous soldiers, he has sent us frankly writ-
ten letters criticizing our policies. As a son, Fu Su has been critical and unfil-
ial. We hereby present him with our sword for him to end his existence. General
Meng Tian has done nothing to correct Fu Su's faults, though he must be aware
of them. Because of his disloyalty, we present him with the opportunity to take
his own life. We further direct that he hand over his troops to the command of
Assistant General Wang Li immediately.

After the letter was sealed with the seal of the emperor, Zhao Gao said
to Li Si, "For our plan to succeed, it is essential that no one must know
of the emperor's demise. We will say that His Majesty is indisposed and is
keeping to his bed in the coach. The messenger who delivers this message
to Fu Su must be someone with authority, preferably a nobleman.

"As soon as Prince Fu Su commits suicide, your position as prime
minister and marquis will be secure. Prince Hu Hai is young, malleable,
and intelligent. He will need your guidance for as long as you live. And
after your death, one of your sons will probably take your place at the
side of the emperor for many generations to come."

◆

The story of Zhao Gao, Li Si, and Prince Hu Hai after the death of Qin's First
Emperor was taught to me in class when I was in the sixth grade in my Shanghai
primary school. I was fascinated and related the tale to my aunt when I came
home from school. I have never forgotten our discussion that evening.

"Always remember this story!" Aunt Baba told me. "Up to the point of his
conversation with Zhao Gao, Li Si was a loyal minister and a moral man. He lis-
tened to Zhao Gao and became corrupted. A person's character is made or unmade
by our intentions. If a person listens to an evil plan without protest, he has already
compromised his integrity, even though he may think he has remained innocent
and uninvolved. Eventually, a deception that Li Si secretly condoned behind closed
doors was carried out and proclaimed by him in public without a second thought.
By overlooking corruption for personal gain, Li Si tainted his conscience and came
to behave in exactly the same way as Zhao Gao.

"In China, we have a concept called qi. Qi means the foundation of courage, will, and intention. It is dependent on moral conviction. Li Si knew very well that he was condoning evil when he went along with Zhao Gao's plans. He thought that he could control and outsmart the eunuch, but he had forgotten about his personal morality. His own behavior eventually made him lose face in his own eyes, and he started loathing himself.

"A person's moral integrity is of the utmost importance. It is the foundation of one's sense of self-worth. If a person feels in his heart that he is right, he will go forth even against thousands and tens of thousands. But if he feels in his heart that he is wrong, he must stand in fear even though his opponent is the least formidable of foes.

"When Li Si listened to Zhao Gao, he lost his integrity and with it his moral authority. At one point, Li Si accused Zhao Gao of saying wang guo zhi yan, 'words that would cause a nation to perish.' The same proverb also means 'advice that leads to total disaster.' Disaster for Li Si himself as well as for the nation because from then on, Li Si was a broken man and could no longer hold up his head. He went over to the side of evil and afterward had nothing but contempt for himself within his own heart. Outwardly, Li Si appeared the same and was still prime minister. But inwardly, he was rotting and he knew it.

"Never forget this story!"

Chinese journals and newspapers often publish articles identifying contemporary politicians with historical figures. The First Emperor is invariably represented as Mao Tse-tung and Zhao Gao as a current villain-at-large such as Lin Biao. The character of Li Si is more difficult to depict, but the general consensus is that he did more good than harm. Diplomatic, conciliatory, and compromising, Li Si has been compared with the Communist premier Zhou Enlai, who was similarly flexible, tactful, and adaptable. Both were skillful at handling human relations and often hid their true feelings so as not to offend anybody. In one of the publications, however, a warning was given that in life it is impossible to please everyone. A policy of accommodation toward amoral and ruthless individuals may, in the long run, lead to personal and national disaster.

CHAPTER 9

Pointing to a Deer and Calling It a Horse

指鹿為馬

Zhi Lu Wei Ma

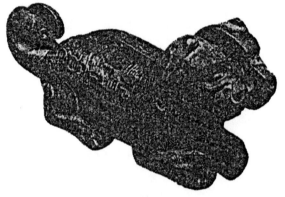

Bronze tiger tally, Warring States period.

*T*hroughout my childhood, the sibling who was closest to me was my third older brother, James. We spent hours playing together and would confide to each other our dreams and fears. With him, I felt that I could discard my vigilance and reveal matters close to my heart. During that awful time, he provided a haven that I desperately needed.

James was the one who dutifully stayed behind in Hong Kong to look after our parents and their business affairs. In their separate wills, they both named him as the executor.

When my oldest sister, Lydia, was seventeen and still a student at Shanghai's Aurora Middle School, Father and Niang decided to arrange a marriage for her. One Sunday they took her out to lunch and introduced her to Samuel Sung, the

thirty-one-year-old son of our family physician, who had just returned from America with an engineering degree. I remember Lydia wandering into my room later that afternoon, looking dreamy and preoccupied. Ye Ye, Aunt Baba, and I were playing cards. She sat down on my bed, refused to join our game, and kept doodling Chinese and English words on a sheet of paper. I finally leaned over and saw that she had scribbled "Mrs. Samuel Sung" in English and Chinese about thirty times. Then she smiled and told us that she had agreed to marry this stranger whom she had just met.

Although Lydia appeared calm and cheerful when she announced this, I felt horrified and frightened on her behalf, wondering if the same fate would befall upon me a few years later.

"Don't do it!" I blurted before I could stop myself, knowing full well that I was courting disaster in advising her to go against Niang.

"Why not?" she asked defiantly.

"When you marry, you'll be taken out of school! No more classes! No more schoolmates! No possibility of ever going to college! Not even a high school diploma! How awful!"

"What do you know?" she asked petulantly with a toss of her head. "What's so wonderful about school anyway? It won't be so bad not to do algebra or geometry again. I can just see Teacher Peng's face when I tell her tomorrow that I haven't done my math homework and have no intention of doing any more homework from now on. Math is a complete waste of time!"

"Is that why you're agreeing to this marriage?" I asked incredulously. "So you won't have to do any more math?"

"Don't be so stupid! Of course not! Father has promised me a great big dowry! Twenty-five thousand American dollars! Who needs a high school diploma with that type of money in the bank. I'll be set for life!"

Thirty years later, when we met again in Beijing, she no longer thought that she had made the right decision at seventeen. Mired in a loveless marriage and living in poverty in Father's Tianjin house with six other families, she sobbed out the sorry tale of her unhappy life in Communist China.

"I was a fool to have trusted Father and Niang at that stage of my life!" she complained bitterly. "Compared to all of you, my life has been a disaster. When I heard that they had sent all my brothers and then even you to university in England, I felt so wretched and depressed. At seventeen, I was naive and weak. They wished to be rid of me. So they devised this plot to shift their burden to someone else, and

I walked right into it. As a result, I don't even have a high school diploma or any skills whatsoever to support myself.

"Over the years, I have repeatedly written to our parents begging them for help, without ever receiving a reply. Niang is a sick woman seething with hate. I know her well. What she enjoys most are intrigues. The more everyone suffers, the happier she is.

"You are the only one in our family who has the courage to go against Niang and do what is right. I know that I am asking a lot of you. You might even get disowned yourself if Niang finds out that you are helping us. I want nothing for myself. But I beg you to help my two children, especially my son. Please give him a chance and sponsor him to go to university in America."

On returning to California, my husband, Bob, and I helped Lydia's family escape from Communist China and emigrate to the United States. Like the proverb that says yi yuan bao de, "No good deed will go unpunished," Lydia secretly resented our assistance and began to hate us. To our faces, she deferred to us and continued to flatter us, but behind our backs, Lydia started her campaign to slander me in weekly letters to Niang.

Blithely unaware of the conspiracy brewing all around, Bob and I returned to Hong Kong in September of 1990 to attend Niang's funeral. As usual, James met us at Kai Tak Airport. He was alone and looked very tired. Almost immediately, I sensed a difference in him that was hard to define. I put it down to the stress of looking after Niang in her last illness. That evening after dinner, the three of us took a long walk around our hotel for almost an hour. A few times James seemed almost ready to say something, but the words did not come. He had kept the secret so well for so long that it was now impossible to admit what he had known for some time. He was fundamentally a decent man and knew that I loved, admired, and trusted him. As we went around and around the hotel in the steaming heat, I felt his pain and wanted to reassure him. So I told him that the worst was over. Niang was irrevocably dead and he was now a free man. I did not know that by saying this I was making things worse. My words of sympathy embarrassed him and seemed to deepen his discomfort. As we went around again for the last time, I could see the sweat pouring down his face like tears. Still he kept his tie firmly knotted and his jacket on and said nothing.

The last time James and I saw each other alone was the day after I discovered Lydia's letters to Niang. He refused to read any of the letters that I tried to show him, telling me that they were private and that he was going to burn them. I mentioned

a particular missive in which Lydia described her daughter Tai-ling's wedding. "In front of over one hundred guests," Lydia reported to Niang, "Adeline had gotten drunk. She stood up and denounced my children and me in a loud voice, using many swear words. All conversation ceased and everyone stared at us. The situation became so embarrassing that I had no choice but to dismiss Adeline from the wedding banquet and send her away."

"Yes!" James said in a wooden voice, "That's what Lydia claimed!"

With a pang I realized that he and Niang had discussed this incident between them. Had Niang shared all of Lydia's letters with him week after week? And had he not said one word in my defense? Why had he not given me any warning while this was going on?

"Did Niang believe Lydia?"

James shrugged his shoulders. "What does it matter whether Niang believed her or not? Besides, it's all water under the bridge. Niang is dead and her will is final."

"It matters because the truth matters. What do you think, James? Do you believe Lydia?"

James avoided looking at me and muttered, "I think the truth lies somewhere in between. . . ."

"Oh, James! What has come over you? How can you sit there and say something like that? Why are you zhi lu wei ma, 'pointing to a deer and calling it a horse'? By doing so, do you not see that you will be unable to face yourself from now on?"

◆

The chosen messenger, who was a follower of Prince Hu Hai, took the forged letter and rode day and night to the Great Wall. When he arrived, he identified himself as a special envoy sent by the emperor. Next he requested that Prince Fu Su, General Meng Tian, and Assistant General Wang Li all be present. In front of the three men, he presented his credentials in the form of the matching half of the tiger tally *(du hu fu)*.

The tiger tally was a traditional token by which Qin rulers bestowed power on their military generals. Forged in the shape of a tiger, it was cleaved into two halves. The right half was retained by the monarch while the left half was given to the commander in chief at the frontier (or battlefield). When the two halves tallied, it proved that an order came directly from the emperor and had to be instantly obeyed.

Meng Tian pulled out his half of the tiger tally hanging around his neck and demonstrated to everyone that the two halves fitted seamlessly. The four men fell to their knees and showed their respect by touching their foreheads to the ground, first toward the direction of the absent emperor, then to one another.

The messenger rose and handed to Prince Fu Su the edict from his father, together with His Majesty's favorite sword. He said, "The emperor wishes you to read the message out loud to everyone present."

On hearing the emperor's harsh words, they were all stunned. Prince Fu Su read it aloud again, and this time his voice was choked with tears. Never for a moment did he doubt that the letter came from his father. Without a word, he held the sword in his hand and entered an inner room in preparation for killing himself.

Meng Tian tried to restrain him. He ran after him and said, "Your Highness, do not act in haste! Something is not right. Your father has been away from Xianyang for nine months. All this time, although he has not established a crown prince, he had enough confidence in the two of us to empower me with the command of 300,000 troops and for you to be my overseer. These are signs that he trusts us and wishes us to learn responsibility and leadership. Yet, upon the arrival of a single letter, you are about to slit your own throat. How can you be so sure that this is your father's true intention? I suggest that we send back a request for clarification. If he should confirm our death sentences a second time, surely it will not be too late then for us to die."

But Fu Su was adamant. With tears running down his cheeks, he said, "Only yesterday, you and I spoke of our dreams and made our plans together. After what we have gone through, you must know that you are closer to me than a brother. My only regret is that I must now bid you farewell. I have no doubt that the messenger's tiger tally came from my father."

At that moment the messenger entered the room. He picked up the emperor's sword, which was lying on the mat, unsheathed it, knelt, and presented the naked weapon respectfully to Prince Fu Su. "It is His Majesty's command that the deed be done at once!" he urged. "I beg Your Highness to honor your father's wishes."

Taking the sword in his right hand and clasping Meng Tian's arm with his left, Fu Su said sadly, "When a father orders his son to commit suicide,

what sort of son am I that I should send back his order for confirmation? You would not think much of me if I were to disobey my father."

With these words Fu Su killed himself with his father's sword.

Meng Tian remained suspicious. He summoned Wang Li into the inner room and asked the messenger to leave them alone. The two officers wept while kneeling by the side of their dead prince's body. After a long silence, Wang Li said, "As far as I am concerned, you are my commander and will always be my commander. Wherever you go and whatever you do, I shall follow. If you need anyone arrested, give the order and it will be done."

Meng Tian gritted his teeth and replied, "The emperor's edict simply makes no sense! For years now, Fu Su and I have fought together side by side. His father entrusted us with the best and brightest of his imperial forces against the northern nomads. We have the heart and mind of every soldier in the hollow of our hands. Yet despite all our hard work, he sentences us to death!

"Why did the Emperor not give any indication of his displeasure before handing us our death sentences? My brother Meng Yi, who has been traveling with His Majesty for the last nine months, sent me a letter not too long ago full of hope and good cheer. If anything untoward was happening at court, surely Meng Yi would have forewarned me.

"The two of us both know that I can easily have the messenger arrested and demand a full inquiry. Most of my men will follow me to the ends of the earth. But it is tantamount to declaring rebellion against His Majesty. This I cannot do.

"You and I, Wang Li, we have been comrades in arms as well as friends for many years. My loyalty to the emperor demands that I now order you to put me in prison. Send the messenger back to inform His Majesty that Meng Tian feels he has committed no crime and does not deserve to die. But alas! Prince Fu Su is no more!"

The messenger placed Meng Tian under guard and immediately transferred him south to Yangzhou, to be imprisoned hundreds of miles away from his power base at the northern frontier. Before leaving, he also appointed a former retainer of Li Si to be the military protector of Assistant General Wang Li and the mighty Qin army.

He then hurried back to report to the plotters, who were still acting out the charade of being on tour with the emperor. Since Fu Su was now

safely out of the picture, Hu Hai suggested releasing Meng Tian and reuniting him with his brother Meng Yi, who had just completed his assignment and was awaiting the group in Xianyang.

But the eunuch Zhao Gao said, "Meng Yi has recently gone back to the capital and is, of course, unaware that your father is dead. Already he has requested to see His Majesty as soon as we return. I should tell you that your father has wanted to name you as heir apparent for a long time. He knew how capable you are and that you will make a great emperor. However, whenever the subject was raised, Meng Yi would oppose your appointment. He obviously prefers Fu Su, and I foresee trouble if the Meng brothers are released, especially when they learn of the emperor's death. The Meng family name is renowned, and the brothers have many followers. To prevent future problems, Your Majesty should have them executed."

They sent word for Meng Yi to be arrested and placed in a prison in Dai, far from his older brother. Meanwhile, to maintain the pretense that nothing untoward was happening, the conspirators continued on their journey and visited the northwestern segment of the Great Wall. They let it be known that the emperor was still unwell and was compelled to stay in his coach. But the weather grew hot since it was high summer, and the emperor's decaying corpse began to give off an increasingly unpleasant smell.

To hide the odor, Li Si gave word that the emperor had developed a sudden craving for salted abalone. As the royal entourage sped back toward the capital, the carriages rumbled down the straight, tree-lined imperial highways loaded with innumerable pounds of stinking shellfish. Bystanders shouted, "May the emperor live for ten thousand years!" and children waved banners to welcome home their sovereign, without realizing that the Lord of All That Is Under Heaven had been dead for some time.

After returning to Xianyang, Li Si made the formal announcement of the emperor's death and the ascension of twenty-year-old Prince Hu Hai to the throne as Qin Ershi (Qin's Second Emperor). Under strict security precautions, a grand funeral was held in September 210 B.C.E., and the First Emperor was buried in the mausoleum he started to build as a teenager.

The Second Emperor proclaimed that it was unfitting for his father's concubines who had borne no children to be sent elsewhere. He ordered that they were to accompany his father on his last journey. This resulted·

in the death of many women who were interred with the First Emperor in his tomb.

Someone reminded the Second Emperor that the craftsmen who worked on the tomb would be fully cognizant of the secret weapons installed there. Therefore, when the mechanism had been successfully assembled and tested, he ordered both the inner and outer gates of the tomb to be closed and sealed, trapping the workers and condemning them to die in terror and darkness.

He summoned Zhao Gao and said to him, "Man's life on earth is not much longer than the time it takes for a team of six colts to run past a fissure in a wall. Now that I am emperor, I wish to enjoy myself constantly: listening to music that is pleasant to the ear, looking at scenes that are beautiful to behold, and delighting in activities that give me joy until my life span reaches its natural conclusion. What do you think?"

"These are the thoughts of an enlightened ruler!" Zhao Gao replied. "One who is muddleheaded and inept would never possess such insight. Your Majesty is entirely correct in his thinking."

"I have noticed that some of the chief ministers are disrespectful and do not appear to think much of me. Unfortunately, they are rather prominent and have great power. What can I do?"

"I have been wanting to speak of this for a long time but have not dared," Zhao Gao replied. "The other princes are all older than Your Majesty, and the chief ministers were all appointed by your father. They are suspicious of the plot that we carried out in Sand Hill and are resentful that you are the one on the throne. I am seriously concerned about this state of affairs on your behalf.

"I suggest that you make the laws stricter and the penalties more severe. See to it that the accused parties implicate others and that punishment extends not only to the criminal but to his entire family. Eliminate those ministers who disapprove of your actions, and get rid of your disgruntled relatives. Strike terror into their hearts. This is the time, not to learn the arts of peace, but to make firm decisions through brute force. Enrich the poor and elevate the humble. Surround yourself with those whom you trust. Appoint those with whom you are intimate. Having benefited from your largesse, the new officials will be forever grateful to your generosity. Your Majesty may then rest peacefully, indulge in your desires, and live life to the full. What can be better?"

The Second Emperor agreed and appointed Zhao Gao as palace chamberlain and special envoy, entitled to arrest, examine, and try anyone who was suspected of being disloyal to the throne.

They began with the prosecution of the Meng brothers. By relay carriage, the Second Emperor dispatched his imperial secretary to the prison in Dai where Meng Yi was incarcerated, and accused him of opposing the First Emperor's plan of appointing Prince Hu Hai as heir apparent. Convicted of being disloyal to the throne, Meng Yi was instructed to commit suicide.

Meng Yi replied, "I have served the First Emperor from the time of my youth and continued to do so until he passed away. Of all the princes, Hu Hai was the only one ever chosen to accompany His Late Majesty on his travels around the empire. If the former ruler had planned to raise him as heir apparent, who am I to have dared to oppose him? What proposal could I have offered to question his plan?

"I'm not saying this in order to avoid death. It's just that I am ashamed to drag the First Emperor's name into dishonor. If I am to be put to death, please bring charges that have some substance. Otherwise, you will be executing the guiltless and punishing the innocent."

The imperial secretary paid no heed to his words. He knew what Hu Hai wanted and had Meng Yi put to death.

Shiji records that Hu Hai also sent an envoy to confront Meng Tian with an order that read, "You have made many mistakes, and your younger brother has committed numerous crimes. We have evidence that you are implicated and are, therefore, guilty by association. As a mark of imperial favor, we allow you to take your own life by drinking poison."

Meng Tian took the cup in his hand and said, "The Meng family has served the Qin rulers faithfully for three generations. With 300,000 men under my command at the northern frontier for so many years, I could have started a rebellion at any time, even from prison if I so wished. Yet I choose to die rather than take up arms against the Qin emperor. Before Heaven, I swear that I have committed no crime. I die an innocent man."

He drank the poison in one gulp. While waiting for the drug to act, he reflected on his role in building the Great Wall and added, "Perhaps there was a crime for which I am responsible. Beginning at Lintao (in present-day Gansu Province) and extending all the way east to Liaodong

(on the Gulf of Bohai), I have erected bulwarks and dug trenches over more than 10,000 *li* (3000 miles). In that great distance, I must have cut through the veins of the earth and disturbed it in other ways. Maybe that is my crime."

So died Meng Tian, apologizing for his role in altering the landscape to fulfill human desires in building the Great Wall. The ancient Chinese concept of *feng shui* is surprisingly modern. In his dying remarks 2200 years ago, Meng Tian was expressing his reverence for nature as well as his belief that the life and vital force of our environment is intimately connected to human destiny.

Prince Zi Ying, an uncle of the Second Emperor, came forward and protested the execution of the Meng brothers, but the Second Emperor paid no heed. His reign of terror continued with the execution of many other ministers as well as twelve royal princes, all older brothers of his. The princes' bodies were exposed and displayed in the marketplace. This was followed by the killing of ten royal princesses, who suffered a worse fate than that of their brothers. *Shiji* relates that their bodies were torn limb from limb, and their properties were confiscated by the government.

Prince Gao, a brother of the Second Emperor, was planning to flee but feared for his family. He sent a letter to the throne:

> *When our father, the former Emperor, was alive and well, he treated me to delicious meals whenever I visited him in his palace. On my visits abroad, he granted me carriages. He gave me presents of clothing and prize horses. When he died, I should have followed him but failed to do so. Therefore, I am an unfilial son and a disloyal subject. Being disloyal, I shall never be able to establish my renown and therefore request that I be allowed to follow my father in death, and be buried near his tomb at the foot of Mount Li.*

The Second Emperor was delighted. He showed the letter to Zhao Gao and remarked, "This is quick!"

"Indeed, if your subjects are all preoccupied with death, they won't have time to do anything else, let alone plot rebellion!"

The Second Emperor approved his brother's request and granted him 100,000 copper coins to pay for his funeral. Prince Gao then took his own life.

The bloody massacres terrified the populace. Anyone who protested was accused of slander. After a brief trial, they and their families would be exterminated. *Bu ke sheng shu,* "innumerable persons were implicated." *Ren ren zi wei,* "everyone felt threatened and feared for his own safety." The ministers clung to their posts by keeping quiet and ingratiating themselves with Zhao Gao.

Meanwhile, the Second Emperor continued his father's building projects. After completing the mausoleum, he restarted the work of building new roads as well as the massive Afang Palace. "If we do not complete my father's projects," said the Second Emperor, "it would appear as if he were wrong in his undertakings."

On the foreign front the Second Emperor went on waging war against the barbarians on every border, even though men of ability were revolting against his own rule throughout China. He moved 50,000 crossbow men from all over the empire into Xianyang to guard his palaces. Since they and their horses, dogs, and pets consumed large supplies of food, he ordered extra beans, millet, grass, and fodder to the capital, further impoverishing the countryside. Within a radius of a hundred miles of Xianyang, farmers were not allowed to eat their own grain.

Harsh new laws were constantly promulgated, and the penalties increased in severity day by day. Taxes became ever more burdensome, and there were ceaseless demands of forced labor and military service. The empire was seething with discontent and heading toward disintegration.

Li Si tried to remonstrate with the Second Emperor, but the latter would not spare the time even to see him. He was reduced to writing long-winded memorials to the throne, with many references to the saintly conduct of exemplary rulers who lived hundreds of years before. Most of these letters were ignored, except when the young monarch wished to lash back. In doing so, he wrote,

What is the point of having the honor of possessing the empire if one has to tire his body and exert his mind daily? That's a job fit for a dullard, certainly not one for a man of substance.

When a man of substance holds the empire, what he needs to do is to use the empire to gratify his every desire. . . . This is the reason I'd like to act as I please, broaden my experience, and enjoy the pleasures of the empire for a long time to come without harming myself.

The Second Emperor proceeded to do just that. From then on he devoted himself to using the empire for his personal pleasure.

Shiji relates that the Second Emperor praised those officials who could squeeze the largest amount of taxes out of his subjects. *"Such are the men who may be said to be truly supervising and punishing correctly!"* he would exclaim.

Penalties were so severe that half the people walking along the roads had endured corporal punishment; and bodies of the executed piled up daily in the marketplace. Having begun his reign with a crime, the Second Emperor now turned to terror to underpin his regime. Oblivious to the suffering all around, he promoted only those ministers who were handing out the greatest number of death sentences, calling them loyal and efficient.

The eunuch Zhao Gao took the opportunity of executing as many of his private enemies as he could. Fearful that the chief ministers who frequented the court would speak ill of him in front of the emperor, he encouraged the young monarch to remain enclosed in the private areas of the palace, under guise of preventing the monarch from making any mistakes in public. The Second Emperor agreed wholeheartedly, and from then on he no longer met with his officials in the throne room but remained in the private recesses of his palace. Zhao Gao and his eunuch attendants were the only ones who had access to him, and all matters of state were decided by Zhao Gao.

Li Si commented unfavorably about this state of affairs, and Zhao Gao decided to take action against him. He sought an audience with the prime minister, prostrated himself, and said, "I hear that many bandits have risen in revolt east of the mountains, and yet at present the emperor is conscripting more and more laborers to build the Afang Palace. He occupies himself by playing with dogs and horses and engaging in other useless activities. I would like to reprove him but am not really in a position to do so. This should be a matter for Your Lordship, who was his father's chief adviser for so many years. Why don't you have a talk with him?"

Li Si answered, "I am aware of this and have wanted to speak to His Majesty for some time. However, he no longer sits in court but stays within his palace. When I ask to see him, he has no time."

Zhao Gao replied, "Allow me to help you. When he is next available, I shall let you know."

Zhao Gao lay in wait until the Second Emperor was feasting and enjoying himself with his women. Then he sent word to the prime minister that he should come at once to meet with His Majesty. Li Si hurried over to the palace gate and sent in a request for an interview, disturbng and irritating the monarch. This happened three times.

The emperor became annoyed and said to Zhao Gao, "There are many days when I am doing nothing special and the prime minister never comes. Then as soon as I am merrymaking with my women, he immediately appears and wants to talk about affairs of state. Why does he slight me this way? Is it because I am young, or does he think I am stupid?"

Seizing the moment, Zhao Gao exclaimed, "Is this what he is doing? Then he is dangerous and Your Majesty must proceed very carefully. The prime minister was a participant in our plot at Sand Hill. These days Your Majesty has become the emperor, whereas his position has not changed. May be he is planning to grab a slice of your territory and make himself a king.

"There is something else I have never dared mention to you before. There have been a few minor rebellious uprisings in the last few months. Recently, I have received confidential information that the most brazen bandit leaders all came from the area of Sanchuan, where the Lis have their ancestral home and where the prime minister's son Li You is the governor. When the rebels marched through Sanchuan recently, Li You stayed behind city walls and refused to attack them. Instead, numerous letters passed back and forth between the two parties. Since Your Majesty has not given me permission to make a full investigation, I have no clear proof at this point."

The Second Emperor sent an envoy to look into this matter. Li Si heard of it and tried to see the emperor, but His Majesty was away at his Sweet Springs palace, attending wrestling matches and theatricals. Belatedly becoming aware that his position was precarious, the prime minister wrote an eloquent memorial to the throne in which he openly attacked the eunuch Zhao Gao.

I have heard that whenever a subject is deceptive and pretends to be the ruler, the state is endangered. Just as when a concubine is false and pretends to be her master, the home is threatened . . .

After quoting numerous historical precedents of greedy and power-hungry ministers who eventually deposed their rulers and ruined their countries, Li Si warned that Zhao Gao was evil and treacherous. He ended his letter with a clear message:

Unless Your Majesty pays attention to this matter, I'm afraid that Zhao Gao will turn traitor and cause revolt.

The Second Emperor disagreed. In his reply, he hotly championed his former tutor, and apparently Li Si was never given the opportunity to see the emperor again. In the ensuing power struggle between Li Si and Zhao Gao, the prime minister was reduced to pleading his case by submitting memorials. He never understood the depth of the eunuch's influence over his former pupil until it was too late. Li Si wrote:

I beg to differ. Zhao Gao comes from lowly origins. He has no principles and his greed is insatiable. He is only interested in profit. His power and rank are second only to Your Majesty and his desires are limitless. That's why I say he is dangerous.

When he read this letter, the Second Emperor was afraid for Zhao Gao and, incited by him, began to fear for his own life. He gave the fatal order to let the matter be decided by Zhao Gao. Li Si was arrested, shackled, and thrown into prison, and Zhao Gao presided over his trial. Li Si and his eldest son were accused of plotting rebellion and aiding the bandits from Chu. All of Li Si's relatives and retainers were taken into custody. The elderly prime minister, then in his seventies, was ordered to be beaten with one thousand strokes of the cane until he could no longer endure the torture and made a false confession.

Still he refused to give up. In order not to die, Li Si wrote a final appeal to the emperor. He began by describing his thirty years of service to the state of Qin: his role in unifying China; in driving out the barbarians; in selecting capable ministers; in standardizing the law, the language, and the weights and measures; in building roads and parks; and in the reduction of penalties and taxes so as to win the hearts of the people. He ended by begging for his life.

From the letter it is obvious that the elderly prime minister never understood that by giving in to Zhao Gao and participating in the Sand Hill plot, he had demeaned himself and lost his moral authority. Toward the end of his life, he did strive to guide the emperor toward enlightened government, but by then it was too late. The young monarch had become Zhao Gao's creature entirely and never even saw Li Si's letter.

Instead, Zhao Gao sent more of his retainers to question Li Si, beating him mercilessly until he submitted to all the false charges. Meanwhile Li Si's eldest son, Li You, was attacked and killed by the rebel army from Chu. Zhao Gao falsified all the reports and submitted those to the emperor, together with Li Si's forced confession of guilt.

The emperor was delighted, "If not for Zhao Gao," he said, "I would have been delivered to the rebels long ago by the prime minister!"

Shiji relates:

> *In the seventh month of the second year of the Second Emperor's reign [208 B.C.E.], Li Si was sentenced to undergo the five punishments as well as to die by being cut in two at the waist in the marketplace of Xianyang. [The five punishments consisted of tattooing the face and amputating the ears, nose, fingers, and feet.] While being led out of the prison, he looked at his younger son, who was to die with him, and asked, "Even if you and I were to yearn once more to walk our yellow dog together out of the East Gate of Shangcai in order to chase the wily hare, can we indeed do so?" Whereupon, father and son wept.*
>
> *Their execution was followed by the extermination of Li Si's three sets of relatives [parents, wife and siblings, children].*

Shangcai was Li Si's birthplace in the state of Chu. His last words to his son are often quoted in Chinese literature as a reminder of the preciousness of life and its simple pleasures.

Meanwhile, revolts were springing up all over China. Although the First Emperor had transferred 120,000 of the richest nobles from the six conquered states to Xianyang immediately after unification in 221 B.C.E., many were left behind in their home states. With the abolishment of feudalism, these former nobles no longer enjoyed their hereditary rights or titles. Wanting to restore their previous rank and privilege, they now seized

their opportunity. One after another, ambitious men rose in revolt all over the empire, and the old feudal families reasserted their claims. Able descendants of earlier rulers from the former six states (Yan, Zhao, Qi, Chu, Haan, and Wei) crowned themselves kings, declared their independence, established armies, and sent their troops west against the emperor.

The Second Emperor dispatched troops to suppress the bandits, but like a brush fire, as soon as one was smothered another would spring up. The lesser brigands subordinated themselves to the better-organized armies under capable new leaders such as Xiang Yu and Liu Bang. General Wang Li (Meng Tian's second in command at the Great Wall) lost a crucial battle against the rebel general Xiang Yu and was captured.

Unaware of the smoldering turmoil within his empire, the Second Emperor, after Li Si's death, promoted Zhao Gao to the post of prime minister. All affairs of state were decided by him. He was now so powerful that he began to have designs on becoming the emperor himself. Only one man stood between him and the throne. On September 27 of the third year of the Second Emperor's rule (207 B.C.E.), Zhao Gao decided to test his authority on the ministers to see whether they would yield to him. *Shiji* relates,

> One day Zhao Gao presented a deer to the Second Emperor, all the time pointing to the animal and calling it a horse. The monarch laughed and said, "This is not a horse. It's a deer. Why do you call it a horse?" Zhao Gao repeated that it was a horse. The emperor then turned to ask the ministers around him. Such was the terror instilled by the eunuch that most of those in attendance claimed it to be a horse. Some remained silent, but there were a few who spoke the truth and agreed with the emperor. Later Zhao Gao arranged for all those who called it a deer to be either killed or arraigned.
>
> The emperor thought that he was zi yi wei huo, "suffering from hallucinations." He became alarmed and consulted the grand diviner, who advised him, "Your Majesty has not been sincere enough when carrying out the suburban sacrifices in the ancestral temple during the spring and autumn. Therefore you have come to this. You must fast and purify yourself."

The Second Emperor retired to Shanglin Park to fast but spent his days hunting and enjoying himself. One day a passerby happened to wander into the park, and the emperor accidentally shot him with an arrow

and killed him. Zhao Gao ordered the magistrate of Xianyang, who was his son-in-law Yan Yue, to bring charges. (Since eunuchs were unable to have children, it was common for them to adopt children as their sons and daughters.) Then he admonished the emperor, saying, "The Son of Heaven has killed an innocent man for no reason. Such actions are unacceptable to Heaven. You must go far away and make sacrifices to ward off evil."

The Second Emperor retired in seclusion to Wangyi Palace in the remote countryside.

Three days later Zhao Gao arrested the mother of his son-in-law Yan Yue and kept her under house arrest in his quarters. Holding her hostage, he ordered Yan Yue to lead one thousand troops to the gate of Wangyi Palace.

On arrival, Yan Yue killed the commander of the imperial guards and took charge with his own troops. He and a few chosen men walked into the palace, shooting arrows and brandishing their swords as they went. The astonished eunuchs and women within the palace were paralyzed with fear. Those who put up a fight were killed. Altogether, they murdered thirty to forty people.

Yan Yue entered the emperor's private quarters, kicked open the door, and confronted the Second Emperor. He told the bewildered monarch that rebel forces from the east had arrived in great numbers and then scolded him, saying, "You are arrogant and killed many of your subjects without cause. The whole empire hates you. You should decide for yourself how to handle this."

The Second Emperor said, "Please let me see the prime minister."

"Impossible!" Yan Yue replied.

"Then let me be the king of just one province."

"No!"

"How about allowing me to become a marquis of ten thousand households?"

"You obviously haven't the slightest idea of the position you are in!" Yan Yue said contemptuously, brandishing his sword.

"Let me then become one of the ordinary people along with my wife and children, but please treat me the same as the other princes," the emperor begged.

"You don't seem to understand," Yan Yue said. "I have my orders from the prime minister to punish you for the crimes you have committed against the empire. I have no authority to negotiate with you."

As his men pressed forward, Yan Yue handed the hapless monarch a short dagger and left the room. Coerced from all sides, the Second Emperor slit his own throat.

On hearing of the emperor's death, Zhao Gao hurried over to the Wangyi Palace, took the imperial seals, and hung them on his belt, intending to mount the throne. However, despite their fear, none of the officials would obey him. When he came into the throne room, they looked at him in silence.

Realizing that he faced a palace revolt should he insist on naming himself emperor, Zhao Gao relented and called a meeting. He summoned all the princes and major ministers and said, "I have punished the Second Emperor on behalf of the empire, and he has committed suicide. However, during the time of his rule, the six former states have all declared their independence. Since Qin's territory has diminished greatly and continues to diminish, there is no point in anyone assuming the empty title of emperor. I propose that Prince Zi Ying be set up as King of Qin. Prince Zi Ying is kind and honest, and the people will respect him."

Prince Zi Ying, who was the First Emperor's brother, was considerably older than the Second Emperor. He must have been a man of courage and integrity because *Shiji* relates,

> Prince Zi Ying came forward during the early days of the Second Emperor's rule and protested the impeachment of Meng Tian and Meng Yi.

Zhao Gao buried the Second Emperor according to the rites appropriate for a commoner. He then ordered Zi Ying to fast for five days in his palace before presenting himself at the royal family's ancestral temple to receive the seal of office.

Prince Zi Ying distrusted Zhao Gao. After fasting for five days, he said to his two sons, "I have heard from reliable sources that Zhao Gao has been communicating secretly with Liu Bang, the commander of one of the two major rebel armies. I suspect that he intends to strike a deal with Liu Bang to make him the king instead. Now he wants me to appear at the

ancestral temple. I think he intends to kill me there. If I claim illness and refuse to go, he'll probably come here to try to persuade me. When he does, you must help me kill him."

Sure enough, Zhao Gao sent word to Prince Zi Ying several times to go to the temple, but the prince remained in the palace. Finally, Zhao Gao appeared in person. Prince Zi Ying called for his men, and they stabbed and killed Zhao Gao. He then ordered the execution of Zhao Gao's three sets of relatives as a warning to the people of Xianyang.

Forty-six days after Prince Zi Ying became the King of Qin, the rebel leader Liu Bang, a commoner who had risen from obscurity, was the first to approach Xianyang with his troops. He sent messengers to Zi Ying to persuade him to surrender. Zi Ying tied a silken cord around his neck to indicate his submission (to this day in the Beijing Opera a cord around the neck signifies a prisoner), rode in a plain chariot drawn by four white horses to signify mourning, handed over the seal of office and tiger tallies, and abjectly surrendered to Liu Bang by the side of the road.

The dynasty founded by the First Qin Emperor in 221 B.C.E. was supposed to last for ten thousand generations. In reality, it survived his death by three years and lasted for a total of only fifteen years, coming to an end in 206 B.C.E.

Following the biographies of the First and Second Emperors, the historian Sima Qian wrote in *Shiji*:

> *There is a proverb that says,* qian shi bu wang, hou shi zhi shi, *"use incidents from the past as lessons for the future." A wise ruler carefully observes the past, and analyzes the reasons for each reign's rise and decline, in order to underscore the correct way of governing.*
>
> *Depending on prevailing conditions, adjustments should be made in establishing appropriate policies. If followed, this will lead to long-lasting peace and stability.*

◆

Throughout my career as a physician, I have observed many instances of zhi lu wei ma, *"pointing to a deer and calling it a horse." In boardrooms and at committee meetings, it was not uncommon to observe cowardly physicians cravenly going*

*along with the demands of powerful executives from health maintenance organiza-
tions. Once in the operating theater, I saw a pathologist change his diagnosis in
order to assuage the ego of a megalomaniacal surgeon.*

*It is strange but true that people who start off an enterprise with a lie are invari-
ably forced to resort to bigger lies to safeguard their venture. There are also other
far-reaching consequences. In killing off Meng Tian, not only did the Second
Emperor lose his best general, he also lost the trust of his other generals. In the
end, there was no one capable or willing to defend him.*

*By going along with Zhao Gao, Li Si placed himself in the hands of a Chi-
nese Iago. More significantly, his own deviousness eventually made him loathe
himself. Nominally he was still the prime minister, but he and his coconspirators
knew what he really was. Although he tried to guide the young ruler to the best of
his ability, the Second Emperor viewed Li Si with such contempt toward the end
that he would not even see him. Bound to the other two inextricably and forever
by his crime, Li Si found his life doomed from that moment on, and he died a sad
and broken man.*

Little Sparrow with Dreams of Swans

燕雀擁有鴻鵠志
Yan Que Yong You Hong Hu Zhi

Terra-cotta figure of a kneeling archer,
Qin dynasty, third century B.C.E.

During my years at a Catholic boarding school in Hong Kong, when I was between the ages of eleven and fourteen, no one ever came to visit me and I was not allowed to go home at Christmas or summer holidays. Often I was the only student left behind in the convent, incarcerated like a prisoner and wandering listlessly between the empty refectory and silent school library. The place was like a tomb. The nuns did not know what to do with me. Day after day there was no one to play with and nothing to do.

Aimlessly flipping through magazines at the library one morning, I stumbled upon an advertisement in an English journal announcing a playwriting competition. It was open to all English-speaking students between the ages of ten and nineteen. I was sorely tempted to send in a request for an entry form.

But I did not do so. A part of me thought it presumptuous that I would dare to think of competing against native English speakers. Although I had entered and won a few writing competitions under the tutelage of my primary school teachers back in Shanghai, they were all in Chinese. I thought that my knowledge of English was too elementary and that I had no chance of success.

A few days later I developed pneumonia and was admitted to hospital. After I was released, my stepmother allowed me to go home for a week to recuperate. Because our apartment was small, I was told to sleep on a cot in my grandfather's room.

Neither of us knew it then, but that would be the last time I saw my grandfather. He died a few months later. Perhaps he had a premonition that his days were numbered, because he made a deliberate attempt to boost my morale.

"Be smart!" he told me. "You have your whole life ahead of you. Study hard and be independent. Everything is possible! Don't be married off like your big sister, Lydia. The world is changing. You must rely on yourself. Regardless of what else people may steal from you, they will never be able to take away your knowledge. I have faith in you. Go out there and dare to compete in the most difficult examinations. Create your own destiny. No matter what happens, always remember that my hopes are with you. One day you'll show the world what you are really capable of."

At the end of my week at home, just before Father's chauffeur drove me back to school, Grandfather gave me a large envelope. Impatient to see what was inside, I opened it in the car. I found a rectangular sheet of paper with the proverb yan que yong you hong hu zhi, *"little sparrow with dreams of swans," beautifully scripted in Ye Ye's distinctive calligraphy. It turned out to be his final farewell present.*

Heartened and encouraged, I wrote to the address listed in the English journal on my return to school and entered the competition, dedicating the play to my grandfather. Ye Ye died in March the following year, just three months before I won first prize. This unexpected triumph changed my life because it convinced my father to send me to university in England. More significantly, I began to believe from then on that everything was possible if I tried hard enough.

◆

The belief that all men (women were thought to be second class in those times) are born equal originated in the teachings of Confucius (551-479 B.C.E.). Previous to his time, the king was considered to be the Son of Heaven by virtue of his lineage. He and his relatives were known as *jun zi*, "aristocratic gentlemen," who possessed the exclusive right to rule by virtue of their noble birth. A man who was not of noble birth could never hope to become a *jun zi*, no matter how talented or virtuous.

Confucius came up with the revolutionary notion that any man could become a *jun zi* regardless of his heritage, provided his conduct justified it. No man was to be considered a *jun zi* on birthright alone; this honor could be earned only by his behavior and character. Contrary to traditional feudal beliefs, Confucius taught that the right to rule depended not on blood but upon ability, conduct, and education. In short, any man could properly occupy the throne, provided he was virtuous and just. Rulers were supposed to hold their power only in trust, subject to revocation by Heaven if they did not use it wisely.

It is impossible to overestimate the impact of these Confucian ideas on the history of China. From then on, it became feasible for any man to claim that he had just been given the mandate to rule from Heaven. A few of these claimants happened to possess talent or virtue and eventually did metamorphose into founders of successful dynasties. Unfortunately, many more evolved into unscrupulous leaders of religious cults or power-hungry warlords, all the while making preposterous assertions to attract a following. It was often difficult to distinguish between the two, especially in the early stages.

The leader, often from a humble background, would allege that he was endowed by Heaven with special powers to cure disease, perform miracles, and protect his followers from harm. Viewed with hindsight, these declarations can easily be perceived as ridiculous or even laughable. But when conditions are ripe for change and the man is charismatic, he may become just the spark necessary to ignite the whole country into revolt.

This was what happened one year after the death of the First Emperor. As Sima Qian wrote in *Shiji*,

> *In times of turmoil, there often arose many people who were adept at performing magic tricks, deceitful swindles, insidious flatteries, and winning people over by devious means.*

Other messianic movements that have occurred in later dynasties include
the Taoist Yellow Scarf Society during the Han dynasty, the Wu Dou Mi
Religious Society during the Jin dynasty, the Bai Lian Sect, the Taiping
and Boxer Rebellions during the Qing dynasty, and many others.

Recently, there have been reports of a new Chinese spiritual movement
called Falun Gong, led by a former granary clerk named Li Hongzhi. In
his books, Li asserts that he will implant a wheel in the abdomen of each
of his disciples and that his *fa shun* ("saintly body") will protect his fol-
lowers from harm. He challenges the very etiology of all diseases, denying
even the germ theory in causing infections. He ascribes moral qualities to
inanimate objects such as stone and wood, and speaks of old cultural ruins
bearing relics from eras that existed "hundreds of millions" of years ago.

Regardless of the teaching of Li Hongzhi, the Chinese government
currently views the group as a threat to public order and is attempting to
suppress Li's followers. However, if a government is faced with a potential
David Koresh (leader of the Waco Branch Davidians) or Osama bin Laden,
how should it respond?

The ancient philosopher Han Feizi showed us by his proverb "watch-
ing the tree to catch a hare" that the only thing that does not change is
that everything changes. Perhaps we should learn from him that there are
no universal moral standards. People respond to cult figures differently,
depending on their own cultural background and psychological condi-
tioning, and there is but a fine line between devoted follower and fanati-
cal terrorist.

When the reign of the Second Qin Emperor failed, a revolt was begun
not by princes or military generals but by two penniless peasants.

Chen She and Wu Guang were both farm laborers from the state of
Chu (present-day Henan Province), living in "humble shacks with tiny win-
dows and wattle doors," according to a Han dynasty poet. When Chen was
a teenager, he worked as a hired hand in the fields. *Shiji* states that times
were hard and work was strenuous. One day, while standing on a hillock,
he suddenly stopped plowing and gazed out with a look of profound dis-
gust at the countryside. Then he said to his fellow workers, "If one of us
should become rich and important one day, he must not forget the rest."

His companions laughed and said, "Don't be ridiculous! How can
anyone like us ever become rich and important?"

Sighing deeply, Chen replied, "*Yan que an zhi hong hu zhi,* 'can little sparrows ever truly understand the dreams of swans?'"

More than anything else, sharing a meal together is an important symbol of family unity in China. The day after Bob and I arrived in Hong Kong in September 1990, my brother James invited us to lunch. His other guests were our oldest sister, Lydia, and our older brother, Gregory. Throughout the meal James seemed preoccupied and nervous. He ordered innumerable dishes of dim sum and piled our plates with food while eating next to nothing himself. I began to have a horrible feeling of déjà vu. I was eight years old again. Niang was about to come into the room, and something bad was going to happen to me. I felt my heart racing and my mouth going dry. I tried to reassure myself and said to James, "Things are going to be different from now on; Niang is dead."

James replied coldly, "So she is dead. Why should things be different?"

"I don't know why," I confessed candidly. "But I feel awful right now, just the way I used to feel when we were little and she ruled over us. For some unknown reason, I feel left out!"

James looked down at his plate and said nothing. The mood at the table was more ominous than ever. I clenched my fists under the table, the way I used to do as a child when things were terrible and felt my nails digging into the palm of my hands. To break myself out of my fear, I forced a laugh and announced gaily, "Now that Niang is dead, I'm going to write the books that I've always wanted to write. Remember those occasions in Shanghai when Father and Niang used to travel by themselves to Tianjin on business, James? Sometimes Ye Ye would take us to Do Yuan Gardens for picnics. He'd practice tai chi while you and I would pretend to be characters from my kung fu stories, speaking the lines and acting the parts. Now that I have the urge to write again, perhaps I might even get something published one day if I'm lucky!"

To everyone's amazement, James suddenly snapped out of his reverie and said, almost violently, "You have a perfectly good job as a doctor. Why do you want to give it up and become a writer all of a sudden? Besides, who on earth is going to read your childish kung fu stories at this stage of our lives? I might have enjoyed them when I was twelve and you were nine, but certainly not now. I predict that you'll never find a publisher. Even if you were to spend lots of money and publish your work yourself, nobody is going to read them. If I, as your older brother, am already telling you that I'm not even going to open the cover of any of your books, who else would buy them?"

I stared at his flushed and excited face, knowing that I had upset him in some mysterious way. After a while, I said feebly, "Ah, James! Cannot a yan que yong you hong hu zhi, 'little sparrow have dreams of swans'?"

In the seventh month of the year 209 B.C.E., Chen She and Wu Guang were conscripted and chosen by the military command to lead a group of 900 peasants for garrison duty at the northern frontier. On the way they encountered such terrible weather that the roads became flooded and impassable. The two men said to each other, "We face execution if we arrive late. However, they'll kill us also if we run away and get caught. Since we're going to die either way, why don't we encourage everyone to stick together as a group and die fighting?"

To gain support, they wrote the words *Chen She will be a king* on a piece of silk and stuffed it secretly into the belly of a fish that someone had caught. One of the soldiers bought the fish, cooked it for dinner, and was greatly astonished to find a divine message from Heaven in the fish's belly.

Later that night Wu hid himself under a basket and wailed like a fox, crying, "The Great Kingdom of Chu will rise again, and Chen She will be its king!" Hearing this, the soldiers were alarmed but highly impressed. The next morning they whispered to one another about Chen and pointed him out with awe.

Having laid the groundwork, the duo next plotted to kill the three commanding officers. Wu had always been well liked and popular. He knew that the men would do anything for him. He waited until the officers were drunk, then deliberately provoked them by announcing that he was going to run away.

As expected, the commander sprang up and began to beat him. While doing so, his sword fell out of its scabbard. Wu seized the sword at once and killed the officer. Chen rushed to his aid, and they killed the two other officers as well. They then called a meeting and announced, "Because of bad weather, we will never reach our destination on time. The chances are that they will execute us for being late. However, even if you were spared and actually became a guard at the frontier, we all know that out of ten conscripts, six or seven are bound to die during the course of garrison duty. Now, if you are afraid of death, we have nothing more to say to you. However, if you are brave and wish to take a chance, then we beg you to put your life on the line for the sake of renown and honor instead

of dying for nothing. *Wang hou jiang xiang ning you zhong hu*, 'kings and marquises, prime ministers and generals, such men are made, not born.'"

The men replied in unison, "We will follow you and carry out your wishes."

To promote themselves and gain loyalty from their men, Chen falsely proclaimed that he was really Prince Fu Su and Wu was Xiang Yan (a renowned general from Chu who had died in battle while fighting the First Emperor). They set themselves up as commander and colonel of a new army dedicated to restoring the Great Kingdom of Chu, bared their right arms (by rolling up their right sleeves symbolically to pledge their support), built an altar, offered the commanding officers' heads as a sacrifice, and swore an oath of allegiance to their cause before it.

Because the First Emperor had confiscated all the weaponry in the land and transformed them into the twelve giant decorative metal figures in Xianyang, the rebels were forced to make do with wooden clubs. They cut down trees, made them into weapons, and raised their flags on garden poles made of bamboo. Over the years, the term *jie gan er qi*, "to hoist a bamboo pole as a banner of revolt," which was first coined by Sima Qian in *Shiji*, has become a proverb to describe any popular revolt against tyranny.

The image depicted by this proverb (jie gan er qi) *is that of a knight-errant who rises from the ranks to lead a band of poor and weary peasants in revolt against injustice. In answer to his call, many adherents gather about the rebels, bringing them food and weapons and following them as shadows after a form. The revolutionaries eventually destroy the ruling house and establish a brave new regime.*

More recently in the twentieth century, Sun Yatsen led a popular uprising that deposed the Qing emperor and ended imperial rule in 1911. After Sun's death, Chiang Kai-shek assumed leadership as head of the Nationalist Party. Then in 1949, Mao Tse-tung rose from obscurity, drove out Chiang Kai-shek, and established Communist rule in China. Although a span of 2200 years separated these three men from Chen She, the grassroots movements led by all three have occasionally been described in Chinese history books as jie gan er qi.

During his reign Mao Tse-tung encouraged the Chinese press to equate Chen She's revolt with his own, calling them both large-scale peasant uprisings. "Wherever there is tyranny or oppression," he wrote, "there is opposition. Because of relentless economic exploitation by the landlord class, large numbers of peasants took their bamboo poles and joined the ranks of resistance. The various forces eventually came

together and became a powerful peasant army. Chen She's success and ours both
prove that the people and the people alone are the moving forces of world history."

Within a month, Chen She's original army of 900 had swelled to 20,000
infantry, 600 chariots, and 1000 horsemen. They captured district after dis-
trict on their way north toward the capital. Chen's fame spread through-
out the land. He named himself King of Chu. Ambitious men who had
suffered under the Qin regime saw their opportunity, murdered their
superiors, incited their friends to rebel, and allied themselves with him.
They were welcomed by the people as liberators but soon set themselves
up as kings of the districts under their control. Chen sent various armies to
attack the Qin forces, including one to take over Xianyang, capital of Qin.

The state of Qin was called the Land Within the Passes because it was
surrounded by mountains and rivers and was easily defended. There were
only two approaches, the Wu Pass in the south and the Hangu Pass in the
east.

In no time at all Chen She's men had entered the Hangu Pass and
were threatening the heartland of the Qin empire. The Second Emperor
was greatly alarmed and consulted with his officials, searching desperately
for a plan of action.

The privy treasurer Zhang Han came forward and said, "The rebels
are at our doorstep. There is no time to transfer troops here from the other
districts. Since there are at present over 700,000 convict laborers still
working on the Afang Palace and the First Emperor's tomb at Mount Li,
I suggest that they be pardoned and given arms so that they may protect
Your Majesty's capital from the bandits!" Zhang tactfully did not mention
that there was also a dearth of capable military generals and magistrates
because the best ones, such as Meng Tian and his brother Meng Yi, had already
been executed.

The Second Emperor agreed. He ordered an amnesty, supplied the
exconvicts with arms, and appointed Zhang as their general. With over
700,000 well-armed troops under his command, Treasurer Zhang led an
attack that routed Chen's forces. Meanwhile, Wu, whom Chen had made
his acting king, was murdered by one of his own subordinate generals.

Much of China was aflame. The deposed nobility of the six states now
rose from the villages and byways in response to Chen's call to arms, hop-
ing to restore their previous status. Although Zhang Han was able to defeat

some of Chen's most important generals, he could not be everywhere at the same time.

In the twelfth month of the year 209 B.C.E., barely six months after the start of the uprising, Chen was murdered by his own carriage driver as he fled eastward after the defeat of his main army. But his death did not stop the rebellion in any way. Many others set up revolts of their own, called themselves kings, and dreamed of setting up their own imperial dynasties. Among them were Xiang Yu and Liu Bang.

Although Chen's fame and fortune lasted for barely six months at the end of his life, his name became legendary and his exploits emerged as a major influence after his death. He is now remembered for having led the first peasant uprising in China and for possessing the self-confidence to proclaim early on the democratic belief that kings and generals are made, not born.

Chen's ideas probably arose from the teachings of Confucius. Even as a penniless peasant, Chen had lofty ambition and high aspirations, exemplified by the proverb *yan que yong you hong hu zhi,* "little sparrow with dreams of swans." Confucius taught that rulers should exist only for the welfare of the people. If a ruler abuses his power, then his mandate of Heaven will be withdrawn and given to someone else. During the early twentieth century, Dr. Sun Yatsen's revolutionary party was once described as the Association for Changing the Mandate of Heaven.

Why did a poor peasant like Chen She with hardly any education or military expertise succeed against the same Qin forces that had defeated the armies of all six former states?

Chen's success took place against the backdrop of the heavy taxation and exactions wielded by the Second Emperor. The Qin monarchs never understood that success in conquering a nation does not automatically mean success in ruling that nation. As long as the First Emperor was still alive his government was tolerated and he was personally admired for his many accomplishments. This changed at his death.

Although the Qin officials feared the Second Emperor, they also held him in contempt because of his incompetence, extravagance, and total reliance on Zhao Gao. Circumstances surrounding the suicide of Prince Fu Su were widely perceived as being suspect. All three participants of the plot at Sand Hill had corrupted themselves. In order to silence dissent, they could only resort to terror.

Chen started by fabricating miracles to legitimize himself as a leader. His rebellion was at first directed not at the Second Emperor but only at his own immediate superiors. It proved to be just the catalyst needed to ignite a wholesale uprising. The outcome probably surprised no one more than Chen. Conditions at that time were ripe for mutiny, and his timing could not have been more perfect. Far from being endowed by Heaven, Chen was merely present at the right place, doing the appropriate thing at the correct time.

◆

In his Gettysburg address of 1863, Abraham Lincoln declared that government should be for the people. Over 2000 years before the birth of Lincoln, Confucius was already teaching that the enlightened ruler must serve the needs of the people. "A good government," he declared, "is one that makes the people happy." Like Lincoln, Confucius believed that there were times when force must be used by moral men to prevent the world from being enslaved. In this regard, it is interesting to note that one of Chen She's advisers was a direct male descendant of Confucius.

Confucius's concept that "any man might be a jun zi, *'moral man,' depending on his conduct," is essentially the same as Thomas Jefferson's declaration that "all men are created equal." This was the belief underlying the proverb* yan que yong you hong hu zhi, *"little sparrow with dreams of swans," which prompted Chen She to "hoist the bamboo pole as a banner of revolt." The same notion motivated me into first entering the playwriting competition and then emigrating to America. In this great country founded upon democracy, I was finally given an even chance.*

CHAPTER 11

Destroy the Cooking Cauldrons and Sink the Boats

破釜沉舟

Po Fu Chen Zhou

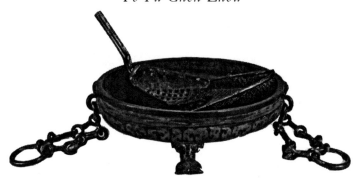

Bronze brazier, charcoal shovel and dustpan,
Warring States period (c. 433 B.C.E.).

*L*ooking back, I see three occasions in my life when my back was against the wall
and I felt compelled to po fu chen zhou, "destroy the cooking cauldrons
and sink the boats," or "make a last, desperate gamble for victory."

The first happened when I was fourteen. After my grandfather died, I was sent
home from boarding school to attend his funeral. Afterward my stepmother, Niang,
called me to the living room. Looking at me with loathing and contempt, she coldly
informed me that I was to leave school at the end of the summer term and get a job
as a secretary.

I was terrified, remembering how Lydia had never finished high school but was
forced into an arranged marriage at the age of seventeen. I knew this was probably
in store for me. I begged to be allowed to go to university like my three older broth-
ers. My parents ignored my request. I became extremely anxious about my future

and spent many sleepless nights gazing at the giant ships dotting the bay of Hong Kong harbor, wondering what was to become of me. I felt that I had arrived at an impasse and needed to make a drastic decision. I remember repeating the proverb po fu chen zhou, *"destroy the cooking cauldrons and sink the boats," over and over as I sat by myself with clenched fists on the balcony of my school dormitory under a dark starry sky. One night I decided to run away. I planned to get enough money somehow for a train ticket to Shanghai, join my aunt, and enter college there.*

Fate intervened in the nick of time. Unknown to me, my name appeared in the newspapers for having won first prize in the playwriting contest I had entered some months previously. Because I had given my father "face" in front of the whole of Hong Kong, he deemed me worthy enough to be sent to university in England despite my stepmother's objections. If I had gone back to Shanghai at fourteen, I probably would have led an entirely different existence in Communist China.

Twelve years later I reached the second landmark in the journey of my life. I was twenty-six and practicing medicine in Hong Kong. My stepmother was still trying to control every aspect of my life, professional as well as personal. It was an impossible situation. I had a feeling of déjà vu, knowing that I had to get away and repeating the proverb po fu chen zhou *every time I wavered. In spite of my parents' refusal to lend me money for a plane ticket, a compassionate American stranger indirectly enabled me to escape to Philadelphia and achieve my American dream.*

The final incident was when I learned I had been unexpectedly disinherited. I could not believe the extent of my stepmother's cruelty, continuing even from beyond the grave. It also devastated me to realize that my brother James and my eldest sister, Lydia, had conspired against me. For a long time I found it difficult to reconcile myself to James's betrayal, hoping against hope that he would come to me with a plausible explanation. I also knew that he did not wish me to write my book.

The yearning for James's approval kept me away from publishers for almost two years. I wrote my brother long letters, hoping for a reply. But he would not answer me. Once we bumped into each other accidentally in a Japanese restaurant in Hong Kong. Throughout our stilted conversation about children and health, the memory of Niang's funeral lay like a monstrous rock between us, slimy and untouchable. He could not wait to get away, while I longed desperately to recapture our childhood harmony.

As he waited for his bill, he asked about my job. "I've been thinking of quitting medical practice," I told him.

"Why? What will you do?"

"Write the book that I've always wanted to write ever since I was a child. The biography of our stepmother, Niang."

He signed the receipt for his lunch and placed his credit card in his wallet. As he rose to go, he said to me in a voice that I had never heard before, "Do that, and I'll sue you!"

A chill went through me. "Sue me? I haven't even begun writing yet . . ." I protested, but he had already left.

That night I had a dream. James and I were children again, playing together in the garden in front of Father's big house in Shanghai. We were burying my pet duckling, PLT, who had just died after being mauled by Father's German shepherd the evening before. James was wearing a white cap and tying a white handkerchief around my hair while telling me that white was the color of mourning. I could smell the sweet scent of magnolia blossoms in the fresh morning air as we dug a big hole under the magnolia tree with all its flowers in bloom. "Go get a milk bottle from the kitchen while I pick some flowers," he was telling me. "Might as well get a rice bowl and put some rice in it. I'm going to dig up a couple of worms and pour in some water. PLT will have a great dinner because that's what she likes to eat. . . ."

I woke up with a jerk, and the wish to please James was stronger than ever. I wanted to write my book, but my big brother would not endorse it. I longed to go to him and say, "If I don't write Niang's story and I continue to work as a doctor in order to please you, will you promise that the real James will come back again, the way he used to be?" Sadly, a part of me knew that the James of my childhood had vanished forever.

Still, I hesitated. A lifetime of trust and dependence on a brother's loyalty was hard to relinquish. Back and forth I vacillated. Then the familiar feeling of "do or die" returned. "Po fu chen zhou!" I told myself. "Po fu chen zhou! 'Destroy the cooking cauldrons and sink the boats!' Time is running out. If you don't write your book now, it will never be written!" I was a solitary little girl again, terrified but determined, hanging on with gritted teeth against all odds. Muttering the proverb over and over, I finally summoned enough courage to hand in my resignation and walk away from my busy medical practice. This was how I began my writing career at the age of fifty-six.

◆

Undoubtedly, there are episodes of *po fu chen zhou* in everyone's life. However, the actual incident of "destroying the cooking cauldrons and sinking the boats" from which the proverb arose was a story first told by Sima Qian. In *Shiji*, the ancient historian described the many brilliant escapades and

ferocious battles fought by the dashing young warrior Xiang Yu. *Po fu chen zhou* was one of the desperate gambles taken by the twenty-five-year-old Xiang Yu during his meteoric rise to becoming the most powerful man in China.

Xiang Yu was descended from a noble family in the state of Chu that had produced many distinguished generals. His grandfather was Xiang Yan, the same legendary commander whose name was falsely assumed by the frontier guard Wu Guang when he revolted. At that time the memory of Xiang Yan was idolized throughout Chu because of his loyalty and bravery during the war of annexation in 223 B.C.E. Refusing to surrender when surrounded by Qin troops, he fought to the bitter end and finally committed suicide on the battlefield rather than be taken prisoner. Members of the Xiang family were already renowned for their military prowess even before Xiang Yan. After many generations of faithful service, the King of Chu had granted them the governance of the city of Xiang. Eventually, the family adopted Xiang as its surname.

When Xiang Yu was a child, his father died and he was brought up by Xiang Liang, the fourth younger brother of his father. The two had a close relationship, and Xiang Yu regarded Xiang Liang as his surrogate father, calling him Fourth Uncle. Xiang Yu was not a good student. Reprimanded by Fourth Uncle, Xiang Yu replied defiantly, "Studying books is merely another term for memorizing names, while learning how to use a sword only enables one to fight against a single enemy. Neither is worthy of my time. What I would like to master is the art of conquering tens of thousands of men." From then on his uncle began teaching Xiang Yu the art of war.

During the First Emperor's last imperial tour, he visited the Wuzhong area (present-day Suzhou, sixty miles west of Shanghai) in Chu. Xiang Yu and his uncle were among the throngs of people watching the spectacle of the grand royal procession. The First Emperor was accompanied by eighty-one teams of horse-drawn carriages, with his own coach positioned in the center. Far from being intimidated, Xiang Yu turned to his uncle and said, "Yes! It is possible to *qu er dai zhi,* 'step into the emperor's shoes and replace him'!" Fourth Uncle hurriedly covered Xiang Yu's mouth and muttered, "Hush! Don't talk nonsense! Rash remarks such as this are going to get us the death penalty—not only for you but for our entire clan!" Although he successfully silenced his nephew, Fourth Uncle secretly marveled at the youngster's ambition and audacity.

Xiang Yu grew to a height of over six feet. Besides being *cai qi guo ren,* "exceptionally quick-witted," he was so strong that he could lift a *ding* (heavy three-legged bronze cauldron) above his head with ease. All the young men of Wuzhong were in awe, and a little afraid, of him. (Ability to lift a *ding* of a certain weight was a measure of a man's strength in ancient China. Recently, a Qin dynasty *ding* made of bronze was unearthed at a burial site. It weighed 467 pounds.) A photo of it was published in the October 2001 issue of *National Geographic* magazine.

After the frontier guards' revolt in the summer of 209 B.C.E., the news spread throughout the empire and the whole of China was aflame. Two months later the governor of the province that included Wuzhong decided to join the revolution. He summoned Fourth Uncle and said, "There have been armed uprisings in many places. It is Heaven's will that the Qin dynasty should fall. I have heard it said that *xian fa zhi ren,* 'he who strikes first will gain control of others,' whereas he who follows will be dominated by others. Therefore I am joining the revolution and hereby appoint you and Huan Chu as my generals." Huan Chu was a condemned rebel warrior who was then in hiding.

Fourth Uncle replied, "The only one who knows the whereabouts of Huan Chu is my nephew Xiang Yu. He is waiting for me outside. Let me go and find him." He went out and instructed Xiang Yu to unsheathe his sword and await his signal. Reentering the governor's headquarters, Fourth Uncle sat down calmly opposite the governor and said, "Your Highness should order Xiang Yu to come in now and go in search of Huan Chu."

The governor summoned Xiang Yu. Almost immediately after his nephew entered the room, Fourth Uncle flashed him the previously arranged go-ahead sign, striking first according to the spirit of the proverb *xian fa zhi ren,* "he who strikes first will gain control of others." Xiang Yu swung his sword and beheaded the governor on the spot with one stroke. Fourth Uncle strode out holding the governor's head aloft in his right hand while wearing the beheaded dignitary's seal of office on his belt. All the officials who saw him were alarmed, and some were angry. Pandemonium broke out, but this was quickly quelled by Xiang Yu, who ruthlessly killed almost one hundred men. Everyone was cowed into silence and groveled on the ground without daring to get up.

Fourth Uncle sent for the army commanders, ministers, and other men of influence whom he had befriended in the past. He informed them

that he was revolting against the Second Emperor and invited them to join him. Soon he had a force of 8000 men with his twenty-four-year-old nephew, Xiang Yu, as second in command. Because the name Xiang was revered throughout Chu, uncle and nephew were soon joined by other rebel armies who subordinated themselves to the pair, including the army under the command of Liu Bang.

Liu Bang was from a peasant family in the district of Pei, a few hundred miles from Wuzhong but still part of the former state of Chu. Born in 257 B.C.E., he was twenty-four years older than Xiang Yu. He had a distinguished appearance with a prominent nose, broad forehead, and luxuriant beard on his cheeks and chin. Legend has it that the first time his future father-in-law set eyes on him, he was so impressed by Liu Bang's physiognomy that he gave him his beloved daughter as his bride.

Huo da da du, "generous and big-hearted," Liu Bang was open-minded and always surrounded by friends. As a young man, he tended to be lazy and *bu shi jia ren sheng chan,* "refused to do the kind of work performed by his father and brothers," such as farming and carpentry. Although he had grand ideas and many interests, he did not know what he really wanted to do. He liked wine and women and, much to his father's despair, lived off his family during his youth and spent much time drinking in wine shops and buying wine on credit. Finally, at the age of thirty, he passed the tests for becoming a government official and was made an administrator, or chief, of a *ting*.

A *ting* was a unit composed of 250 to 500 families, and as chief, Liu Bang was in charge of both military and civil affairs. The laws of Qin were strict, and many people had been arrested for violations. The First Emperor would sentence these convicts to forced labor on his massive building projects. After the First Emperor's death his son, the Second Emperor, continued this policy.

One of Liu Bang's duties as chief was to escort convicts from his *ting* in the district of Pei to the capital city of Xianyang to work on the First Emperor's palaces and tomb. Thus he had ample opportunity to observe the pomp and grandeur surrounding His Majesty. Awed and inspired by the spectacle, he once sighed deeply and muttered, "Ah! This is how a real man should live!"

In the year 209 B.C.E. there was general unrest throughout China and *min bu liao sheng,* "the common people had few means of livelihood." Like everyone else, convicts from the district of Pei were also aware of the many rebellious armies being formed in Chu and other areas. About that time Liu Bang was escorting a levy of convicts from Pei to Mount Li to work on the First Emperor's tomb. Under Qin law, Liu Bang as chief was person-ally responsible for each prisoner and would receive severe punishment if anyone escaped.

No sooner did they start off on their long, arduous journey than many of the convicts ran away to enlist in the rebel armies. As Liu Bang watched his prisoners disappear one by one, he became increasingly alarmed. There was the very real possibility that by the time he reached his destination he would be the only one left. Not knowing how to face the consequences, he made a drastic decision. At the next rest stop he treated his men to wine and drank with them deep into the night. Then he released them and said, "Gentlemen, you are free to leave and go wherever you wish. Since I've already lost so many prisoners, I can no longer go home. I have no choice but to set you all free and become a fugitive myself, just like you."

Most of the men walked off, but ten of the strongest convicts decided to follow him. Together they hid from the authorities in the mountain bush and marshes. More and more joined them protesting the oppressive taxes, harsh laws, and forced labor. Soon Liu Bang's band numbered sev-eral hundred.

At that time ambitious men throughout China were murdering the ruling Qin officials, calling men to arms, and establishing themselves as warlords. Many of the scattered feudal nobility of the six former states were also lying in wait to restore their previous status. In the ninth month of 209 B.C.E. the magistrate of the district of Pei (Liu Bang's hometown) decided to rebel. He dispatched Fan Kuai, a powerfully built butcher who was Liu Bang's brother-in-law, to find Liu Bang. After Butcher Fan's departure, the magistrate had a change of heart. Fearing retribution from the authorities, he locked the city gates, posted soldiers on the city walls, and decided to execute his fellow plotters.

Liu Bang returned to the city of Pei with his brother-in-law and other followers, but they were denied entry. He therefore wrote a message on a piece of silk, tied it to an arrow, and shot it over the wall. Addressing the

city elders, many of whom he knew personally, he urged them to lead the city's people into rebellion against the Second Emperor, execute the magistrate, and make common cause with former nobles such as Xiang Liang and Xiang Yu. "Otherwise," he warned, "you run the risk of being slaughtered yourselves when noble rebels like the Xiang family take over the city. Do not allow this to happen!"

The elders took his advice and killed the magistrate. They opened the gates, admitted Liu Bang, and nominated him Lord of Pei.

But Liu Bang demurred and said, "At present, All Under Heaven is in disorder. The former nobles from the six conquered states have risen in arms. Should you select someone who is not capable, you will be *yi bai tu di,* 'smeared to the ground after a single defeat'! This matter is of vital import. Instead of choosing me, perhaps you should select a more capable man."

However, many feared retaliation from the Second Emperor and refused to be considered. After due deliberation, everyone was still in favor of Liu Bang. Although he refused several more times, no one else was willing to step forward. Thus a common man from peasant stock assumed leadership by popular vote in 209 B.C.E. and became Lord of Pei at the age of forty-eight.

When the deaths of the two foremost revolutionaries of the day, Chen She and Wu Guang, became known throughout China, the warriors Xiang Liang and his nephew Xiang Yu called a meeting of the various insurgent leaders. The Xiangs wished to formulate a comprehensive strategy to defeat the mighty Qin army, which had been placed under the capable command of the former privy treasurer Zhang Han.

By that time the Qin empire was crumbling. Nobles, scholar-officials, and generals from the old ruling families of the six former states were variously establishing themselves as local warlords or kings, each with his own army. Although the First Emperor had abolished all noble titles in 221 B.C.E., the old aristocracies remained behind the scenes, still retaining much of their prestige. The Xiangs themselves owed their early success to their family's reputation, which brought them many recruits.

A Confucian scholar and strategist named Fan Zeng (Old Man Fan), who was then in his seventies, came forward and said to the Xiangs, "Although Chen She was called the Father of the Revolution, he was bound to fail. Instead of naming the legitimate heir of the previous rul-

ing family as King of Chu, he named himself. Ever since the last King of Chu was taken into captivity by Qin's First Emperor, the people of Chu have mourned him. It has been said, *Chu sui san hu, wang Qin bi Chu,* 'even if there are but three families left in Chu, the Qin empire will be toppled by someone from Chu.' The reason for the various generals placing themselves under your command is precisely because of your family's traditional loyalty toward the House of Chu. To earn the respect of All Under Heaven, I think it imperative that you place the rightful Chu heir back on the throne and serve under him."

The proverb Chu sui san hu, wang Qin bi Chu, "even if there are but three families left in Chu, the Qin empire will be toppled by someone from Chu," was frequently quoted in newspapers as a rallying cry during the Japanese occupation of China, 1937–1945. When I was a little girl in Shanghai, our history teacher told us the story of Old Man Fan and made us copy the proverb twenty times in our exercise book, telling us that there were many implications to the proverb.

During the Vietnam War, Ho Chi Minh asked for military aid from the People's Republic of China. In one of the discussions between the two parties, Ho Chi Minh, who was well versed in the Chinese language, was said to have quoted the proverb and greatly impressed the Chinese. Subsequently, China did supply aid to Vietnam.

The Xiangs agreed. Following an extensive search, they succeeded in finding a scion from the ancient House of Chu. The grandson of the last King of Chu had become a shepherd after unification and was herding sheep for a living. The Xiangs placed him on the throne as King of Chu and titular head of all the revolutionary forces, thus legitimizing their uprising. More and more rebels joined them, including the army of Liu Bang, Lord of Pei.

Fourth Uncle Xiang Liang placed the main army under his own command and attacked the major Qin forces under the direction of Treasurer Zhang Han. Initially, Xiang's revolutionary army inflicted a series of defeats on the Qin army. Flushed with victory and holding the enemy in contempt, Fourth Uncle dispatched his nephew Xiang Yu with a division of soldiers to assist Liu Bang in recapturing the city of Feng. Meanwhile, the Second Emperor sent fresh troops and reinforcements to Treasurer Zhang.

The momentum suddenly changed. Replenished with troops and supplies, Zhang now succeeded in completely surrounding the revolutionary army. With Xiang Yu and Liu Bang away in Feng, Fourth Uncle was caught shorthanded and unprepared. Despite a valiant effort, his army suffered a resounding defeat and Fourth Uncle himself was killed on the battlefield in October 208 B.C.E.

Hearing the devastating news, Xiang Yu and Liu Bang withdrew to the Chu city of Pengcheng to mourn the death of their commander and plan their next move. Fourth Uncle's loss was a tremendous blow, and they were both deeply depressed. To boost their morale, the recently enthroned King of Chu made a covenant with the two men. He promised that the one who would first enter and capture the capital city of Xianyang would be named king of the Land Within the Passes. This area, known nowadays as Shaanxi Province, is surrounded by mountains and the Yellow River. Within this natural fortress was the rich and fertile Wei River Valley as well as the great city of Xianyang.

Having inflicted this major defeat on the Chu army and killed their supreme commander, Treasurer Zhang Han decided to focus his attention elsewhere because rebellion had flared up throughout the whole of China. He led his force of 300,000 men north into present-day Hebei Province against the King of Zhao, who had recently declared independence and joined the rebellion. After routing the Zhao army and forcing the King of Zhao into withdrawing to the city of Julu, Zhang ordered his assistant, Deputy General Wang Li, to surround and besiege the city. This was the same Wang Li who witnessed Prince Fu Su's suicide and was second in command to Meng Tian at the Great Wall two years earlier.

The besieged King of Zhao sent emissaries far and wide to the other states requesting rescue. The King of Chu decided to divide the Chu army into two divisions, a minor and a major. Liu Bang was sent west with the minor division of 3000 men to take the capital city of Xianyang, whereas Xiang Yu was sent north across the Yellow River with the major division to relieve the siege of Julu and fight the main Qin army.

Xiang Yu had initially requested to head the Western Expedition in place of Liu Bang, but the older Chu ministers advised the King of Chu against him. They said, "Xiang Yu is young, hot tempered, impetuous, and ruthless. He destroys and kills wherever he goes. Let us instead send someone who is older, wiser, and known for his generosity and kindness. Who-

ever takes Xianyang will have to deal with the thorny issue of Zhao Gao and the Second Emperor. It is better to conquer by winning the hearts and minds of the people than by the sword."

The King of Chu, therefore, flattered Xiang Yu by telling him that he was the only warrior capable of challenging the might of the main Qin army under Zhang Han. Eager to avenge the death of his beloved Fourth Uncle, Xiang Yu finally agreed to serve as second in command under Commandant Song Yi, who was named head of the Northern Expedition.

When the troops arrived at the bank of the Yellow River, Commandant Song halted the advance and adopted a wait-and-see attitude. Chafing at the delay, Xiang Yu repeatedly urged Commandant Song to launch an attack, but his requests were ignored. Finally, after forty-five days, he confronted Commandant Song and criticized him to his face for cowardice.

But Commandant Song replied, "I have my reasons for waiting. *Yu bang xiang zheng, yu wung de li,* 'while the snipe and mussel were fighting each other, the fisherman captured them both.' You may be braver at physical combat, but I am definitely the wiser at military strategy." He then pointedly gave the order that those insubordinate officers who were fierce as tigers, greedy as wolves, stubborn as goats, and disobedient to orders from their superiors be immediately beheaded. This threat was obviously directed at Xiang Yu.

It was the eleventh month of the year 208 B.C.E. Winter arrived with a vengeance, and the weather suddenly turned frosty with an icy rain. The soldiers were cold and hungry. Meanwhile, General Song gave a big dinner party to celebrate his son's appointment as prime minister of the state of Qi (present-day Shandong Province).

There was general discontent among the troops, and morale was low. Seizing this opportunity, Xiang Yu said to the officers, "Commandant Song is wining and dining his son while our soldiers get only taro and beans to feed their hunger. There is very little food left. Our men are freezing. Their padded winter uniforms have not yet arrived since no one anticipated this delay. Why is Commandant Song waiting and not leading our men across the river to take on the enemy? He claims that the Qin army will be worn out by the prolonged siege. In actuality, Qin is so strong that it will be even more powerful after swallowing Zhao. What weakness is he talking about? Meanwhile, our own King of Chu is so nervous that he is *zuo bu an xi,* 'hardly able to sit with ease on his mat.' His Majesty has

entrusted his best troops to us, but Commandant Song is more concerned with entertaining his son than with fighting the war. His actions are not those of a great leader. *Cheng bai zai ci yi ju,* 'my next move will determine success or failure of our entire enterprise.' The safety or collapse of Chu depends on it."

Early next morning, Xiang Yu requested a private interview. Face-to-face with Commandant Song in his tent, Xiang Yu calmly unsheathed his sword and cut off Song's head. He then declared to the army, "Commandant Song was planning to rebel against Chu, and His Majesty the King of Chu ordered me to execute him."

The officers concurred that Xiang Yu should be the acting commander in chief. After capturing and executing Commandant Song's son for good measure, Xiang Yu sent news of his deeds to the King of Chu. The latter had no choice but to confirm Xiang Yu's appointment as commander in chief of all the allied armies that had joined together to topple the Qin Empire.

Now Xiang Yu concentrated his attention on the relief of the city of Julu. First he ordered that the army should take along only three days' food rations. He knew that this was a defining moment and a case of do or die. In order to avenge the death of Fourth Uncle, he was prepared to sacrifice his own life. After crossing the river, he *po fu chen zhou,* "destroyed the cooking cauldrons and sank the boats." He notified his men that they were at a point of no return. It was a case of victory or starvation. To emphasize his determination, he burned the tents and camping equipment as well, demonstrating once and for all that there was absolutely no possibility of turning back.

Although the Qin army outnumbered them ten to one, Xiang Yu bravely met them head-on. Altogether nine engagements were fought. The Chu army was finally able to cut off Qin's supply route. Along with Xiang Yu's fearlessness, determination, and inspired leadership on the battlefield, this move struck a mortal blow and resulted in a resounding victory for the intrepid young warrior. Many Qin officers were killed, and some committed suicide. Deputy General Wang Li was taken prisoner. His capture was particularly sweet for Xiang Yu because his grandfather had committed suicide on the battlefield after being defeated by Wang Li's grandfather years earlier.

At that time various revolutionary armies from the other six former states had also responded to the cry for help from the besieged King of Zhao. Although they were all encamped in strategic strongholds on the outskirts of Julu, no one had dared to challenge the mighty Qin army. When Xiang Yu gave the order to his own troops to attack, officers from the other armies were reduced to *zuo bi shang guan,* "watching the action from the safety of their tents." They saw the valor of Xiang Yu's soldiers with their own eyes and heard their resounding cries of battle echoing to the skies. Despite being greatly outnumbered, *yi yi dang shi,* "every Chu soldier was equal to ten of the enemy." Seeing this, the onlookers could not help but be impressed and a little fearful.

After his victory, Xiang Yu summoned the nobles commanding the assorted armies from different states for a meeting in his tent. When he entered, one and all fell to their knees and approached him kneeling. No one dared raise his head to look him directly in the eye. They were in awe of him and ashamed of their own cowardice. At that instant Xiang Yu's reputation soared and he became the commander in chief of all the revolutionary armies in fact as well as in name.

Losing this battle broke the backbone and will of the Qin army. Commander Zhang Han retreated with the remnants of his troops, totaling about 200,000 men, and entrenched himself closer to the capital. There was a temporary lull in the war as Xiang Yu pondered his next move.

The Second Emperor heard the news of Zhang Han's defeat and sent a letter to reprimand him. Alarmed, Zhang dispatched his second in command, Sima Xin, as his emissary to explain the circumstances. Back at the capital, Sima Xin sent in his request for an audience with the monarch, but neither the Second Emperor nor the prime minister, Zhao Gao, would see him. After cooling his heels outside the palace gates for three days without a response, Sima Xin became suspicious. Suddenly fearful for his life, he beat a hasty retreat back to his army camp and took an alternate route as extra precaution. Sure enough, Zhao Gao sent his men to arrest him after he learned of his abrupt departure, but they failed to catch him.

Back at the camp, he said to his commanding officer, Zhang Han, "Zhao Gao has assumed total control. None of the ministers has any say whatsoever. If you should win the war, Zhao Gao is bound to be jealous and cause you trouble. And if you should lose, I'm afraid he'll probably

have you executed as well. After my recent experience at the capital, I hope that you'll weigh your options very carefully."

Meanwhile, Zhang Han received a letter from Scholar-General Chen Yu, one of the two commanding generals of the previously besieged Zhao army, advising him to defect and surrender to Xiang Yu. Reminding him of the tragic fate of General Meng Tian, who died an unjust death despite rendering a lifetime of valuable service to the First Emperor, Chen Yu continued in his letter,

> You have served the Second Emperor faithfully for almost three years. In spite of your efforts, noble warriors from different states are banding together in increasing numbers to fight against Qin. Your army has already suffered substantial losses. Everyone realizes that the political situation at the Qin court is precarious. Zhao Gao himself must be fearful that the Second Emperor might suddenly turn against him. Hence it is likely that Zhao Gao will blame you for losing the war and have you executed to save himself. Because of your military duties, you have been away from court for a long time. I'm sure there are those in the palace who are jealous. I can only conclude that you will be executed if you win the war. Unfortunately, you will also be executed if you lose the war. Besides, anyone can see that it is Heaven's will that the Qin dynasty will soon end.
>
> Why not change sides and unite with all the other noble warriors? Instead of fighting each other, we could band together and destroy Qin, divide her vast territory, and nan mian cheng gu, "become rulers of separate kingdoms ourselves."

When he read Chen Yu's letter, Zhang Han was sorely tempted. He sent a junior officer to Xiang Yu's camp, but in the midst of discussions, Xiang Yu suddenly launched a full-scale attack, which routed the Qin forces. After this second defeat, Zhang Han felt he had no choice but to make an unconditional surrender.

Since Xiang Yu happened to be short of food at that moment, he agreed to an immediate cessation of hostilities. The two commanding officers met, and Zhang Han wept as he related his woes at the hands of Zhao Gao. Xiang Yu comforted him, conferred upon him the title of King of Yong, and incorporated the 200,000 newly surrendered Qin soldiers into his own army as a vanguard force to spearhead the march toward the capital.

Within a few days however, Xiang Yu was already receiving reports of general discontent and complaints of discrimination among Zhang Han's rank and file. The majority of the surrendered Qin soldiers had been recruited originally from areas in and around Xianyang, whereas the rest of Xiang Yu's army consisted of troops from Chu and other states. Previous to the uprising, many non-Qin soldiers had suffered harsh treatment from Qin functionaries when they were forced to pass through or work in the capital. Now they took their revenge and treated the surrendered Qin troops like slaves, bullying and insulting them at will. The Qin soldiers whispered to each other, "Our commanding officer Zhang Han first tricked us into surrendering and then betrayed us. Who needs this type of treatment? If we lose the next battle against our former comrades, Xiang Yu is bound to retreat. Instead of going home, we would be marching eastward to his state of Chu. If this happens, the Second Emperor and the eunuch Zhao Gao will probably execute our parents, wives, and children back home."

When their complaints were reported to Xiang Yu, he became concerned and said to his subordinates, "Two hundred thousand is a large number, and these soldiers will be more and more difficult to control. If they are already dissatisfied at this early stage, their resentment will only grow once we enter the passes and approach their homeland. It's probably wiser to kill them right now. And only allow Zhang Han and his two chief assistant generals to accompany us into the capital."

Xiang Yu's orders were carried out in the middle of the night. Caught by surprise, the entire surrendered Qin army of 200,000 soldiers was executed without a fight in one day.

Xiang Yu and his main army of 400,000 soldiers continued westward and reached the Hangu Pass. They found the gates closed and entry denied. To their amazement, they learned that the guards were not from Qin and did not belong to the Second Emperor. Xiang Yu's ally, Liu Bang, Lord of Pei, had already entered the capital of Xiangyang, and those were Liu Bang's troops patrolling the pass and refusing them passage.

Enraged, Xiang Yu ordered his men to attack and storm the Hangu Pass. Having overpowered the small sentinel force, they entered and made camp at a place called Hongmen (Wild Goose Gate), twenty miles east of the capital, not far from the First Emperor's tomb.

The last time Xiang Yu had seen Liu Bang was one year earlier when the latter had been dispatched by the King of Chu to go west and capture

the capital city of Xiangyang. At that time Xiang Yu remembered that Liu Bang had been provided with only 3000 soldiers and was many miles away. "How is it possible," Xiang Yu asked himself, "that Liu Bang could have moved so fast and conquered so much territory with so few soldiers in such a short time?"

As he was mulling over this, Old Man Fan entered. This old scholar had been much valued by Fourth Uncle Xiang Liang before his death. Xiang Yu also respected him and called him *ya fu*, Second Father.

"There is a soldier here sent secretly to us by someone called Cao, who is an officer in Liu Bang's army," Old Man Fan reported. "He claims that Liu Bang has ambitions of being King of the Land Within the Passes. The Second Emperor and Zhao Gao are both dead. A member of Qin's royal family called Zi Ying is now King of Qin, and Liu Bang is planning to appoint Zi Ying as prime minister in his new cabinet. Liu Bang has already confiscated all the jewels and other treasures from the Qin palaces."

"The bastard!" Xiang Yu cried. "Alert the troops and give them a feast tonight! First thing tomorrow we launch a full-scale attack and get rid of Liu Bang!"

Old Man Fan concurred. He said, "In the old days, Liu Bang used to be greedy for money and beautiful women. I hear that his behavior has changed radically since he conquered the capital city. He is no longer avaricious and does not consort with pretty girls anymore. His new behavior shows that he has lofty ambitions and big plans. You must destroy him before he becomes too dangerous!"

◆

Throughout China's history, the days immediately following the death of an emperor were often a "time of crisis," especially if his successor was believed to be weak and indecisive. The word crisis *is translated as* wei ji *in Chinese.* Wei *means danger, and* ji *means opportunity. The proverb* wei ji si fu *means "beset with danger and opportunity on every side." At no time was this truer than in China immediately following the death of Mao Tse-tung on September 9, 1976.*

The year 1976 was probably the most eventful during the twenty-seven years of Mao's rule. Premier Zhou Enlai had died in January, followed by the downfall and exile of his protégé Deng Xiaoping. To everyone's surprise, Mao had appointed Hua Guofeng, a benign and obscure functionary from Mao's home state of Hunan,

as his premier and official successor in April. Finally, Mao had died three months later at the age of 83.

At that time, the power structure was divided among three groups, each with its own agenda. Mao's widow, Jiang Qing, and her three collaborators, collectively nicknamed the Gang of Four, had risen to power because of the Cultural Revolution and were therefore anxious to continue that movement.

The veteran cadres, led by Deng Xiaoping, were elderly revolutionaries who had struggled alongside Mao and helped him drive out Chiang Kai-shek in 1949. They had been Mao's main targets of attack and had suffered the most during the Cultural Revolution. As a consequence, they hated the movement, viewing it as madness.

The third group, headed by Mao's handpicked successor Hua Guofeng, had risen to power during the Cultural Revolution. Although tied politically to that movement, they tended to side with the veterans but wished to remain neutral.

In the tradition of the proverb yi zi qian jing, "one written word is worth a thousand pieces of gold," the struggle for power between the three groups distilled down ultimately to two words in Mao's last statement.

The Gang of Four claimed that Mao had given them the instruction that future policies must an zhi ding fang zhen ban, "abide by fixed principles." But Hua Guofeng insisted that he had in his possession Mao's written statement that future policies must an guo qu fang zhen ban, "abide by past principles."

To all three groups, fixed principles meant that the campaigns to criticize the veteran cadres were to continue indefinitely, whereas past principles meant that the campaigns could now be modified or even eliminated. After all, Mao himself had rehabilitated many of the veteran revolutionaries from time to time in the past.

The veterans approached Hua on several occasions to enlist his support for eliminating the Gang of Four, but Hua initially refused to commit himself. One week after Mao's death, however, Hua read in the People's Daily *on September 16 that Mao had issued the statement "future policies must abide by fixed principles." Hua confronted Jiang Qing and a quarrel ensued.*

On September 19, Jiang Qing made a formal request to be the official guardian of her late husband's papers and books. Cognizant of the crucial impact of the dead Mao's every written word and fearing forgery, Hua refused. Jiang Qing protested vigorously, but Hua replied that all of Mao's papers were now the Party's exclusive property.

In early October, Hua again came across the "erroneous version" of Mao's last edict (containing the words fixed principles) while reviewing a speech to be read at the United Nations General Assembly. No sooner did he delete the two words

than they resurfaced for the third time two days later. On October 4, Hua read an article in the Guanming Daily asserting that certain revisionist capitalists were distorting Mao's fixed principles and betraying the dead chairman's vision of continuous revolution.

Now thoroughly alarmed and fearing for his own safety, Hua finally decided to po fu chen zhou, "destroy the cauldrons and sink the boats" and cast his lot with the veteran cadres. Acting in unison, they arrested the Gang of Four on October 6. When news of their detention leaked out, 1,500,000 people demonstrated in Beijing in support of their downfall. At her trial, Jiang Qing claimed that she was only following orders. "I was merely Mao's dog," she pleaded. "He told me to bite, and I obeyed."

Two years later, Deng Xiaoping assumed leadership and Hua was gradually eased into retirement. Jiang Qing committed suicide while imprisoned. Although a time span of 2200 years separated the deaths of the First Emperor and Mao Tsetung, both the eunuch Zhao Gao and Mao's widow, Jiang Qing, believed that the possessor of the dead ruler's last edict would be vested with the "mandate of Heaven" to rule over China.

This Young Man Is Worth Educating

孺子可教

Ru Zi Ke Jiao

Liu Bang, who established the Han dynasty,
which lasted some four hundred years.

*W*hile growing up in Shanghai, I was constantly being told that boys were cleverer than girls and therefore deserved to be better educated. Since my three brothers were all older and bigger, I never dared challenge this assumption. However, fate intervened one day.

One Chinese New Year when I was seven, my siblings and I were each given a stick of candied crabapples as a special treat after dinner. Bright red, glossy, and stuffed

with walnuts and sweet bean paste, these crabapples were delicious and much loved by us children. As usual, my brother Edgar wolfed his down and started eyeing mine. Soon he moved closer and grabbed for my stick. I made a clean getaway, and as he came after me, the two of us crashed into a tray of dirty dishes, breaking them all. Father, who was in the living room next door entertaining important guests, heard the commotion. He came into the dining room in a fury and glared at the two of us. After telling us to be quiet, he handed us a book of Chinese poetry that he had just received from his visitors. Our punishment was to copy the poem on the first page, learn it by heart, and write it again from memory. Until we could do this to the satisfaction of Grandfather Ye Ye, we were forbidden to talk or play with anyone. As we went sheepishly upstairs, Father added, "Let's see who can finish first!"

There were only four lines of poetry, but I did not know many of the characters, let alone their meaning. I thought that Edgar, who was four years older, would be able to dash off the assignment in no time at all. I watched him copying the words onto a sheet of paper and disappearing into his room without a word.

Laboriously, I began my task, slowly writing one word at a time. Tears came to my eyes. I thought that I would be studying this poem forever.

Then Ye Ye said, "You will learn much faster if you find out the meaning of these words and how to pronounce them. Use your dictionary."

Even today, after so many years have passed, I still remember that poem. A younger brother was being persecuted by his older brother and pleading for his life. He was ordered to come up with a poem that would explain his predicament in the time it took him to take seven steps. Otherwise he would be executed. This was what he composed:

> Pea-stalks were kindled for cooking peas
> The pods in the cauldron began to plead
> "We both sprang from the selfsame root
> Why torment each other and be so mean?"

I remember searching for the unfamiliar words in my dictionary and writing them down methodically in my notebook ten times, the way Teacher Lin taught me to do at school. It took a while but became easier and easier. The lines even rhymed with one another! Soon I ran into my grandfather's room and wrote the poem from memory, word for word, in front of his eyes.

When Father came upstairs not long afterward, Ye Ye proudly showed him my finished assignment. Neither of them called for Edgar, who never emerged from his

room again that evening. I could see from Father's rueful expression that he was pleased with me but disappointed that his daughter had won over his son. "That Edgar!" he muttered. "He just doesn't apply himself!" Then he told me to run downstairs and play with James. As I left the room, I heard him say to Ye Ye, apropos of Edgar, "Ru zi nan jiao! 'This young man will be difficult to educate!'"

I did not know it then, but this incident was to become an important milestone in my life. From that moment on, I started believing that a girl could be as clever as a boy if she tried hard enough, even if he were bigger and stronger.

◆

The emphasis on learning has become ingrained in the consciousness of the Chinese people for a very long time. It is interesting to note that over 2100 years ago, the Grand Historian Sima Qian was already stressing the role of scholarship. In *Shiji* he tells the compelling story of two of Liu Bang's most astute advisers, Mad Master and Zhang Liang. Their scholarship and education were to play pivotal roles in the career of their master, Liu Bang, and in affecting the course of history in China.

Mad Master was an old man who lived in the suburb of a major city called Chenliu (present-day Kaifeng city in Henan Province). Although his real name was Li Shichi, everyone knew him by his nickname, which was Kuang Sheng, or Mad Master. Known for his scholarship and intelligence, he spent his time writing and reading the classics. In spite of this, no official dared employ him because of his rudeness, independence, and tactlessness. Deferring to the proverbial thin line between madness and genius, they respected his erudition but left him alone. He liked to drink and would make bombastic and insensitive remarks when under the influence. Because of this, he had fallen on hard times and was reduced to working as a watchman at the city gates.

In the second month of the year 207 B.C.E., Liu Bang had reached the outskirts of Chenliu on his westward trek. Recognizing the city's importance and its unique location, he made camp a little way outside to study the terrain.

Mad Master had a friend from his home village who worked as a cavalry officer in Liu Bang's army. While billeted nearby, the officer came home to visit his relatives. Mad Master approached him and asked for an introduction to Liu Bang. "Many nobles and generals have passed through this

area," he said, "but the way I see it, Liu Bang is the best of them all and has the brightest future. Put in a good word for me and tell him that I'm coming to visit him at his camp."

"Whatever you do," the officer warned, "don't call yourself a Confucian scholar in front of Liu Bang. I once saw him remove the headgear from a Confucian scholar's head and piss in it. He thinks all Confucian scholars are useless!"

A few evenings later Mad Master appeared at Liu Bang's camp. Even though he had been forewarned, Mad Master dressed in his Confucian costume just to be contrary. At the door he greeted the guard and requested an audience with Liu Bang.

Inside his tent Liu Bang was lying on his bed and relaxing, with two maids washing his feet in preparation for bed. He asked the guard, "Who is it?"

The guard replied, "Looks like a Confucian scholar. He's dressed in the full regalia of Confucian robe and hat."

Liu Bang was less than impressed. "Go tell him that I have no time to chat with scholars. I'm too busy handling important affairs of state."

When the guard related Liu Bang's message, Mad Master became angry. Placing his right hand on the handle of his sword as if to unsheathe the blade, he glared at the guard and shouted, "Get back in there and tell His Lordship that I'm not a Confucian scholar but a lover of wine!"

The guard rushed back and reported to Liu Bang, "The visitor is a warrior."

Having overheard the commotion outside, Liu Bang wiped his feet, picked up his spear, and said, "Bring him in!"

Mad Master swaggered in, raised his folded hands up and down in greeting, but did not prostrate himself. Then he asked, "Is it Your Lordship's intention to help Qin defeat the revolutionary army, or is it to help the revolutionary army defeat Qin?"

Liu Bang was annoyed and said, "What a stupid question! All Under Heaven have suffered for far too long under Qin's inhuman regime. That is why the nobles from the six other states have united and formed the revolutionary army against Qin. How can you ask whether I wish to help Qin?"

Mad Master replied without fear, "Since it is your intention to defeat Qin and perform great deeds, then you must not *yi mu pi xiang*, 'judge my

ability by my appearance.' If you persist in doing so, you might miss meeting some truly talented people. The way I see it, you are not as intelligent as I nor as brave. You would also have made a big mistake this evening if you had not seen me. Besides, is it fitting for Your Lordship to be behaving so disrespectfully when interviewing someone so much older than you?"

Hearing this, Liu Bang rose, dismissed the maids, wiped his feet thoroughly, begged Mad Master's pardon several times, and invited him to sit in the place of honor at the head of the table. He ordered food and wine, and the two men conversed deep into the night.

Mad Master began by analyzing the strengths and weaknesses of the two warring parties. "At present, Your Lordship has a force of fewer than 10,000 men. Though called an army, it really consists of stragglers from other armies and *wu he zhi zhong,* 'an assortment of rough and untrained ruffians.' The eunuch Zhao Gao has selected Qin's best troops to defend the capital city, professional soldiers who are disciplined and well armed. If you should attempt to dash into the pass now with your unruly mob, it will be akin to *zi tou hu kou,* 'voluntarily stepping into the tiger's mouth.'

"What you need is a safe and secure base from which to plan your maneuvers and train your forces. The city of Chenliu will be ideal for these purposes. Because of its strategic location, it is one of the best hub cities under Heaven. *Si tong ba da,* 'Many highways radiate from it in every direction,' linking all parts of the empire. In addition, the city is rich with a huge depository of grain and other essentials.

"We are lucky because I'm acquainted with the mayor of Chenliu. If you wish, I can try to persuade him to surrender to you. Should he refuse, then I suggest that we take the city by force. With your soldiers attacking from outside and me influencing the city gatekeepers from within, we should be able to take the city without any problem."

Liu Bang was bowled over. He agreed and immediately dispatched Mad Master to Chenliu with a few soldiers. However, the mayor of Chenliu refused to turn against the Qin government. No matter how hard Mad Master tried, the mayor would not change his mind. Mad Master felt he had no choice but to adopt Plan B and take the city by force.

Following Mad Master's plan to the letter, Liu Bang was able to take possession of the hub city of Chenliu and its rich stores of grain without losing a single soldier or even shooting one arrow. For this, Liu Bang

rewarded Mad Master with the title of *guang yeh jun* (baronet of territorial enlargement). He also sent for Mad Master's younger brother to come to Chenliu and appointed him as officer in charge of defense of this newly acquired city.

After replenishing his provisions, Liu Bang continued westward from Chenliu. He fought and won a few minor skirmishes against Qin forces along the way, taking some cities and enlarging his force by incorporating stragglers from other armies. In the third month of 207 B.C.E., Liu Bang was proceeding cautiously in the direction of the capital when he was hailed on the road by his great friend, the brilliant military strategist Zhang Liang.

Military strategists were scholars who specialized in advising rulers on the planning and conduct of war. Their role is similar to that provided nowadays by the secretary of defense and political scientists in think tanks. Because the Chinese revere their ancestors and venerate intelligence, stories of battles won as a result of ploys devised by clever strategists are much appreciated. Some tales become immortalized into folklore and are passed from generation to generation for thousands of years.

Zhang Liang was descended from a renowned and learned family in the state of Haan. His father and grandfather had both been prime ministers, having served continuously under five generations of Haan monarchs. Before Haan was annexed by Qin, Zhang's aristocratic family used to own three hundred slaves.

In 218 B.C.E., as we have seen, he tried to assassinate the First Emperor by hurling a specially designed metal cone at the royal coach. When his missile *wu zhong fu che,* "accidentally struck the wrong vehicle," Zhang Liang escaped to Chu and became a fugitive. Knowing that there was a price on his head, Zhang Liang changed his name and hid in a small remote village. There he lived quietly and anonymously for the next ten years.

One day he went for a walk and passed a bridge. While he was standing there, an old man dressed in a short jacket made of rough cloth sauntered by, deliberately dropped his shoe below, then turned and said to Zhang Liang, "Young man! Go down and get my shoe for me!"

Surprised, Zhang Liang was at first tempted to give the oldster a beating. But seeing that the man was old and feeble, he restrained himself, went below, and retrieved the shoe.

The old man now extended his foot and said, "Put it on for me." Since he had already taken the trouble to reclaim the shoe, Zhang Liang thought he might as well help him put it on. So he knelt on the ground and put on his shoe for him. The old man smiled at him and left.

Wondering if he had been recognized, Zhang Liang suddenly felt afraid and anxiously eyed the stranger. Then the old man turned back and muttered, almost to himself, "*Ru zi ke jiao!* 'This boy is worth teaching!' Meet me here early in the morning five days from now." Zhang Liang knelt and said, "I will."

Five days later Zhang Liang came in the early morning and found the old man already on the bridge waiting for him. The old man scolded him for being late and told Zhang Liang to meet him again five days later.

As soon as the cock crowed this second time, Zhang Liang sprang out of bed and rushed to the bridge. Again the old man was already waiting. He reprimanded Zhang Liang again and told him to return five days later.

This time Zhang Liang was up and standing on the bridge shortly before midnight. A little while later the old man arrived. He smiled and said, "That's the way you should behave!" Then he took out a book, gave it to him, and said, "If you study this book carefully, you will one day become the teacher of kings. I predict that in ten years' time there will be radical changes and you will find the material here very useful."

The next morning Zhang Liang examined the book. It was titled *The Art of War*, by Tai Gong. This book is now lost. Zhang Liang was delighted with his gift and considered it a rare treasure. Over the years he read the book over and over and was able to impart much of its wisdom to Liu Bang when the two met.

Liu Bang and Zhang Liang first met in February 208 B.C.E., two years after the death of the First Emperor. Although he had a frail physique and was frequently ill, Zhang Liang finally felt secure enough to emerge from his self-imposed exile. He gathered about a hundred followers and was wandering around in search of a king to whom he could attach himself when he met Liu Bang by chance while he was passing through the city of Pei.

The two became friends, and Zhang Liang imparted to Liu Bang much of what he had learned from the old man's book. Meanwhile, Liu Bang became increasingly impressed by Zhang Liang's incisive mind and broad vision.

Perhaps because of his heritage, Zhang was determined to restore the monarchy in his native state of Haan. So he left Liu Bang and spent the next year living a hand-to-mouth existence while fighting a guerrilla war. No sooner did he take a city than the Qin forces would retrieve it a few weeks later.

When Zhang Liang heard that Liu Bang was in the area and had just taken the nearby city of Chenliu, he went to congratulate him. The two friends met again in May 207 B.C.E. and decided to join forces. With Zhang Liang planning the strategy and Liu Bang making overall decisions, they thought they would make a good team.

Almost immediately they won a major victory against the Qin general Yang Xiong, routing him and sending him fleeing. The Second Emperor was so irate that he sent a special messenger to behead Yang Xiong as an example to others. This did not endear the monarch to the other generals in the Qin army.

Following this breakthrough, Liu Bang conquered more than ten cities with ease and seized the entire former state of Haan for Zhang Liang. The two friends established the ancient capital of Haan as their base of operations and left the newly installed King Cheng of Haan in charge. After that Zhang accompanied Liu Bang, and the duo continued westward toward Xianyang.

In August 207 B.C.E. Liu Bang reached the city of Wan (present-day Nanyang in Henan Province). He saw the sturdy ramparts and row upon row of archers standing in position with their crossbows above the city walls. Recognizing that the city was well defended, he bypassed Wan and had moved some miles west of the city when Zhang Liang said to him, "Your Lordship is naturally anxious to be the first to enter the pass and take the capital. But we must be aware that Qin's strongest defensive force is still ahead, holding the most strategic positions. Now that we have bypassed the city of Wan, what if the army of Wan should follow and attack from the back while we are fighting the Second Emperor's troops in front? Would that not make us highly vulnerable? This is a dangerous policy."

Liu Bang agreed. The two friends conferred and drew up a plan. They waited till nightfall then returned to Wan quietly by an alternate route. Liu Bang ordered that all the flags and banners be rolled up and the horses' tongues be tied so that they would not neigh. As a final precau-

tion, he issued small sticks for the soldiers to bite between their teeth so that they would not converse with each other.

When dawn broke Liu Bang's soldiers had surrounded Wan and stood three deep in the early morning silence. The chief administrator of Wan took one look over the wall and wanted to slit his own throat. But one of his retainers, named Chen Hui, said to him, "You have a lot of time to cut your throat if that's what you want to do. But why be in such a hurry? Please allow me to speak to Liu Bang first."

Retainer Chen climbed over the wall and was admitted into Liu Bang's tent. "I have heard that Your Lordship has made a covenant with Xiang Yu that the man who first enters the capital city of Xianyang will be made king of the Land Within the Passes," Chen began. "But at present Your Lordship is detained here in Wan and unable to move on. Everyone in Wan believes that you will kill us if we surrender. That is why we are mounting such a strong defense. If you decide to attack us it will doubtless take you many days and delay you further. The battle will also inflict heavy casualties on both sides.

"Should you abandon the siege and bypass us, our troops will probably pursue you and attack you from the back. Thus you run the risk of losing the covenant by attacking us, but you run the risk of an assault from the back if you bypass us.

"From your vantage point, there is nothing better than accepting a conditional surrender from us. Appoint our chief administrator as an official in your new government, elevate his status and grant him a noble title, order him to go on defending the city of Wan, and take some of his troops into your army.

"When the other cities hear of this, they will bend themselves backward to open their gates and welcome you. From then on, Your Lordship will have *tong xing wu zhu,* 'free passage without hindrance,' all the way to the capital." Liu Bang was pleased and replied, "Excellent!"

Toward the beginning of September 207 B.C.E., the two parties signed an agreement. Liu Bang accepted the formal surrender of Wan, conferred on the administrator the noble title of marquis of Yin, and rewarded the retainer Chen with an income of one thousand households. After that all cities yielded to him.

Discipline in Liu Bang's army was strict. His soldiers were orderly and polite. Pillage and plunder were forbidden. As a result the people were

delighted with him. More and more rebelled against Qin to follow him. His army swelled to 100,000 men as he climbed the mountains surrounding the capital city of Xianyang.

Instead of approaching Xianyang from the heavily guarded Hangu Pass, Liu Bang avoided it altogether and took the southern Wu Pass instead. By then he was impatient. He wanted to attack the defensive forces head-on and take the pass by storm. But strategist Zhang Liang restrained him.

"Never underestimate your enemy!" Zhang Liang advised. "The Qin forces are still strong. However, I have heard that the local commander is the son of a butcher. Coming from that type of family, he probably has a tradesman's mentality and may be susceptible to bribery.

"I suggest that Your Lordship send some men to the highest mountaintop. Put up as many flags as possible with your name, Liu Bang, prominently displayed so as to be visible for miles around. This way, the enemy will believe that there are enormous numbers of troops awaiting them. Meanwhile, send Mad Master to meet with the Qin commander. Order him to wag his *san cun bu lan zhi she*, 'three inches of immortal tongue,' and lure the Qin generals to surrender with promises of gain."

The Qin generals proved amenable to Mad Master's "immortal tongue," but Zhang now said, "This just means that the top generals wish to rebel. Their juniors may not follow. However, it proves that they are not motivated to fight and are off their guard. We must attack right now and finish them off."

Liu Bang therefore made a surprise attack and routed the Qin troops completely. He then entered the Land Within the Passes. The prime minister, Zhao Gao, became fearful. He had the Second Emperor murdered and sent a messenger to Liu Bang suggesting that they divide the kingdom of Qin between them. But Liu Bang distrusted the eunuch and would not consent. The eunuch then, as we have seen, set up an uncle of the Second Emperor, Zi Ying, as King of Qin but was himself murdered.

After a series of further defeats, King Zi Ying surrendered to Liu Bang. Some of Liu Bang's followers wanted to execute King Zi Ying. His brother-in-law and bodyguard, the powerfully built former butcher, Fan Kuai, whipped out his sword and begged for permission to behead Zi Ying on the spot. But Liu Bang said, "His Majesty, the King of Chu, selected me to come west and capture the capital city for one reason and one reason only. He had heard of my reputation for generosity and kindness. Besides, when

a man has made an unconditional surrender and thrown himself at our mercy, it is neither right nor auspicious to execute him." So he turned to the terrified Zi Ying lying prostrate at his feet and proclaimed, "Your life and the life of your family will be spared. The past is past. My officials will protect you."

Liu Bang continued west and finally entered Xianyang in triumph. It was an exhilarating moment. To the peasant leader, the capital city was both familiar and strange. As chief of a *ting,* he used to escort conscripts occasionally from Pei to work on the palaces and tomb of the First Emperor. In those days, while not working, he would stay at minor hostels and frequent cheap wineshops. Sometimes he caught a glimpse of the First Emperor's imperial carriage, surrounded by pomp and circumstance. As an ordinary man, however, he had no chance of ever speaking to the emperor or visiting any of his palaces.

Now, in front of his eyes, lay the splendid sight of the greatest city under Heaven: two hundred and seventy magnificent palaces, gardens extending for miles and miles, massive highways lined by trees, all at his mercy and under his command.

Xianyang, striding both banks of the River Wei, was China's largest city as well as its financial and political center. The First Emperor had conscripted the most skillful workers from all over China to build a model city that was unparalleled in its grandeur, beauty, and orderliness. Waste-water, for instance, was carried away by two separate waterways: one above ground and one underground. Spanning the Wei River and connecting the two banks was a massive stone bridge sixty feet wide and a thousand feet long, probably the longest bridge existing at that time anywhere in the world.

He drove to the emperor's main palace and visited all the rooms, store-houses, and treasuries and could hardly believe what he was seeing. The throne room alone could seat 10,000 people. The main door of the palace was made of magnetic stone so as to prevent hidden metal weapons from being smuggled in. Outside the massive doors were colorful black and white flags fluttering on poles fifty feet high, each scripted with the word *Qin.* Leading away from the palace was a long, covered walkway that extended all the way to the top of South Mountain. Twelve colossal metal figures were lined up like monster toy soldiers in the garden, each weighing over a quarter of a million pounds. Inside the rooms of the palace were

jade and pearl ornaments, drums made of alligator skins, gold and silver containers, coral bowls, and beautiful embroidered silks.

Among the rarities was a tall lamp made of blue jade. It was six feet high and sculpted in the shape of five coiled dragons covered by scales, each holding a light in its mouth. When lit, the scales quivered from the heat. The dragons appeared to come alive, spitting fire from their mouths and filling the room with luminous light.

In another room he found twelve men made of bronze sitting on a mat. They were about two feet high, dressed in brightly colored silk robes, and each held a lute or a reed organ. Below the mat were two bronze pipes that ran beneath each figure and protruded behind the mat several feet into the air. One pipe was empty while the other contained a rope the size of a finger. Two men were needed to operate the "orchestra," with one blowing into the empty pipe and the other making knots with the rope. When they did so, the group of little bronze figures would make music and play together like real musicians.

He also came across a jade flute about two feet long containing six holes. When the flute was blown, Liu Bang saw a succession of carriages, horses, and miscellaneous exotic animals rushing past mountains, forests, and other beautiful scenery.

Liu Bang was, of course, thrilled by all this. He was especially enraptured with the thousands of beautiful women, all of them alluring and eager to please. For someone of his peasant background, this was heady stuff. He decided to stay and rest for a few days.

But his bodyguard and brother-in-law, Fan Kuai, objected. "Is Your Lordship interested in being ruler of the entire country or merely becoming a rich warlord of Xianyang?" Fan asked.

"My goal is to reunite all the states and become their overall ruler, of course. You know the answer! Why do you ask?"

"We have seen wondrous sights today," Fan said, "marvelous objects surpassing belief and beautiful women lovely to behold. The Second Emperor had them all. Look how long he lasted! We still have much to accomplish. I beg Your Lordship to return to camp and not linger here."

"Has my wife been telling you to spy on me again?" Liu Bang grumbled good-naturedly. "She and that wife of yours are always telling me what to do. I've never seen a pair of sisters more alike. Nag! Nag! Nag!"

But strategist Zhang Liang overheard and said, "Your Lordship is here today because of the Second Emperor's tyranny. During his rule he lived in wanton luxury while the people suffered. Show the world that you are different. Cleanse out all the previous rottenness. Live modestly! Keep in mind the following maxims: *Zhong yan ni er li yu xing,* 'loyal advice that sounds unpleasant must still be followed.' *Liang yao ku ko li yu bing,* 'effective medicine that tastes bitter must still be swallowed.' I beg Your Lordship to heed Fan's words."

Liu Bang acquiesced and sealed all the treasures. Before returning to camp he allowed Administrator Xiao He to gather all the charts, maps, registers, documents, and other important writings. From these he learned the terrain of the country, the records of harvests and famines, the sites of granaries, and the people's complaints.

A few days later he summoned the most distinguished elders from Xianyang and the surrounding provinces and respectfully said to them, "Fathers and elders, you have long suffered from the cruel laws of Qin. Those of you who dared to criticize the Qin government used to be executed with their entire families. Even talking in pairs was considered a crime and could result in public execution in the marketplace. We revolutionaries have made a covenant among ourselves that whoever enters first through the passes will be king of the Land Within the Passes (Guanzhong). Therefore, as King of Guanzhong, I wish to come to an agreement with you regarding my new code: *yue fa san zhang,* 'a code that consists of only three laws':

First, a man who murders another will receive the death penalty.
Second, a man who harms, robs, or steals will be punished according to his crime.
Third and last, all the other laws of Qin are hereby repealed.

As long as you follow my code, you will be undisturbed and live in peace. Fathers and elders, be not afraid! We have not come here to exploit or tyrannize you but to deliver you from harm. Now that Qin is no more, we await the noble warrior Xiang Yu and others so that we can make an agreement with them."

Then Liu Bang sent messengers to accompany the former Qin officials to the districts, cities, and hamlets to make his code known to everyone. The people were pleased and vied with one another to bring cattle, sheep,

wine, and food for the enjoyment of the soldiers. But Liu Bang would not accept and said, "We refuse to be a burden to you. Besides, the granaries are full. Our soldiers lack nothing."

His popularity soared. The people now feared only that he would not be king.

It is amazing that a man like Liu Bang, who came from a lower-class background and maintained the habits and behavior of a peasant, should have succeeded in capturing the people's imagination in such a short time. By all accounts he was lazy and feckless as a young man. Even when he became chief of a *ting,* he was always squatting on the mat like a peasant, something considered undignified by nobles. His language was uncouth. Scholars and officials alike looked down upon him. With the exception of Zhang Liang, all his followers were commoners, mostly from his hometown of Pei.

However, unlike the other warlords, he cared about the grievances of the common people and had a genuine desire to help them. They, in turn, felt understood and were attracted to him. His aptitude in recognizing talent, his willingness to accept advice from all sorts of people, and his ability to make quick decisions were all powerful assets. He knew by instinct that good publicity was vital and often sent emissaries in advance of his troops to announce his virtuous intentions.

Despite his peasant background, or perhaps because of it, Liu Bang became the emblem of a just and benevolent ruler. He was widely perceived by the people as someone who would exercise power for the benefit of the masses. He made them feel that he was one of them and that if given the authority to govern, he would do so not in his own interest alone, like all the previous monarchs, but in their common interest instead.

◆

Unlike the two warlords Xiang Yu and Liu Bang, who were born three hundred years after him, an impoverished aristocrat named Confucius (551–479 B.C.E.) had conquered the Chinese people in another way: through education. He formed the first private school for higher learning in China and set out to develop his students' intellect, cultivate their morals, and discipline their minds. Ever since then,

the Chinese have revered scholarship and education. One of the highest compliments that can be paid to a young man is to quote him the proverb ru zi ke jiao, "this young man is worth educating."

Although Mao Tse-tung identified himself with the First Emperor during the last two decades of his life, his background was actually similar to that of Liu Bang. Mao's father was a peasant from Hunan Province who through thrift and hard work was able to acquire three acres of land. The old man was autocratic, badly educated, bigoted, and mean. Mao set out to be different. He was an excellent student and an avid reader, but his father took him out of school at thirteen and turned him into a laborer. After two years he ran away from home and enrolled at another school against his father's wishes. At the age of twenty he entered the Hunan First Normal School and studied there for five years to become a schoolteacher. By the time Mao graduated at the age of twenty-five, he was well versed in modern European thought as well as classical Chinese literature. He traveled to Beijing and worked as an assistant librarian at Beijing University before returning to Hunan as a primary school teacher. He continued to read widely, including translations of Marxist texts, and began to contribute articles to various local publications. His essays and poetry were widely admired, and his name began to be known. He became a political activist and introduced the groundbreaking concept that impoverished peasants (rather than urban proletariats) should be the backbone of the Chinese Communist revolution.

Like Liu Bang, he led his peasant army into the mountain wilderness, escaping from the Nationalists and the Japanese. He forbade his soldiers to steal food or even a single needle from the people. He became known as a soldier-poet, waging guerrilla warfare and tending a farm during the day and reading and writing at night.

When I was a young medical student in London in the early 1960s, I had a Chinese friend from Shanghai named H. H. Tien who was a postgraduate student in mathematics at Imperial College. H. H. worshiped Mao, and we used to have long discussions about Communist China. I remember him telling me one day that Mao's talents were already evident even as a young boy. While Mao was still a teenager, a family who lived nearby insisted on giving him their eighteen-year-old daughter as his bride because they considered him to be ru zi ke jiao, "a young man full of promise." Mao was reluctant because the girl was four years older but finally went through with it. The marriage was never consummated, and Mao eventually rejected her and married his professor's daughter.

Filled with idealism and high hopes, H. H. left England in 1962 and went back to China to work for Mao. I never heard from him again. Years later we heard that he had been persecuted and imprisoned during the Cultural Revolution. Far from finding a heroic knight-errant at the helm of China, H. H. was horrified to discover that the ru zi ke jiao, *"young man full of promise," called Mao Tse-tung had turned into the cruelest despot in Chinese history. Depressed and disillusioned, my friend H. H. committed suicide in 1967.*

CHAPTER 13

Banquet at Wild Goose Gate

鴻門宴

Hong Men Yan

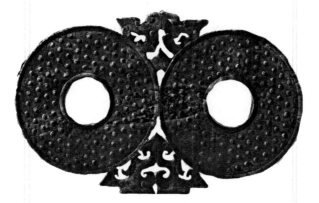

Jade double-*bi* disk with spiral design,
Western Han dynasty, second century B.C.E.

*S*ince the publication of my autobiography, I have been asked over and over again, "What is the response of your family to your book? Are you still in touch with any of your siblings?"

I encountered tremendous difficulty initially in getting my book published. After a series of rejection letters, my manuscript was finally placed in the hands of Susan Watt, considered by many the best editor in London. To my surprise and delight, Susan asked to see me in her office.

Our meeting was brief but to the point. Susan said, "Your manuscript is too long, but I like your story. Shorten it by 100,000 words." Then she added, "I know

it must have taken great courage to write this book. You know, don't you, that your family is not going to be happy."

After a year of extensive deletions and painful rewrites, Susan did accept the book for publication. She had been correct in every aspect. The original manuscript was too long, and some of my relatives have never forgiven me for revealing the truth about my Chinese family.

The book was published in London in 1997. Even today, I am seized from time to time by an urge to phone my brother James—not to talk about anything important or profound, but to share those childhood impressions floating randomly like leaves on a wintry Shanghai afternoon, dredged from our common past by the fragrance of a magnolia blossom, the pungent flavor of vinegar and ginger coating the claw of a Shanghai crab, or the familiar, plaintive cries of street vendors overheard in old Chinese movies. At such moments, I long to pick up the phone and say to James, "Do you remember eating those warm sweet potatoes Aunt Baba used to buy from street vendors around New Year's, or the delicious smell of chestnuts being sautéed in giant woks over hot coals on Avenue Joffre?"

One morning not long ago in Hong Kong, Bob and I met Uncle Hui, an old family friend. Over lunch, I mentioned to him my wish to contact James.

"Don't bother!" Uncle Hui said. "He will never forgive you for writing Falling Leaves.*"*

"But why? All I did was to write the truth."

"Precisely! Now everyone knows! Some of your siblings feel that you have made them lose face in front of the whole world. Not many Chinese are willing to write the truth about their parents. Don't you realize how vital the concept of face is in the Chinese psyche? To your family members, what you did was almost sacrilegious! Have you heard of the story of hong men yan, *'the banquet at Wild Goose Gate'? The entire history of China was altered because of the concept of face at a singular moment 2200 years ago. Not much has changed. Face is as important now as it was then!"*

◆

In January 206 B.C.E. both Xiang Yu and Liu Bang were encamped outside the capital city, Xianyang. Xiang Yu was at Hongmen (Wild Goose Gate) and Liu Bang at Bashang, about nine miles away. Xiang Yu's army totaled 400,000 men, whereas Liu Bang had only 100,000, a ratio of four to one.

Xiang Yu decided to destroy Liu Bang after the latter's troops refused him entry into the Hangu Pass. He and his chief adviser, Old Man Fan, called a meeting to discuss plans for an all-out attack on Liu Bang's army, scheduled for the next morning. Among those present was one man who felt deeply torn at the turn of events.

The man's name was Xiang Bo. He was Xiang Yu's youngest uncle, and he held the position of deputy prime minister in Xiang Yu's army. In his wild youth, Xiang Bo was often in trouble with the Qin authorities and once killed a man. Someone introduced him to Zhang Liang, later to become Liu Bang's strategist, who at great risk to himself sheltered him for many years. While in hiding, the two became close.

When the meeting ended, Xiang Bo mounted his horse and galloped in the night to Liu Bang's camp. There he saw Zhang Liang and warned him of next morning's impending battle.

"Come with me!" Xiang Bo advised. "You saved my life when I was in dire peril. Now it is my turn to do the same for you. The matter is urgent. There is no need for you to perish with Liu Bang in tomorrow's bloodbath. You must come with me now!" He then related to Zhang Liang all the facts.

But Zhang Liang said, "His Lordship and I have made a pact to help each other achieve one another's dreams. Now that he is in mortal danger, it would be dishonorable of me to abandon him. I must inform him and hear what he has to say. Please wait here."

Zhang Liang went to Liu Bang's tent and told him the news. Liu Bang was terrified and said, "I listened to bad advice and refused Xiang Yu entry, thinking that he would honor the covenant and recognize me as king of the Land Within the Passes because I reached Xianyang first. Obviously I was wrong and have now offended him. What should I do?"

"Does your Lordship think that your army can match up with that of Xiang Yu?"

Liu Bang replied glumly, "Of course not. And so, what do I do now?"

"Then it is urgent that Your Lordship speak to Xiang Bo yourself. Tell him that you had no intention of offending his nephew Xiang Yu. Explain to him specifically your reasons for what took place at Hangu Pass. That is a key issue and a very sore point with him."

Liu Bang nodded, deep in thought. Then he suddenly asked, "How long have you known Xiang Bo?"

"For years and years! Your Lordship need have no fear on that score. Yes! I know him well. In those days I was in hiding myself for trying to assassinate the First Emperor. Xiang Bo came to me in great peril, having killed a man. I gave him shelter and we became friends. That's why he rushed over tonight to warn me."

"Who is older, you or Xiang Bo?"

"He is a few years older. Why do you ask?"

"Please invite him to my tent. I shall treat him with the same courtesy as if he were my older brother."

Zhang Liang returned with Xiang Bo. Liu Bang ordered wine and greeted his visitor with the utmost respect. Using special wine cups made of ox horn reserved for the most important guests, he repeatedly drank to Xiang Bo's health. As the wine loosened their tongues and washed away their inhibitions, the two got along so well that they soon contracted their children to each other in marriage.

Then Liu Bang said, "Ever since I entered the pass, I have *qiu hau wu fan,* 'not disturbed the finest downy hair' or 'trespassed against the people to the slightest extent' (*qiu hou* means 'autumn hair' or 'newly grown down'— something so small as to be almost invisible). Neither have I confiscated anything for my personal use. Instead, I made a registry of all the household names and sealed up the treasuries and depositories in preparation for your nephew's arrival. The reason I sent troops to guard the passes was only to prevent the entrance of bandits and other criminals. Day and night I have been waiting for Xiang Yu. I would never have dared to betray him.

"I beg you to go back to your nephew and make clear to him that I had no intention of offending His Highness."

Xiang Bo nodded but advised, "Tomorrow you must go in person first thing in the morning to make your own apology to Xiang Yu."

Xiang Bo rushed back to camp and told Xiang Yu all that Liu Bang had said. Seeing that Xiang Yu was wavering, he took the opportunity to add, "If Liu Bang had not crushed the Qin troops in the first place and smoothed your way, how could you, sir, have entered the pass so easily? Besides, when a man has done you a great service, it is not honorable to attack him. Since you are allies pursuing the same cause, why don't you befriend him instead?"

Xiang Yu indicated that he would do so.

All through the night, Liu Bang sent his spies to monitor troop movements in Xiang Yu's camp. When he learned that all was quiet, Liu Bang rode in his chariot to see Xiang Yu at Hongmen the next morning. He took with him his strategist, Zhang Liang, his brother-in-law and bodyguard, the former butcher Fan Kuai, and just over a hundred cavalrymen. They were all aware that their very survival depended on the outcome of this visit.

Face-to-face with Xiang Yu alone in his tent, Liu Bang began by making his apologies. Then he said, "General Xiang, you and I made a pact one year ago to combine our efforts to defeat Qin. You were responsible for fighting the enemy to the north of the Yellow River and I to the south. I myself never dreamed that I would be so lucky as to be the first to enter the pass and to have the honor of welcoming Your Highness today. Unfortunately, some small-minded people have made certain remarks that have estranged us from each other."

Xiang Yu replied, "This misunderstanding arose because of words said to me by someone from your own camp, Officer Cao. Otherwise, why should I have been angry with you? Since this matter has now been resolved and my uncle Xiang Bo tells me Cao was lying, let me invite you to a banquet that I have arranged on your behalf."

They sat at a round table in the banquet hall with Xiang Yu and his uncle Xiang Bo facing east, Liu Bang facing north, Old Man Fan facing south, and the strategist Zhang Liang facing west. They drank a few toasts to one another, but the mood was guarded.

Seizing the moment, Old Man Fan threw several pointed glances at Xiang Yu. When the young warrior did not respond, Old Man Fan raised his jade *jue* three times as an urgent signal that this was the time to kill Liu Bang. (A *jue* is a bracelet-sized jade ring with one end open, an ornament worn on a belt in ancient China. The character *jue* resembles and sounds like two other characters pronounced in the same way. One means "to resolve or decide"; the other means "expertise" or "to bid farewell." By raising his *jue,* Old Man Fan was telling Xiang Yu, "Be resolute and use your sword to kill Liu Bang, thereby getting rid of him forever.")

Xiang Yu, however, would not respond and simply went on eating and drinking. Exasperated, Old Man Fan rose and went outside. He summoned Xiang Zhuang, the youthful first cousin of Xiang Yu, and said to him, "Our leader, Xiang Yu, is too softhearted to kill Liu Bang, but it is

imperative that he does so right away. I suggest that you go in now. First pour some wine and drink to Liu Bang's health. Then offer to perform a sword dance. While dancing, approach Liu Bang and kill him. Otherwise, I'm afraid we'll all end up as his captives one day."

Cousin Zhuang did as he was told. After greeting Liu Bang and drinking a toast to his health, he turned to Xiang Yu and said, "In our camp, we have nothing to entertain important guests such as those visiting us today. I beg for permission to perform a sword dance."

Permission being granted, Cousin Zhuang drew his sword and began to dance. Grasping his intentions, Uncle Xiang Bo rose from the table, drew his sword also, and began to accompany his nephew in the dance. The two men danced at cross purposes, but each time Cousin Zhuang thrust his sword in the direction of Liu Bang, Uncle Xiang Bo would make a counter move and shield Liu Bang with his own body.

Increasingly nervous, Strategist Zhang Liang left the room and hurried outside to look for Liu Bang's bodyguard, the powerfully built mountain of a man, the former butcher Fan Kuai.

"How are things progressing at the banquet?" Fan Kuai asked.

Drawing him aside, Zhang Liang whispered softly, "Not good at all. In fact, our situation is desperate. *Xiang Zhuang wu jian, yi zai Pei Gong:* 'While Xiang Zhuang ostensibly performs a sword dance, his real intention is to kill Liu Bang, Lord of Pei.'" (We'll return to this proverb at the end of this story.)

Fan Kuai immediately picked up his sword and shield and strode briskly toward the banquet hall. Two guards at the door crossed their spears and refused him entry. Fan Kuai leaned his muscular body against the guards, toppled them to the ground, and forced his way in. He raised the flaps of the inner tent and appeared suddenly at the entrance: a massive hunk of a man with his hair standing on end and his eyes practically popping out of their sockets, as if he could *mu zi jin lie,* "split the corners of his own eyes wide open with the blazing anger in his gaze." Without uttering a word, he glared at Xiang Yu. The music and sword dancing stopped.

Placing one hand on his sword, Xiang Yu half rose and demanded in alarm, "Who are you? What are you doing here?"

Zhang Liang, who had followed Fan Kuai into the hall, said, "He is His Lordship Liu Bang's bodyguard. His name is Fan Kuai."

Xiang Yu eyed Fan Kuai's impressive physique with admiration and exclaimed, "What a fine specimen of a man! Get the big warrior a liter of wine!"

They brought him wine, and Fan Kuai knelt briefly in acknowledgment. Then he stood up and drank the wine in one gulp.

Xiang Yu then said, "Now get him a shoulder of pork!"

They handed him a huge joint of freshly roasted pork. Using his shield as a temporary plate, Fan Kuai placed the meat on it, cut off pieces with his sword, and devoured the whole lot.

Amused by the spectacle, Xiang Yu asked, "Big Warrior! Can you drink more wine?"

Fan Kuai suddenly shouted, "Your humble servant is not even afraid of death, so what is a cup of wine to him? Let me remind you instead of the Second Emperor, who had a heart as cruel as a tiger and as rapacious as a wolf. However many people he executed, it was never enough. Finally, All Under Heaven rose up against him. The King of Chu made a covenant with the revolutionary generals: that he who entered first would be king of the Land Within the Passes. Our Lord Liu Bang entered first. Because of you, he has not touched a single object in any of the palaces. He also sealed the treasuries and moved out of Xianyang to await your arrival. The reason he guarded the passes with troops was to prevent the entrance of bandits and criminals. Despite all this, not only have you not rewarded him with a noble title, you have listened to the gossip of small-minded people and are even thinking of killing him. This type of conduct is a continuation of that which destroyed Qin. Your Highness should not behave thus!"

There was a brief silence. Xiang Yu kept a blank expression on his face and merely said, "Be seated."

Fan Kuai took the seat next to Zhang Liang. After a while, Liu Bang left to go to the toilet and beckoned Fan Kuai to follow him. Outside, they were joined by Zhang Liang.

Liu Bang said, "I should leave right away. However, I have not said good-bye to Xiang Yu."

Fan Kuai replied, "Major undertakings should never be hindered by minor scruples. When you are under such peril, why worry about something as trivial as bidding your host farewell? At present, *ren wei dao zu, wo wei yu rou*, they are like 'the knife and chopping board,' whereas we are

'fish and meat about to be minced.' When your very life is at stake, why bother to say good-bye at all?"

Liu Bang agreed. Before going, he ordered Zhang Liang to stay behind and render thanks on his behalf. He said, "I've brought gifts, but seeing that they are unhappy with me, I have not dared present them. Will you please do so for me?"

Zhang Liang said, "Of course!"

In order to escape as fast and far as possible, Liu Bang did not summon his chariot driver or cavalry escort but simply mounted a horse, accompanied by Fan Kuai and three other trusted aides who followed on foot with their swords and armor. Instead of following the major highway, they decided to take a shortcut at the foot of Mount Li. Before galloping off, Liu Bang said to Zhang Liang, "Since we're taking the shortcut, our camp is only five or six miles from here. Don't be in a hurry to return to the banquet. Tarry awhile. Wait until you think we're safely back. Only then should you speak to Xiang Yu."

Zhang Liang waited for a good long while before going back to Xiang Yu, saying, "His Lordship Liu Bang has a very limited capacity for wine. Hence he was not able to bid you farewell in person. He wishes to render his apologies and has asked me to present to Your Highness this pair of white *bi* [a round flat piece of jade with a hole in its center]. He is also presenting General Fan Zheng (Old Man Fan) with this pair of jade wine cups."

Xiang Yu asked, "Where is Liu Bang?"

Zhang Liang replied, "His Lordship Liu Bang thinks that you are displeased with him and may reprimand him. Hence he left by himself and is probably back at his camp by now."

Xiang Yu accepted the jade *bi*s and placed them at his side. But Old Man Fan took the cups and angrily threw them on the ground. Then he drew his sword and slashed them to pieces. In an agitated voice he shouted, "Useless younger generation! You are unworthy of me! Mark my words! The one who steals your kingdom from you Xiangs is bound to be Liu Bang. And we will all end up as his prisoners in the not too distant future!"

◆

The proverb Xiang Zhuang wu jian, yi zai Pei Gong, *"While Xiang Zhuang ostensibly performs a sword dance, his real intention is to kill Liu Bang, Lord of Pei," alludes to words or actions that contain a hidden motive. The idiom was used recently in a Chinese newspaper's obituary published after the death of Young Marshal Zhang Xueliang in October 2001.*

The Young Marshal was the son of a Manchurian warlord. He nursed a life-long hatred toward the Japanese because his father, the Old Marshal, had been murdered by Japanese agents. Hoping to persuade the Nationalist leader Chiang Kai-shek to scrap his anti-Red campaign and form a united front with Mao Tse-tung's Communists against the invading Japanese, he devised a devious plan.

In December 1936, the Young Marshal sent his troops to seize Chiang Kai-shek while the latter was staying at the hot springs resort in Xi'an. Chiang escaped barefoot through a window, leaving behind his false teeth, his diary, and his shoes. He was discovered four hours later, injured and shivering behind a nearby rock, and taken into custody.

The kidnapping shocked the world and became known as the Xi'an Incident. It ended two weeks later when Chiang Kai-shek was released unharmed after promising to join forces with Mao's Communists in fighting the Japanese. This had been the Young Marshal's sole purpose for his daring escapade. Afterward, he sur-rendered voluntarily to his leader, Chiang Kai-shek. By subjugating himself, he gave his leader back the face that Chiang had lost by being kidnapped. However, Chiang never forgave him and placed him under house arrest for the next fifty-four years.

Using the proverb "While Xiang Zhuang ostensibly performs a sword dance, his real intention is to kill Liu Bang, Lord of Pei" Chinese newspapers claimed that the Young Marshal's kidnapping of Chiang Kai-shek provided a decade of cooperation between Nationalists and Communists that allowed the Communists to recover their strength and eventually take over mainland China.

After the Young Marshal's death at the age of 101 in Honolulu, the Chinese president, Jiang Zemin, hailed him as a great patriot. It is widely believed that the Xi'an Incident altered the course of Chinese history by giving the Communists breathing space at a crucial stage in their development, allowing them to consoli-date their power and drive out the Nationalists thirteen years later.

Why did Xiang Yu not kill Liu Bang during the course of the banquet at Wild Goose Gate? I believe it was because he did not wish to lose face in front of his own army. Liu Bang had come to Xiang Yu voluntarily, accompanied by only a

hundred cavalrymen, making abject apologies and handing over unconditionally the great city of Xianyang, which he had just conquered. By humbling himself, he had given Xiang Yu a big dose of face in front of the latter's troops. Chinese etiquette and honor demanded that Xiang Yu should reciprocate by inviting his visitor to dinner, thus giving back some face in return. This is known as ke qi, *"courtesy" or "qi toward guests."*

By becoming a guest at Xiang Yu's table, meekly enjoying his hospitality and sharing his food, Liu Bang placed Xiang Yu in a difficult situation. To kill him, Xiang Yu needed an excuse to justify his violence. At that moment he could think of none. For a host to suddenly turn on his guest who had just given him face would have been rude, shameful, and despicable.

Face means "self-respect" or "honor." The concept is deeply ingrained in the Chinese psyche and signifies a person's sense of self-worth. In China, face can be lost, sold, bought, borrowed, given, or denied. Most of all, face must be preserved, especially in front of an audience composed of one's own henchmen. To please the Chinese, it is vitally important to give them face at every opportunity. On the contrary, making someone lose face is perceived as having done something unforgivable. This is what I inadvertently did when I wrote my autobiography. It is my family's perception that I made them lose face when I wrote my book. Because of this, some of them are angry and probably will never speak to me again. The fear of causing family members to lose face may be the principal reason why so few true autobiographies have been written in China.

Dressed in the Finest Brocades to Parade in the Dark of Night

衣錦夜行

Yi Jin Ye Xin

My *lao jia*—the Yen family home in Shanghai, November 2001.

*T*he Chinese term lao jia, "old family home," is difficult to translate because it encompasses the city as well as the dwelling you used to live in before the age of ten. You might have loved or hated it while you were there; it doesn't really matter. But despite your feelings for it at that time, this particular place will become special as you grow older and will affect you in a way no other place can duplicate. It is different from any other location in the world. You might even say that its shadow has become part of your soul. No matter how old or how young you are, when you go there again, it will conjure emotions and invoke memories that are unique.

For me, that city and place is Shanghai. Although I was born in Tianjin, a northern city one thousand miles away, my mother, father, aunt, and grandparents were all from Shanghai. My father took me to Shanghai when I was five years old, and I lived there for the next five years.

Readers ask me, "Where is your home?" And now it has become a very difficult question to answer. I have lived in many places, including Hong Kong, London, and Los Angeles. But no city can ever replace Shanghai in my heart. This is the spot where my psyche was formed, so to speak. Every metropolis afterward became an anticlimax, no matter how glamorous or romantic.

My parents wrenched me away from Shanghai and my Aunt Baba when I was ten years old. They placed me in a succession of boarding schools in Tianjin, Hong Kong, Oxford, and London. Throughout that time, I dreamed of running away and returning to my lao jia *and my Aunt Baba in Shanghai. The dream persisted even after I entered London Hospital Medical School. As a medical student, I belonged to the Chinese Students' Union. A group of us from Shanghai used to get together on Saturday afternoons and go ice skating at a nearby rink. Afterward, we would eat great bowls of soup noodles, drink jasmine tea, and speak to one another nostalgically about boat rides on the Huangpu River or walks along the Bund.*

Although many spoke of going back, only one of our group actually returned to Shanghai during the 1960s. We never heard from him again. His disappearance distressed me greatly and shattered every fantasy. I finally recognized that the one thing that remained of my lao jia *was probably the comforting image of a safe haven existing solely in my mind. Everything else had vanished.*

It took many years for me to learn the painful lesson that I can never go back to my lao jia *again. My grandfather told me long ago that the only thing that does not change is that everything changes. Some people never seem to grasp this simple truth. For them, the yearning for their* lao jia *persists throughout their life, so much so that nothing else can be as meaningful as going home in triumph. Such a person was the ancient warrior Xiang Yu. When he became the most powerful man in China, he chose to go home and show his people that he had made good rather than remain in Xianyang and consolidate his power. "Otherwise," he claimed, "life would be like* yi jing ye xing, *'dressing in the finest brocades to parade in the dark of night.'"*

◆

As soon as he was safely back in his own camp, Liu Bang executed the informer Cao. A few days later Xiang Yu entered the capital city of

Xianyang. In contrast to Liu Bang's policy of *qiu hou wu fan,* "not disturbing the finest downy hair," Xiang Yu went on a wild spree of murder, looting, and arson.

Xiang Yu had been only ten when Qin annexed Chu and his grandfather Xiang Yan committed suicide on the battlefield. Since then he had nursed a burning hatred against the Qin emperors. This feeling had been exacerbated when his Fourth Uncle Xiang Liang was killed while fighting the Qin army two years earlier. Now he found himself the supreme warlord of All Under Heaven at the age of twenty-six.

In his heart he had no thought of benevolence or righteousness, only hatred and revenge. In his eyes the Qin people were not individuals with hopes and aspirations similar to those of the people of Chu, they were merely the enemy. He did not care that the surviving King of Qin, Zi Ying, was as much a victim of Zhao Gao as everyone else. To Xiang Yu, King Zi Ying was the head of the evil force that had killed his grandfather and beloved Fourth Uncle and as such needed to be exterminated. He did not recognize that the magnificent palaces, bridges, temples, tombs, and gardens stretching in front of him for a hundred miles represented the blood, toil, and tears of years of disciplined organization and hard labor. To the young warrior, they were only the trappings of his adversary and therefore had to be demolished. He never realized that he was standing at the threshold of a new era and was, at that moment, the overlord of *tian xia,* "All Under Heaven." The whole empire was clamoring for change, and Xiang Yu was perfectly placed to bring this about, but he chose a different path.

He began by killing the surrendered King Zi Ying, his entire family, and Qin's chief officials. He plundered the palaces and ransacked the treasuries, appropriating for himself all the gold and silver ingots, jewelry, ornaments, precious objects, and beautiful women. He set fire to and burned the palaces and courts of the Qin emperors, including the imperial library with its unique collection of ancient books. An area extending for a hundred miles was soon ablaze. Buildings at that time were constructed of wood. They burned quickly, but it still took three months before the flames of Xianyang finally subsided. He dug open the entrance to the First Emperor's tomb, which had just been completed, seized the best weapons of the buried terra-cotta army, and torched the subterranean chambers.

Shiji mentions briefly that Xiang Yu sacked the First Emperor's tomb. In another book written a few years later, *Book of Han,* it is recorded that a shepherd was searching for a lost sheep that entered a tunnel. The shepherd followed, carrying a torch to light his way. The pit caught fire, and its contents were burned, including many coffins.

Nothing of what Xiang Yu saw or touched was left without damage. The people of Qin, picking through the rubble for their belongings after the fire finally died, were *da shi suo wang,* "greatly disappointed in their hopes." However, since they feared Xiang Yu, they dared not protest or rebel.

Having packed his booty and captured the city's most beautiful women, Xiang Yu prepared to depart. A scholar named Han Sheng now approached to offer him advice.

"The Land Within the Passes (Guanzhong), which used to be the state of Qin, is unique in its geographical location," Han Sheng said. "It is surrounded by high mountains that are difficult to traverse. Its lofty terrain and narrow passes make the area easily defensible, while the land within is well irrigated year round and rich in productivity. You should consider making Xianyang your capital instead of returning to Chu. From Xianyang you can rule the rest of China."

Xiang Yu gazed out, but all he saw was the waste and destruction he himself had wrought. Knowing that he was unable to restore the city to its former pristine glory, he felt more homesick than ever and longed to return to Chu. He said to Han Sheng, "A man who conquers All Under Heaven and does not return home to enjoy his fame and fortune is like someone who *yi jin ye xing,* 'dresses in the finest brocades and parades around in the dark of night.' Who would know of his success?"

Han Sheng was disappointed at Xiang Yu's narrowness of vision. He said nothing but related their exchange to many of his acquaintances and added, "I don't know what I was expecting when I met Xiang Yu but certainly not this! It has been said that the people of Chu are like *mu hou er guan,* 'restless monkeys in tall hats' or 'worthless people dressed up as dignitaries.' Sure enough, it's true!"

Someone reported Scholar Han Sheng's remarks to Xiang Yu. The young warrior became incensed. Without further ado, he arrested the scholar and executed him.

· · ·

While clearing out my parents' apartment after my stepmother's death, I came across a letter to my father from one of his employees who had emigrated to San Francisco in the 1960s. The import-export firm he started in California was prospering, and by 1973 he had a fancy office and a staff of twenty employees. His sole regret, he wrote, was that his relatives and friends in Hong Kong (like my father) could not witness his success for themselves, with their own eyes. He ended the letter by quoting the proverb yi jin ye xing, *"dressing in the finest brocades and parading around in the dark of night."*

At this very moment, sitting in the study of our bright and sunny London flat surrounded by my computer and my books, I wish I could speak to my father and tell him of my writing career. I long to describe to him my early morning routine. What joy it gives me to get up at six and climb the steep steps to my study, turn on the kettle for my first cup of jasmine tea, and read over what I have written the night before! How beautiful and peaceful it is in my study, with the whole of London stretched out like a picture canvas at my feet! Sheer exhilaration comes over me when I have captured on paper what I never dared to express as a child. I feel indescribable delight at the sight of a newly completed manuscript and the knowledge that it will remain even after my life is over. I long to say to him, "Please forgive me for giving up medicine and becoming a full-time writer. I know it is not what you wanted, but it is what I've dreamed of doing since I was a child. This is the happiest time of my life. Please be proud of me."

Alas, this conversation will never take place. My father will never read any of my books or hear any of my talks about my writing. Without my father's stamp of approval, am I also yi jin ye xing, *"dressing myself in the finest brocades to parade in the dark of night"? Or is that merely a state of mind, somewhat akin to the endless search for our* lao jia, *"old family home," and Xiang Yu's lifelong yearning to return to his roots in Chu?*

Xiang Yu had Hang Sheng executed in one of the cruelest ways: by frying him to death in a cauldron of hot oil. At that time, the death penalty was carried out in seven ways, depending on the severity of the crime, and Hang Sheng's punishment was the worst.

1. Beheading.
2. Being cut in two at the waist.
3. Having holes chiselled in the head.
4. Having ribs extracted.

5. Being torn limb from limb (the head and four limbs were attached to five different horses or chariots. These were then forced to move in different directions at a given signal).

6. Five punishments (consisting of branding the forehead or tattoing the face, cutting off the nose, ears, fingers, or feet, and death by flogging, followed by exposure of the corpse in the marketplace).

7. *Peng si:* Being fried to death in hot oil or boiled to death in water.

The First Emperor kept a boiling cauldron in his throne room, into which he threw those who dared to oppose him. He added four additional methods of carrying out the death penalty.

1. Being buried alive.
2. Being put to death by a thousand cuts, inch by inch.
3. Execution of the entire family to the third degree (wife, concubines, siblings, parents, and children).
4. Execution to the ninth degree or death of the entire clan (wife's and siblings' families, parents' families, and children's families).

Apart from these various forms of death penalty, there were corporal punishments:

1. Flogging by bamboo lash.
2. Tattooing the face.
3. Cutting off the nose.
4. Amputating the feet or hands.
5. Castration.
6. Cutting off the ears.

Chinese people perceive life as a temporary phenomenon and death as the great equalizer. Even the cruelest despots are eventually forgiven and forgotten when they die. After the death of the First Emperor, a ballad was composed that became very popular:

> *The First Emperor will also die!*
> *He entered my door*
> *And sat on the floor*

He tasted my gravy
And demanded more
He drank my wine
Without telling me why
I'll use my bow
And pin him to the wall
When he goes to Sand Hill
He'll pay the final bill.

As for Xiang Yu, he simply viewed himself as the supreme ruler with the right to dispense death in the cruelest manner to whomever he wished. Having buried alive the surrendered Qin army, executed their king, ransacked their treasury, burned their palaces, raped their women, terrorized the population, and fried Han Sheng to death in hot oil, he now sent a messenger to the King of Chu. After bragging about his conquests, he hinted that the king should now give his blessing for Xiang Yu to do whatever he wished regarding the Land Within the Passes (Guanzhong). But His Majesty replied, "Let Guanzhong be ruled according to the Covenant we all agreed to a year ago."

Xiang Yu felt that the king had treated him unfairly the previous year by not allowing him to go west and storm the passes with Liu Bang. Instead, Xiang Yu had been sent north to relieve the siege of Julu and fight the main Qin army, a far more hazardous assignment. Consequently, he had no chance of reaping the benefit of the covenant, which fell to the hands of Liu Bang by default.

So he said to the generals, "The King of Chu was merely a shepherd whom my Fourth Uncle and I rescued from obscurity. He neither fought nor achieved any merit of his own. Why should he be the one to make decisions? Men like us, who wore the armor, held the spear, and lived in the rough, are the real conquerors of Qin. We are the heroes and as such deserve to reward ourselves accordingly!"

Feigning respect, Xiang Yu made the King of Chu an emperor and gave him the honorary title of Emperor Yi. In reality, he kept all the power himself and began issuing orders to the generals in his own name only, without even pretending to legitimize them by adding the emperor's name.

Arbitrarily dividing the Qin empire according to his likes and dislikes, Xiang Yu first set himself up as King and Lord Protector of the state of

Chu, seizing 25 percent of China as it existed at that time and ruling over nine provinces, with his capital at Pengcheng.

He and Old Man Fan were both worried that Liu Bang might cause them trouble later if he ruled the Land Within the Passes, but they were also reluctant to go contrary to the covenant for fear of causing ill will among the other generals. So they plotted between themselves and said to each other, "The district of Bashu and Hanzhong (present-day Sichuan Province), to the southwest, is difficult to reach because road conditions are hazardous. The First Emperor used to banish his convicts there. Why don't we make Liu Bang the ruler of that area and name him King of Han?"

Liu Bang was therefore banished to an outlying area outside of central China, still considered wild and uncivilized at that time. To add insult to injury, Xiang Yu pared down the number of Liu Bang's troops from 100,000 to only 30,000.

When the First Emperor had ascended the throne as King of Qin, China had been divided into seven states. It took him twenty-five years to unify the country. Now Xiang Yu went backward and separated the empire into twenty different states, each with its own king.

Besides seizing Chu for himself and banishing Liu Bang to Hanzhong and Bashu with the title of King of Han, Xiang Yu placed a barrier between himself and Liu Bang. He divided the Land Within the Passes into three different parcels and appointed three surrendered Qin generals as their three new kings, each ruling a third.

In partitioning the country, Xiang Yu rewarded those who were syco-phantic and obedient but punished those who were independent and strong-minded. Many of the old feudal families who had reasserted their ancient claims were resentful of his authority, considering him an upstart still wet behind the ears. Xiang Yu's decisions were impulsive and emotional. It never occurred to him to consider the ramifications and long-term con-sequences of his ordinances. Carving up the empire like a giant water-melon, he handed out pieces of territory not on merit or ability to rule but according to his personal preferences. He never recognized until too late that *he* would be the one expected to enforce the boundaries between the new kingdoms, a thankless and never-ending task.

Liu Bang wanted to be King of the Land Within the Passes and felt that Xiang Yu had gone contrary to the covenant. He was particularly incensed

that Guanzhong had been awarded to three surrendered Qin generals against whom they had all fought for three long years. He called a meeting to discuss launching an attack against Xiang Yu. But his chief administrator, Xiao He, said, "Although being the King of Han is not as desirable as being the King of Guanzhong, surely you prefer that to dying?"

"What do you mean by that?" Liu Bang angrily demanded.

"At present, we cannot match Xiang Yu either in manpower or in military equipment. If we attack him we're bound to lose. Would that not be tantamount to seeking your own death? Why not simply accept our allotment and make Bashu and Hanzhong our base—train our troops, husband our resources, and await our opportunity? You can be sure that we are not the only ones who are unhappy. When the time is ripe we will mount a full-scale attack, reclaim Guanzhong, and take over the rest of the empire."

On reflection, Liu Bang knew that Xiao He was correct. He decided to say nothing and abide by Xiang Yu's ruling for the time being.

In May 206 B.C.E. Xiang Yu made a formal announcement that warfare was over and discharged all the nobles. Each went to his own kingdom. Even though Liu Bang was given only 30,000 soldiers, such was his popularity that tens of thousands of people voluntarily followed him. The strategist Zhang Liang accompanied him halfway to see him off before returning to his own home state of Haan.

Between Guanzhong and Liu Bang's allotted land of Hanzhong and Bashu were a series of precipitous mountain ranges that were hazardous to cross. From north to south they stretched for 150 miles and from east to west for 300 miles. The people of Qin had risked their lives to build two roads linking Guanzhong and Hanzhong. These were known as "cloud bridges" or *zhan dao,* literally meaning "plank road built along the face of a cliff." When using these bridges hanging among clouds and suspended over chasms thousands of feet deep, travelers had to take extreme caution not to lose their footing or risk falling into plunging ravines and raging waterfalls below.

Of the two roads, the first, called Baoxiedao, "Commending the Tilt Road," was shorter and more direct. The second, called Chengcang or Gudao, "Former Road," was longer but less precipitous. Over the years, because most people chose to use the shorter road, the existence of the neglected Former Road was forgotten.

Studying the terrain as they inched along the cliff-hanging planks on each other's heels, Zhang Liang said to Liu Bang, "The reason Xiang Yu is banishing you to Hanzhong is to isolate you so that you will not cause him problems. Why don't you play along and lull his suspicions by burning some of these plank roads? That will not only prevent would-be attackers from entering your kingdom but also send a clear message to Xiang Yu that you have no intention of returning east and competing with him. Besides, only the locals are aware that there are two roads between Hanzhong and Guanzhong."

Liu Bang thought it an excellent idea. Just before they parted, Zhang Liang added with a smile, "Be sure to burn only those portions of the road that are easily reparable!"

Liu Bang and Zhang Liang made sure that news of the road burning traveled all over the empire, especially to the ears of Xiang Yu.

In his new kingdom of Han, Liu Bang and his chief assistant, Xiao He, pored over the maps, policies, records, and files that they had procured from the First Emperor's palaces in Xianyang. Through them they learned about the terrain of the empire, the people's grievances, distribution of the population, and the water supply and grain productivity of various regions.

Many of Liu Bang's followers were from provinces east of the pass and had expected to return home after a short stay in Han. They were greatly disappointed to see Liu Bang burning the cliff roads and giving the impression of settling down in Han for good. The officers and soldiers sang songs of their native states and spoke of returning east to their *lao jia*. Some simply left and went home.

Administrator Xiao He also had run away, leaving Liu Bang feeling bereft, since the two had grown up together in the same village. But after two days Administrator Xiao He returned as suddenly as he had disappeared. Liu Bang was both overjoyed and annoyed, and he scolded him upon his return.

"I did not run away, Your Majesty," Xiao He protested. "I went in search of someone who ran away and persuaded him to come back to us— Hahn Xin, the keeper of the granary."

Liu Bang was incredulous. "What? Hahn Xin!" he shouted angrily. "So many officers have run away, and you go after a mere keeper of the granary! What's so special about him?"

"I am very impressed by him. I have had several occasions to speak to him in depth, and I say to you that his talents are extraordinary and unique. *Guo shi wu shuang!* 'There is no other officer like him in our entire country!' If Your Majesty is satisfied with being King of Han, then you do not need him. However, if your ambition is to control the empire one day, there is nobody else who can plan better than Hahn Xin."

Becoming curious, Liu Bang asked, "Tell me about him. What is his background?"

"He was born in Chu and came from a poor family. Though an intellectual, he could not make a living and was reduced to living off his friends. To satisfy his hunger, he went fishing by the river. There were several old women washing and rinsing clothes. One of them took pity on the hungry young man and fed him lunch. This went on for a few months, and the old woman brought him food every day. Hahn Xin was grateful and said to her, 'Should I become rich someday, I'll reward you very handsomely. Thank you for your *piao mu zhi en,* "kindness from a washerwoman."'

"But the old lady said, 'You are obviously an educated young man temporarily down on your luck and unable to *zi shi qi li,* "feed yourself by your own effort." I help you because I feel sorry for you. Who needs to be rewarded?'

"No matter how poor he was, Hahn Xin always wore his sword on his belt. This annoyed some youths around town. One day a butcher's son accosted him and said, 'Even though you are tall and well built and wear a sword, actually I think you are a coward at heart.' They were soon surrounded by a crowd, and the youth said, 'Hahn Xin, if you are really brave, draw your sword and kill me. But if you don't dare to kill me, then crawl between my legs under me.'

"Hahn Xin looked around at the jeering crowd, then he calmly lowered his body and crawled between the young man's legs. Everyone sneered, but Hahn Xin knew that he had passed a test of supreme courage by undergoing *kua xia zhi ru,* 'insults from under the hips,' and voluntarily enduring the worst kind of humiliation."

Throughout my dismal childhood, my siblings discriminated against me. Being the youngest of five stepchildren, I was considered the lowest of the low. When treats were handed out, the two children of my stepmother were always given first choice,

followed in order of birth by my four older siblings. My turn invariably came last. Not infrequently, my oldest sister and second older brother would help themselves to whatever they fancied from my plate when no adult was around. I learned from an early age that protests and tears got me nothing but beatings. The best defense was to study hard and get as good a report card as I could because that was the way to my father's heart.

I did not know it then, but during all those years in Shanghai, my childhood traumas were erecting my life's foundation and building up my inner resistance. By the time I entered medical school in London, I had been conditioned to take the slings and arrows of discrimination unflinchingly, with equanimity and fortitude. After being challenged by a whole series of kua xia zhi ru, *"insults from under the hips," I had passed the test and was prepared to face the world.*

Xiao He continued, "Hahn Xin enlisted in Fourth Uncle Xiang Liang's army as an ordinary soldier. After Fourth Uncle's death, Hahn Xin became one of Xiang Yu's bodyguards. He offered a variety of military strategies to Xiang Yu but was repeatedly rebuffed. Disillusioned, he decided to follow you instead. Soon afterward, he committed an offense and was sentenced to death with thirteen others. When all the others had been executed and the guards were leading Hahn Xin to the execution block, he happened to see your personal assistant, Xia Houyin, walking by. Hahn hailed him and said, 'I hear that Liu Bang wishes to conquer the world. If this is true, why is he killing a warrior like me, who can help him achieve his goal?'

"Xia was intrigued and halted the execution. After interviewing Hahn Xin, he realized that the man did have many ingenious ideas. So Xia pardoned him and recommended him to you. You promoted him to be keeper of the granary but ignored all the strategies he proposed. That's why he ran away. When I found him gone, I hurried after him and persuaded him to return. In order to keep Hahn Xin, you must promote him. Otherwise, he will leave again. If Your Majesty intends to conquer All Under Heaven, you will need Hahn Xin."

"All right! All right!" Liu Bang exclaimed impatiently. "Because of your recommendation, I shall promote Hahn Xin to be a general."

"I'm afraid he might leave again if you make him only an ordinary general."

"How about general in chief?"

Xiao He visibly brightened, "As general in chief I think he will stay."

"Tell him to come over and I'll appoint him!" Liu Bang said.

"If you are sincere in wanting to designate Hahn Xin as your general in chief," Xiao He replied, "how can you be so arrogant as to summon him hither and thither like a little boy? You must demonstrate some respect. Make his appointment special and hold a grand ceremony for the occasion. Then *deng tan bai jiang,* 'perform the ceremony on a platform in front of the entire army.' Only then will Hahn Xin be convinced to stay."

When it was announced that "someone" was about to be appointed general in chief of Liu Bang's army, excitement ran high among the rank and file. Every officer wondered whether he was going to be the lucky one.

An auspicious day was selected by the court astrologer. Liu Bang fasted for three days, bathed, and changed into ceremonial robes. The whole army assembled in front of a high platform specially erected for the occasion, surrounded by tall red flags fluttering in the early morning breeze. (Red was the color chosen by Liu Bang to represent his new kingdom of Han.) Liu Bang knelt and prayed to Heaven at the altar. Then he stood up, turned to the audience, took the seal and tally with both hands, and announced in a solemn voice, "Will the general in chief please ascend the platform to accept his seal of office."

There was a gasp of astonishment when the tall figure of Hahn Xin stood up and strode forward to the sound of beating drums. He went up the stairs to the platform, knelt in front of Liu Bang, and accepted the seal and tally into his two outstretched hands with his head bowed. Never did anyone imagine that the new general in chief would be the former keeper of the granaries, who had narrowly escaped execution a few months earlier.

After the ceremony a banquet was held. For the first time, Hahn Xin found himself seated next to Liu Bang.

"Xiao He has told me repeatedly of your abilities," Liu Bang began. "Now that we have an opportunity to talk, please tell me your plans and strategies."

"I thank Your Majesty," Hahn Xin replied. "May I begin by asking you a question? When you go east to conquer All Under Heaven, would your chief opponent be Xiang Yu?"

"Of course."

"In your own estimation, who is braver on the battlefield, you or Xiang Yu?"

After a long silence Liu Bang said, "I am not as brave as Xiang Yu."

Hahn Xin bowed and said, "I agree with your estimation. Your Majesty has the vision to know yourself and the courage to admit the truth. These are unusual traits. Another of your strong points is your ability to listen to advice from others. This comes from a generosity of spirit that not many people possess.

"As for Xiang Yu, I used to work for him and know him well. When he shouts in anger on the battlefield, *chi zha feng yun,* he appears to be 'commanding the wind and the clouds' and 'earthshaking in his power,' so much so that he can frighten away a thousand brave warriors. However, he is unable to delegate authority and is jealous of those who are capable. That is why I consider him to be *pi fu zhi yong,* 'an ordinary man whose bravery is really recklessness.' Toward his friends and subordinates he appears soft and kind. When they are wounded, he cares for them and shares his food, often with tears in his eyes. But when an officer performs a valiant deed deserving of promotion, Xiang Yu is frequently reluctant to hand over the appropriate award. *Fu ren zhi ren,* 'his benevolence is like that of a woman.' (Note the prevailing misogyny in the ancient historian Sima Qian's comments about women.) Even though presently he rules the world and is overlord of all the kings in the empire, he has not the wisdom to recognize the importance of geographical location in determining his own ultimate destiny. This lack of foresight resulted in his choice of his native state of Chu as his base rather than the vastly superior 'Land Within the Passes.'

"In front of the whole world, Xiang Yu went against the covenant. Wherever he sends his army, he allows his soldiers to burn, rape, rob, and steal. He rules by fear, and *tong ru gu sui,* 'everyone hates him to the marrow.' Although nominally he is Lord Protector and rules All Under Heaven, in reality he has already lost the heart of the people and no one wants to be ruled by him.

"The three kings set up by Xiang Yu to rule 'The Land Within the Passes' were all surrendered generals from Qin. Many of their troops were killed while under their command. Remember that less than a year ago, Xiang Yu executed 200,000 surrendered Qin soldiers and only spared the lives of these three generals. How terrible that of all the people under heaven, Xiang Yu should appoint these three as the Qin people's new kings! What arrogance! What stupidity!

"When Your Majesty entered Xianyang last year, *qiu hao wu fan*, you did not 'trespass against the smallest downy hair' (encroach on the interests of the people to the slightest extent). Not only did you liberate them from the cruel and complicated Qin laws, you made a pact with the elders to adopt your three simple codes. You have the Qin people's support, and they are on your side. Should you decide to attack, I think you will be able to take the Land Within the Passes without difficulty.

"Many of your officials and soldiers are from east of the mountains and are longing to return home. If you use their homesickness *ji feng er shi*, 'without delay, as a weapon when it is still sharp,' you can accomplish a lot. But when everything settles down and people become accustomed to their new surroundings, their homesickness disappears and that weapon is gone. Therefore it is better to move forward as soon as possible."

Liu Bang was highly pleased with Hahn Xin's analysis and knew that he had chosen the right man to be his general in chief. Hahn Xin worked out a plan whereby Xiang Yu's three kings could be outwitted and the Land Within the Passes taken over in a surprise attack. Liu Bang and Hahn Xin trained the officers, drilled the troops, and piled up provisions. They also deployed spies to the other states to gather information while preparing for a major assault to the east.

◆

The concept of using homesickness as a weapon demonstrates that the yearning for one's lao jia *is a natural and universal phenomenon that has been recognized by the Chinese for over 2000 years. When one moves away and adapts to her new environment, homesickness gradually lessens but never entirely disappears.*

My lao jia *still stands in the heart of Shanghai in the old French Concession. To reach it, you walk through an imposing gate into a long* tang, *a complex of similar houses built in the same style, surrounded by a communal wall. On each side three narrow alleys open onto a central main lane ending in bustling Avenue Joffre, now called Huai Hai Central Road.*

So many of my childhood memories are connected to that house. They start with the living room where we had our family reunion and I as a six-year-old spoke up against my stepmother's beating of her baby daughter, thereby incurring her wrath. The curved, wooden banister on which I used to slide instead of using the stairs. The landing where a leaking water tank caused my three brothers to be whipped by Father. The room that I shared with my Aunt Baba and the hours and hours

we spent reading together. The feeling of sheer joy when I watched my pet duck-ling, PLT, wandering between our beds before she was bitten and killed by my father's German shepherd. The countless evenings when I did my homework or wrote my kung fu stories with the door closed. The closet where my aunt kept her safe deposit box. The day my stepmother caught me attending a friend's birthday party and my terror as she drilled me in my room. The awful afternoon twelve of my classmates secretly followed me home to give me a surprise celebration party for winning the election for class president and I was summoned upstairs by my step-mother, where she screamed at me and slapped me for breaking her rules and let-ting them into the house. The final hours I spent with my aunt before I was wrenched away from her at the age of ten, when she made me promise that I would try to do my best at all times, and we went through the contents of her safe deposit box together.

This is the house where my aunt lived for most of her life. It is also where much of my autobiography was recorded and written. Between 1990 and 1994, I spent many days there alone with my aunt, taping an oral history of our family and reliving my past. She spent the last days of her life in this house and died there. At the age of eighty-nine she became bedridden following a fall that broke her hip. X rays showed that she had cancer of the colon, which had already spread. She categorically refused to consider surgery or even hospitalization, chiding me for my grandiose plans of rescue and telling me that she did not wish to prolong the agony of dying.

A few days before she died, she asked me to find a black handbag buried beneath a pile of towels in her closet. From it she extracted a pair of jade earrings, which I had given her for her eightieth birthday, and a large envelope, telling me, "These are for you." When I opened the envelope, I saw with a pang that it contained all the American dollars I had given her since we met again in 1979. Instead of spending them, she had saved them all and was now returning them to me.

My aunt was almost ninety years old when she died, and I had the privilege of spending her last days with her. Toward the end she could no longer see but con-tinued to ask me to read to her and tell her stories from America, saying it was the one remaining activity we could still share. She and I both knew that her days were numbered, but she wished to listen and learn even to the last, looking forward to as yet another adventure with every turn of the page.

It has been eight years since my aunt passed away. Since then I have received many offers from would-be buyers who are interested in purchasing my Shanghai house. But somehow, I cannot sell it. It still seems incredible that I, the unwanted

daughter who was thoroughly despised as a child, should end up owning the Yen family residence from which I was so terrified of being banished at the age of ten.

Recently, I leased the house to three young men, one of whom had read Falling Leaves *and professed an interest in restoring the house to its former glory. In less than three months they succeeded in transforming the dilapidated building into a slice of Old Shanghai. Tears welled up in my eyes when I visited my renovated* lao jia *recently. Its beautiful parquet floors were polished and glistening. The original window frames, metal grilles, and old-fashioned handles were neatly painted and glazed. A beautiful Chinese lantern hung in the hallway above the gracefully curving wooden stairway. Outside in the replanted garden, granite stones bordered a neat lawn that surrounded the giant magnolia tree, under which I had buried my beloved duckling, PLT.*

As I stood in the radiance of my redecorated former bedroom looking down at the dewy green grass where Father's German shepherd used to roam, I was filled with a sense of nostalgia. I knew that my three young tenants had put their hearts into the project, and I was deeply moved. Since two of them were Chinese and one was American, I silently dared to hope that my lao jia *would be a dwelling where East and West would live in amity and where Shanghai's past would step harmoniously into a bright new future in the twenty-first century.*

If this dream should become reality, then instead of yi jing ye xing, *"dressing in the finest brocades to parade in the dark of night," I would be* yi jing huan xiang, *"returning to my* lao jia, *hometown, in silken robes after having made good."*

helping her two children out of Communist China and getting them educated in America. My hunger for my family's approval was so strong that I was blithely unaware of her true feelings.

I bought two new bicycles at the Friendship Store in Shanghai and gave one to my aunt's surgeon and the other to the administrator at the best hospital in the city. The very next day they hospitalized my Aunt Baba, excised her tumor under general anesthesia, and discharged her five days later to recuperate at home.

One morning after breakfast, I was clearing the dishes when Aunt Baba said to me, "Let me comb your hair and give you a new hairstyle. Remember how you used to wear your hair when you were little? I think you will look so much prettier without a fringe on your forehead."

"Let me comb your hair first," I said. "Then you can do mine."

We were happily engaged in combing each other's hair when Lydia walked in. She watched us in silence for a while. Aunt Baba said, "Younger women like you two with lots of hair should spend at least twenty minutes every morning combing your hair. Use a fine-toothed comb like this one here, which I've had for fifty years. Be sure that the comb touches the scalp with every stroke. This way, the scalp gets repeatedly massaged and will remain healthy. By doing this, I still have some hair left on my head even though I'm already eighty."

Lydia suddenly said to me, "Come into the kitchen for a minute, Wu Mei, Fifth Younger Sister! My eyes are failing, and I need you to read a label."

Somewhat reluctantly, I followed Lydia into the kitchen. I was feeling relaxed and a little drowsy. It had been enormously comforting to have my hair lovingly combed by my aunt, reminding me of another era when she and I shared a room and meant everything in the world to each other.

In the kitchen Lydia said, "Actually, there is no label for you to read. I just wanted to tell you something in private. How can you let your clean, shampooed hair be touched by that filthy old comb of hers, which probably has never been washed? You are in Communist China, not the United States of America! I know for a fact that during the Cultural Revolution, she didn't have a bath for years. Nobody did! Aren't you scared of picking up some awful disease like head lice? Just look at the flakes of dandruff on her collar! I'm only telling you this because you are my sister and I want to protect you. For heaven's sake, keep this conversation between us private and don't breathe a word! Let's not hurt her feelings!"

Images of creepy-crawlies invading my hair entered my mind in spite of myself. On returning to Aunt Baba's bedroom, I suddenly had no further wish for her to comb my hair.

CHAPTER 15

Plot to Sow Discord and Create Enmity

反間計

Fan Jian Ji

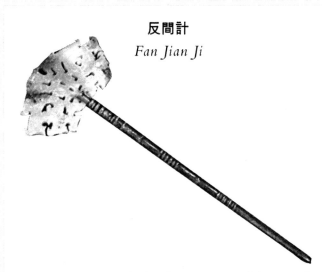

Jade hair ornament inlaid with turquoise, Neolithic period,
Shandong Longshan Culture (c. 2000 B.C.E.).

*A*lthough my father was still alive in 1985, he was already suffering from
advanced Alzheimer's disease and had been hospitalized in the Hong Kong
Sanatorium for over two years. One evening, at home in California, I received an
urgent phone call from my stepmother. She informed me that Aunt Baba, who lived
alone in Shanghai, was seriously ill from colon cancer. Would I fly there to help her?

Less than a week later I was in Shanghai. At Aunt Baba's bedside I found my
oldest sister, Lydia, who, unlike the rest of my siblings, had never left China. In those
days Lydia was extremely affectionate toward me, hooking her arm protectively in
the crook of my elbow whenever we crossed the street and placing the tastiest morsels
from her bowl onto my plate at every meal. She would also thank me repeatedly for

helping her two children out of Communist China and getting them educated in America. My hunger for my family's approval was so strong that I was blithely unaware of her true feelings.

I bought two new bicycles at the Friendship Store in Shanghai and gave one to my aunt's surgeon and the other to the administrator at the best hospital in the city. The very next day they hospitalized my Aunt Baba, excised her tumor under general anesthesia, and discharged her five days later to recuperate at home.

One morning after breakfast, I was clearing the dishes when Aunt Baba said to me, "Let me comb your hair and give you a new hairstyle. Remember how you used to wear your hair when you were little? I think you will look so much prettier without a fringe on your forehead."

"Let me comb your hair first," I said. "Then you can do mine."

We were happily engaged in combing each other's hair when Lydia walked in. She watched us in silence for a while. Aunt Baba said, "Younger women like you two with lots of hair should spend at least twenty minutes every morning combing your hair. Use a fine-toothed comb like this one here, which I've had for fifty years. Be sure that the comb touches the scalp with every stroke. This way, the scalp gets repeatedly massaged and will remain healthy. By doing this, I still have some hair left on my head even though I'm already eighty."

Lydia suddenly said to me, "Come into the kitchen for a minute, Wu Mei, Fifth Younger Sister! My eyes are failing, and I need you to read a label."

Somewhat reluctantly, I followed Lydia into the kitchen. I was feeling relaxed and a little drowsy. It had been enormously comforting to have my hair lovingly combed by my aunt, reminding me of another era when she and I shared a room and meant everything in the world to each other.

In the kitchen Lydia said, "Actually, there is no label for you to read. I just wanted to tell you something in private. How can you let your clean, shampooed hair be touched by that filthy old comb of hers, which probably has never been washed? You are in Communist China, not the United States of America! I know for a fact that during the Cultural Revolution, she didn't have a bath for years. Nobody did! Aren't you scared of picking up some awful disease like head lice? Just look at the flakes of dandruff on her collar! I'm only telling you this because you are my sister and I want to protect you. For heaven's sake, keep this conversation between us private and don't breathe a word! Let's not hurt her feelings!"

Images of creepy-crawlies invading my hair entered my mind in spite of myself. On returning to Aunt Baba's bedroom, I suddenly had no further wish for her to comb my hair.

This episode came back to me when I was doing research on the continuing struggle between Liu Bang and Xiang Yu for the control of China. In hindsight, I now realize that Lydia's words and actions were part of a deliberate plot on her part to sow dissension between my aunt and me. Far from wishing to protect me, Lydia was trying to alienate me from my aunt.

While reading Shiji, *I came across a passage in which the Grand Historian Sima Qian coined a special term to describe stratagems similar to the one that Lydia used. It is called* fan jian ji, *"plot to sow distrust by spreading rumors." Over two millennia before Lydia was born, professional military advisers were already devising similar plots in order to divide and conquer.*

◆

To Liu Bang's delight, his spies reported that most of the new kingdoms created by Xiang Yu were in a state of turmoil. Those who were given kingdoms considered them too small whereas those who were denied felt excluded and left out.

A case in point was Xiang Yu's decision regarding Qi (present-day Shandong Province on the northeast coast of China).

Before unification, the Tian family ruled Qi for many generations during the Warring States period. King Jian, the last king of Qi, surrendered to the First Emperor against his ministers' advice without a fight in 221 B.C. Considered a coward by his countrymen, King Jian's capitulation did not earn him the reprieve he expected. Instead, he was imprisoned in a remote area and starved to death.

Following the frontier guards' rebellion one year after the death of the First Emperor, aristocrats from the old ruling Tian family resurfaced. The nobleman Rong rose and declared Qi to be a new and independent kingdom. He named himself as Prime Minister and his nephew Shi as King. Wishing to remain neutral, Rong did not send troops to assist Xiang Yu in the battle of Julu. One of his junior officers, Commander Dou, disagreed with Rong's policy and brought his own troops to Xiang Yu.

Subsequently, Commander Dou accompanied Xiang Yu in storming the Hangu Pass. Wishing to reward his friend, Xiang Yu divided Qi into three parcels. He bypassed Rong, who had ruled Qi for four years and held all the power in that area. Of the three men he named to govern the three sections of Qi, the first was his friend Commander Dou, the second

was Rong's nephew Shi, and the third was a grandson of the last king of Qi, who had been starved to death.

Not only was Rong left out in the cold, he was expected to give up his army and subordinate himself to his rebellious former army officer, his young nephew, and the grandson of a cowardly king whom he despised. It was an impossible situation for Rong and he revolted.

He began by refusing entry to his former junior officer Commander Dou. The latter complained to Xiang Yu. Rong heard of this and responded by killing the two other newly nominated kings of Qi. He re-united the three parcels and declared himself the only king of Qi. Far from kowtowing to Xiang Yu, Rong began openly recruiting others to join him in a revolution against him.

The first to respond was Peng Yue, a minor warlord and guerrilla fighter with a band of ten thousand men who was itching to prove his mettle. Rong immediately made him a general and sent him the appropriate seal.

The second to join the "anti-Xiang Yu forces" was Scholar-General Chen Yu from Zhao. Chen Yu was the one who had written the famous letter that successfully prompted Treasurer Zhang Han to surrender to Xiang Yu after the battle of Julu. Chen Yu held a grudge against Xiang Yu because the latter did not make him a king and gave him only three small counties to govern, whereas his counterpart (and ex-partner) Scholar-General Zhang Er was made king of the entire former state of Zhao. He now requested to borrow some troops from Rong to even the score.

Rong obligingly sent over an auxiliary division to augment Chen Yu's small army. With this new force, Chen Yu was able to defeat his ex-partner Zhang Er and topple him from the throne. Zhang Er fled but, to everyone's surprise, he turned to Liu Bang instead of Xiang Yu for refuge.

This was a slap in the face for Xiang Yu. Immediately after the battle of Julu, Xiang Yu's power and prestige had been such that all the nobles had fallen to their knees when they were summoned into his camp, and none dared look him in the eye.

Now, less than a year later, Xiang Yu's reputation had already diminished to such an extent that warlords of the area were turning to his arch rival, Liu Bang, instead. It did not help that on returning to his capital city of Pengcheng, Xiang Yu continued to behave as if he were still the almighty commandant of All Under Heaven, answerable to no one but himself.

Resentful of Emperor Yi for not going against the covenant, he had him murdered. Following this atrocity, he had King Cheng of Haan killed as well, thereby further aggravating the enmity of Liu Bang's strategist, Zhang Liang, who was born and bred in Haan.

Having gathered all the reports, Liu Bang concentrated his efforts on expanding eastward. Following General in Chief Hahn Xin's war plan to the letter, Liu Bang first made a public announcement that a few hundred soldiers were being dispatched to repair the burned *zhan dao,* "planks built along the face of a cliff." Everyone knew that this was a time-consuming and intricate task that would take at least a year.

Meanwhile, in October 206 B.C.E., General in Chief Hahn Xin and Liu Bang led their well-drilled army by way of the little-known *Chencang gu dao,* "former road," and made a surprise attack on Treasurer Zhang Han. Utterly unprepared, Zhang Han suffered two major defeats and fled. Thereupon Liu Bang subjugated the area with ease and entered the former capital city of Xianyang. He was enthusiastically welcomed by the Qin people. Of the three kings of Guanzhong appointed by Xiang Yu, Zhang Han committed suicide while the other two defected to Liu Bang.

Hahn Xin's famous war plan, which resulted in Liu Bang's rapid capture of Guanzhong, has become a proverb: ming xiu zhan dao, an du Cheng Cang, *"openly repairing the plank roads but secretly crossing via Cheng Cang." The proverb means "outwardly pretending to advance along one path while secretly following another route" or "doing one thing under cover of another."*

Throughout the Cultural Revolution, Mao Tse-tung's wife, Jiang Qing (Madame Mao), actively promoted the cult of Mao's personality throughout China. She traveled from province to province, lectured at political rallies, produced ballets, movies, and musicals, and appeared frequently on television. I once commented to my father that she and Mao Tse-tung did not seem to spend much time together. With a twinkle in his eye, Father replied, "Ming xiu zhan dao, an du Cheng Cang!" By saying this, Father meant that while Mao's wife was extolling his virtues to an adoring public, Mao was actually having secret affairs with other women.

Xiang Yu was beside himself with fury at the turn of events. Torn between attacking Liu Bang for taking the Land Within the Passes or Rong for taking Qi, Xiang Yu could not decide what to do. At that moment he received a letter from Liu Bang's strategist, Zhang Liang.

Zhang Liang was traveling in his native state of Haan pacifying his people after Xiang Yu executed King Cheng of Haan. In his heart he hated Xiang Yu for this deed but did not dare voice his resentment. In his letter Zhang Liang wrote, "Liu Bang's only desire is to go according to the covenant and possess the Land Within the Passes. Once he has done so, he will stop his conquests."

Soon afterward, Zhang Liang sent Xiang Yu a second letter in which he related the rebellion of Rong and his military alliances. "Your servant has heard that Rong and Scholar-General Chen Yu have joined forces for the sole purpose of destroying Your Majesty and Chu. Their accord will pose grave dangers for Your Majesty. These two are your real enemies."

Convinced, Xiang Yu attacked Rong instead of Liu Bang. He marched northward into Qi and inflicted a total defeat on Rong. The latter fled in panic to a city nearby, where he was killed by the local people. Qi then surrendered to Xiang Yu.

In spite of the Qi people's surrender, Xiang Yu's soldiers rained destruction on their homes, temples, and shops. They burned their city walls, buried alive Rong's surrendered soldiers, and kidnapped the women. Then Xiang Yu went north along the coast, allowing his troops to kill and destroy wherever he led them.

Thereupon the people of Qi rose and rebelled against Xiang Yu again. Rong's younger brother and son gathered 50,000 men and retreated to the city of Chengyang. They dug in and made that city a fortress of opposition against Xiang Yu. Although Xiang Yu's troops surrounded the city walls, the people were determined not to surrender and resisted valiantly.

While Xiang Yu was causing havoc in the state of Qi, Liu Bang was busy in his own way. First he proclaimed a general amnesty in the territories he ruled. Besides Han and Bashu, his kingdom now included the Land Within the Passes. He ordered his people to remove the Qin dynasty's gods of the "land and grains" and establish the Han dynasty's gods instead. (Traditionally, a change in the gods of the "land and grains" was only made at the beginning of a new dynasty.) He showed his bounty by exempting his people from land tax for a period of two years. Those who were fifty years or older, incorrupt, respected their parents, possessed leadership qualities, and did good works were elevated to the position of *san lao,* a respected elder, one in each district. The *san lao*s were exempt from forced labor and garrison duty and were given wine and meat at the new

year. One of the district *san lao*s was selected to be the prefectural *san lao*. The latter served as a consultant to the prefect and the chief of police.

San lao *is an interesting term. The two words mean "three olds," but there are many meanings. As the first part of the proverb* san lao si yan, *the words* san lao *mean "three honests," or being honest in thought, deed, and words; and the words* si yan *mean "four stricts," or setting strict standards for work, organization, attitude, and observation of discipline. However,* san lao *also implies someone who has been recommended to those in power as possessing certain desirable qualities such as moral fiber, filial piety, leadership, and intelligence. It is interesting to note that in 1989 the second-generation Communist Chinese leader Deng Xiaoping (Mao was the first-generation leader) handpicked the third-generation leader Jiang Zemin as his successor precisely because Deng thought Jiang possessed these* san lao *qualities. President Jiang has held the reins of power since Deng's death in 1997. He and Premier Zhu Rongji are widely perceived in Chinese circles as being incorruptible ministers who have successfully managed the difficult task of maintaining political stability while fostering economic growth for the last thirteen years.*

During the summer of 1996, Jiang Zemin invited eight leading Chinese historians to the seaside resort of Beidaihe and asked each to present his views on Chinese and world history. "If a person does not know Chinese history," Jiang proclaimed, "he will never comprehend the principles governing the evolution of Chinese society."

Although Jiang's term of office will end in the fall of 2002, it is expected that his will be the dominant voice in selecting the forthcoming fourth-generation Chinese leader, doubtless once more taking into account the candidate's san lao *qualities. Jiang's designated successor appears to be fifty-nine-year-old Vice President Hu Jintao, who first came into prominence in 1992, while Deng Xiaoping was still alive. Transition of power is scheduled to take place toward the end of 2002, and Hu is expected to become President of China in the spring of 2003.*

One of the prefectural *san lao*s, His Excellency Duke Dong, came to Liu Bang and said, "Your Majesty has the intention of defeating Xiang Yu. In order to win, you must convince everyone that you are fighting for a just cause. Xiang Yu has acted in a cruel and inhuman fashion. He has murdered his lord, Emperor Yi, for no reason. Make clear to All Under Heaven that Xiang Yu is a wrongdoer. Your enemy can thereupon be conquered without difficulty."

Grasping immediately the significance of the *san lao's* suggestion, Liu Bang agreed wholeheartedly and ordered that everyone in his army should wear white mourning garments to commemorate the death of Emperor Yi. He himself rode around in a plain coach drawn by white horses, uncovered his arm, and wailed loudly while his whole army mourned and lamented.

After three days Liu Bang sent messengers to all the nobles, saying, "All of Us Under Heaven together placed Emperor Yi on the throne as our sovereign. Now Xiang Yu has banished and murdered him without cause. This was *da ni wu dao,* 'treason and heresy of the worst kind.' We and our troops are all wearing mourning garments to lament his loss. We are sending soldiers to sail southward down the Yangzi River toward the state of Chu and would like to unite with you, nobles and kings, to attack the one in Chu who has committed this inhuman act and murdered our emperor."

In his attack on Chu, Liu Bang was joined by five other kings who had previously been crowned by Xiang Yu. With Xiang Yu away in Qi, Liu Bang sailed down the Yangtze River with a great army totaling half a million troops and easily captured Pengcheng, Xiang Yu's home city and the capital of Chu.

Liu Bang and his men took over Xiang Yu's luxurious palaces, gardens, treasures, and beautiful women. Night after night they feasted at great banquets and enjoyed themselves.

Receiving the news that Liu Bang had taken Pengcheng, Xiang Yu took immediate action. Leaving his generals to continue the siege of Chengyang in Qi, he picked only 30,000 of his best troops and rode night and day by way of unfrequented paths back to Chu. At dawn he made a surprise attack against the Han army of Liu Bang and fought a great battle at Pengcheng. By noon he had already crushed it. So many officers and men were killed that the river became blocked with corpses and would not flow. It was estimated that over 100,000 Han soldiers died.

Liu Bang himself was surrounded by Xiang Yu's soldiers and about to be captured. Suddenly a great wind arose from the northwest, toppling trees and blowing away houses, stirring up so much sand and gravel that the day became dark and it was difficult to see anything. During the confusion Liu Bang quickly escaped with a few cavalrymen. He went by way of his hometown of Pei, hoping to find his family. But his family had already fled.

On the road west back to the Land Within the Passes, Liu Bang happened to see his two children hurrying along in panic among a crowd of refugees. It had been four years since he had last seen them. At first they were all delighted to see one another, and Liu Bang carried them into his chariot. But Xiang Yu's cavalrymen continued to pursue them. Liu Bang pushed the two children onto the road so that his chariot could travel faster. But his driver and personal assistant Xia (the same man who rescued General in Chief Hahn Xin from execution) gathered them back into the chariot. He looked reproachfully at Liu Bang and said, "Even though this road is fraught with hazards, by continuously whipping the horses so fiercely you will not make them run any faster. Neither should you throw away your own children!"

Liu Bang's wife and father were trying to flee by unfrequented paths, but they were captured. Xiang Yu placed them under guard and held them hostage, taking them with him wherever he went.

When the other nobles saw that Liu Bang had been defeated, they all fled and some even defected back to Xiang Yu. Liu Bang encamped at the city of Jungyang and replenished his troops and provisions. He built a walled road connecting the city to the Yellow River in order to be supplied with grain from the Ao Granary nearby.

Xiang Yu several times invaded and captured the walled road of Han, thus depriving the Han army of food. In June of 204 B.C.E. Xiang Yu besieged Liu Bang at the city of Jungyang. Liu Bang begged for peace, suggesting that Xiang Yu should rule the area east of Jungyang while Liu Bang would govern the territory west of Jungyang. Xiang Yu was tempted to accept, but his Second Father, Old Man Fan, objected. "Don't do it!" Old Man Fan advised. "You have him cornered, and he needs peace desperately to survive right now. If you do not take this golden opportunity to destroy him, you'll regret it one day."

Liu Bang was very much worried about Old Man Fan's cunning and decided to adopt a special plan devised by an adviser called Chen Ping. Chen Ping was a brilliant thinker who had defected from Xiang Yu after the latter accused him of being disloyal. He was familiar with Xiang Yu's paranoid tendencies.

Liu Bang gave a war chest of 40,000 catties of gold to Chen Ping to carry out his plan. With this gold, Adviser Chen Ping bribed the officers in daily contact with Xiang Yu and told them to spread the rumor that Old

Man Fan was planning to rebel and was in secret contact with Liu Bang. The next time Xiang Yu's messenger arrived at Liu Bang's camp, a most sumptuous banquet with the best foods, including pork, lamb, beef, and wines, was laid out in front of him. As soon as he walked into the room, Liu Bang pretended to feign surprise and exclaimed, "I was told that Old Man Fan's messenger was lunching with me! But are you not the messenger of Xiang Yu instead?" Thereupon Liu Bang ordered that the best dishes be removed, replacing them with inferior fare.

The messenger returned and reported everything to Xiang Yu. Liu Bang was entirely successful in his *fan jian ji,* "stratagem of sowing discord between his enemies." Xiang Yu began to suspect Old Man Fan of treason and started to strip away his power. The two quarreled frequently and were now often at odds with each other. Feeling unappreciated, Old Man Fan finally said angrily, "Since all the major matters under Heaven have already been settled, I'm sure Your Majesty will be able to decide everything for yourself from now on. I beg to be allowed to retire and spend the remaining years in my village home."

Xiang Yu readily gave his consent. Old Man Fan left in a huff, full of anger and resentment. Halfway south on the road to Pengcheng, he developed a malignant ulcer on his back and died.

In spite of this, Liu Bang's predicament within the city of Jungyang was becoming desperate. It was July, and he had been besieged for three months.

One night Liu Bang sent out more than 2000 armor-wearing women by the east gate. Xiang Yu's troops attacked them from all sides. Meanwhile, one of Liu Bang's officers, named Ji, mounted the king's imperial chariot, with its distinctive yellow canopy and plumes of pheasant feathers attached to the bit of the left outside horse, saying, "Our food is finished. I, the King of Han, hereby surrender!" Hearing this, Xiang Yu's soldiers all called out, "Long live Our Majesty!" and rushed to the east gate to surround the imperial chariot and capture the pretended King of Han.

In the confusion, Liu Bang slipped out of the western gate with a few cavalrymen and fled.

Xiang Yu approached the imperial coach, recognized Officer Ji, and asked, "Where is Liu Bang?"

Officer Ji replied, "He has escaped and is no longer in the city."

Whereupon Xiang Yu burned Officer Ji to death.

. . .

Back in the Land Within the Passes, Zhang Liang advised Liu Bang to deploy various generals to attack Xiang Yu on several fronts simultaneously. For a whole year Liu Bang kept Xiang Yu scurrying hither and thither fighting one battle after another. Finally, in July 203 B.C.E., Xiang Yu stormed the city of Jungyang and captured its defender, Grand Secretary Zhou, alive.

Xiang Yu said to Zhou, "If you agree to defect to my side, I will make you a top general and appoint you with an income of 30,000 families."

But Zhou derided him and said, "Unless you surrender to Liu Bang forthwith, you will soon become his captive. You are no match for him."

Enraged, Xiang Yu boiled Zhou to death.

Mad Master, Li Shiqi, now approached Liu Bang and said, "I have noticed that Xiang Yu has one glaring weakness. He does not pay enough attention to the question of food. An army fights on its stomach, and no hungry army survives for long. Now Xiang Yu has taken the important city of Jungyang. Just outside Jungyang is Chengkao and the huge Ao Granary, which contains enough grain to feed the entire state of Qin for at least two years. Having captured this vital edifice, Xiang Yu does not seem to recognize its significance.

"He who can pick out the essence of what is most important will be able to possess All Under Heaven. If one lacks that ability, then there is no possibility of long-term success. To a king, the support of his people is the essence of what is most important. But to the people, *min yi shi wei tian,* 'the essence of what is most important is food.' Therefore, of Everything Under Heaven, nothing is more important than food.

"As for the Ao Granary, I hear that its capacity is immense and the grain there plentiful. Xiang Yu neither pays attention to the Ao Granary nor guards it with care. He has transferred his best troops eastward and left only a few soldiers with disciplinary problems to man the granary. Xiang Yu's lack of perception is Heaven's gift to us. You must get the Ao Granary back as soon as possible and never allow it to be retaken again."

◆

As mentioned previously, after I recovered from pneumonia at the age of thirteen, my stepmother allowed me to recuperate at home for one week. I was still weak and spent a lot of time resting in the room I shared with my grandfather. Neither of us realized that it would be our last summer together.

To while away the time, we used to play chess hour after hour. At one point, during a hard-fought game, while my attention was diverted in trying to capture one of his knights, he checkmated me. Immediately he took down his copy of Shiji *from the bookshelf and read me the section containing the biography of Mad Master Li Shiqi.*

"I have often thought that life is similar to a game of chess,"Ye Ye said. "According to Mad Master, 'He who can pick out the essence of what is most important will be able to possess All Under Heaven.' In playing chess, the king is the most important piece and must be guarded at all times. Before you make a move, any move, look and see whether your king is being threatened. Protecting your king, and taking the opponent's king, is the essence of the game of chess. If you lose your king, you lose the game even though all your other pieces are intact.

"In life, health is the essence of what is most important. By the word health, *I include physical, mental, and emotional health. Think of life as a number. Health is represented by the number one. Delineate the rest of life by adding a zero for each attribute you attain: education, spouse, friends, money, car, house, and so forth. You end up with a number such as 1,000,000,000,000,000,000,000,000,000,000,000,000. No matter how many zeroes you manage to accumulate, when you lose your health, the number one gets erased. What do you end up with? A big bunch of zeroes!"*

After the death of our father in 1988, our stepmother, Niang, summoned her five stepchildren back to Hong Kong to attend his funeral. Of her own two children, one had died from polio at the age of thirteen and the other she had disowned after a quarrel fifteen years earlier. By 1988 Lydia had already successfully poisoned Niang's mind against me, but I was not aware of it.

They wished to involve my brother James in their plot, so Niang told everyone that Lydia was staying with her at her flat on Magazine Gap Road during Father's funeral. In actuality, Lydia stayed with James at his flat. My two other brothers and I were put up in a small hotel nearby.

Throughout the week that I was in Hong Kong, I believed that Lydia was staying at my stepmother's flat. By obeying Niang's commands and keeping Lydia's lodging place during that period a secret from me, James was forced into playing their vicious and soul-destroying game. Worse than that, he had to involve his wife, his children, and his servants in the falsehood.

I only found out the truth years later, from Niang's two live-in maids, who assured me that Lydia never stayed with Niang while she was in Hong Kong. The

knowledge saddened me greatly. I asked them to speculate why Niang resorted to such lengths to involve James in perpetuating so meaningless a lie.

They said, "Min xiu zhan dao, an du Chen Cang! 'Ostensibly repairing the plank roads, in actuality crossing via Chen Cang!' "

It must have sounded pretty harmless and trivial when Niang first mentioned to James her plans to deceive me. My poor brother probably had no idea that Niang and Lydia were in the midst of hatching an elaborate fan jian ji, *a "plot to sow discord and create enmity." By including James in their fraudulent conspiracy, not only did they drag James down to their level, they also managed to destroy the trust between my brother and me.*

The Heart of the People Belongs to Han

人心歸漢

Ren Xin Gui Han

Gilt bronze lamp from the Western Han
dynasty, late second century B.C.E.

*A*lthough *I lived the first fourteen years of my life in China, my teenage and adult years were spent in England and America. From time to time I have been asked, "Do you still consider yourself Chinese?" Also, "What is the essence of being Chinese?"*

The truth is that when I am among Americans (such as my Chinese-American husband, Bob, who was born and bred in America) and conversing in English, I feel American. But when I am among Chinese people and speaking Chinese, I feel Chinese.

Concepts are expressed by words. If certain English words are absent in Chinese, it follows that the concept expressed by those English words will be absent in China, and vice versa. The language we speak, therefore, affects our thoughts and reasoning.

My grandfather spent the last three years of his life living with my parents in Hong Kong. Since he could not speak the local Cantonese dialect, he spent most of his time reading. He read the newspaper regularly, but outside of that his reading gradually became limited to only three books: the I Ching, Shiji, *and the Chinese dictionary.*

Once I asked him why he restricted his reading to these three particular books. Looking at me thoughtfully, he replied, "I used to read widely, but nowadays I've lost all interest in reading fiction or make-believe. Maybe it has something to do with my age. Only true events happening to real people interest me anymore. That is why I read the newspaper. As for books, I consult the I Ching *whenever I need help in making difficult decisions. I study the dictionary if I don't know a certain word. But I read* Shiji *because it is the foundation of China's civilization and culture. For me personally, these three books define the essence of being Chinese."*

◆

Although Liu Bang was able to alienate Xiang Yu from his adviser, Old Man Fan, by the clever use of a *fan jian ji*, a "plot to sow discord and create enmity," he continued to be dominated militarily by Xiang Yu in the south. Meanwhile, General in Chief Hahn Xin was fighting Scholar-General Chen Yu for supremacy on a separate front in the north.

Chen Yu and Zhang Er were both Confucian scholars from the state of Wei. After the First Emperor annexed Wei in 226 B.C.E., the two scholars joined a secret society aimed at restoring the deposed aristocrats and resurrecting the banned teachings of Confucius. The Qin authorities placed a price on their heads. They fled to Chu and disguised themselves as watchmen. During this period, although Chen Yu was much younger than Zhang Er, the two developed *wen jing zhi jiao*, "a friendship so close that they would risk having their throats cut rather than betray each other."

When the frontier guards revolted in 209 B.C.E., the two friends went north and joined the revolution in Zhao. They established a scion of the old ruling family of Zhao, named Zhao Xie, to be King of Zhao.

After Treasurer Zhang Han killed Fourth Uncle Xiang Liang and defeated his army, he turned his attention northward toward the state of

Zhao. King Zhao Xie fled with Scholar-General Zhang Er to the city of Julu, where they were besieged by the Qin army. However, Scholar-General Chen Yu happened to be away at that time with a force of 50,000 men. Zhang Er repeatedly asked Chen Yu to come to their rescue, but Chen Yu did not do so. As a result, the two friends had a falling-out. Eventually, Xiang Yu relieved the siege by routing the Qin army at the battle of Julu. Chen Yu then wrote the famous letter to Treasurer Zhang Han that convinced the Qin commander to defect to Xiang Yu, thereby leading to the downfall of Qin.

Soon after their victory at Julu, Zhang Er followed Xiang Yu when the latter marched triumphantly into Xianyang. Feeling bereft because his contribution toward the war effort had not been sufficiently appreciated, Chen Yu left in a huff and went fishing. Perhaps because of Chen Yu's absence at this critical juncture, Xiang Yu made Zhang Er the new King of Zhao but gave Chen Yu only three small counties to govern when he divided the empire. Chen Yu was so insulted that he "borrowed" troops from the rebellious King Rong of the state of Qi to attack his erstwhile friend Zhang Er. After defeating Zhang Er on the battlefield, Chen Yu further defied Xiang Yu by welcoming back the former Zhao Xie as King of Zhao.

Driven from his throne, Zhang Er fled. Instead of turning to Xiang Yu for justice, however, he decided that Liu Bang had the better future. He betrayed his former benefactor by beheading Xiang Yu's relative Xiang Ying and presenting his head to Liu Bang as a gift. The latter was delighted and immediately gave Zhang Er refuge. The two got along so well that Liu Bang betrothed his daughter to Zhang Er's son. Liu Bang then sent Zhang Er north to help General in Chief Hahn Xin launch a battle against Chen Yu for Zhao.

As General Hahn Xin's forces neared Zhao, a scholar named Li approached Chen Yu and advised, "There is an old saying that 'when food has to be transported over great distances, troops run the risk of getting nothing to eat; when wood has to be chopped on the run for cooking, soldiers' stomachs will be half empty.'

"General Hahn's army has to travel a long distance over wild and mountainous terrain in order to reach us here in Jinjing. The roads are rough and difficult even for horses, let alone chariots. After a couple of hundred miles, their food carts are bound to fall behind. I beg Your Highness to 'lend' me 30,000 troops. I will take a shortcut, slice off their food carts, and destroy

them. Meanwhile, Your Highness will remain safe behind your fortress. No matter how much they provoke you, simply stay within your barracks and do not engage them in battle. After a few days of hunger, they will face the terrible dilemma of not knowing whether to advance or retreat.

"When they do turn back, our troops will await them on their route and ambush them. This way, they will not be able to forage for food from our countryside and fight a protracted guerrilla war. I predict that within ten days I will be able to present you with the heads of General Hahn and Zhang Er on a plate."

Scholar-General Chen Yu prided himself as a Confucianist, high-minded and righteous. Even in battle, he despised subterfuge and believed in honor. So he said, "It is written in the *Art of War,* 'If you outnumber the enemy ten to one, surround them. If you outnumber the enemy two to one, fight them.' Although General Hahn claims to command an army of tens of thousands, in reality I think the number is closer to a few thousand. Besides, they come to us after having traveled a great distance and must be exhausted. If we don't fight them while their numbers are small and they are tired, how will we cope when their main army arrives in full force? Besides, if I hide within my barracks and avoid combat, the nobles from all the other states will perceive Zhao as being weak and vulnerable and might even send troops to invade us themselves."

General Hahn sent spies to gather military information in advance and was delighted to hear that Chen Yu was going to tackle them head-on without subterfuge. About nine miles from the city of Jinjing, Hahn ordered his troops to encamp for the night.

At midnight, General Hahn alerted his troops. He selected 2000 light cavalrymen and issued to each a red Han flag. (Red was the color chosen by Liu Bang to be the symbol of Han.) He led them up a mountainous path to the back of the Zhao barracks, hid them behind bushes, and bade them to watch secretly the movement of the Zhao troops. He cautioned them and said, "When Chen Yu sees our army retreating, he will order his troops to leave their camp en masse to pursue us. Take that opportunity to rush into their barracks. Remove all the Zhao flags and hoist our red Han flags instead."

Then he ordered that food boxes be prepared and issued to the soldiers, telling his officers, "Spread the word to the men that we will meet after defeating the Zhao army and eat our dinner together this evening at leisure."

None of General Hahn's officers believed him because they knew themselves to be outnumbered. At that time, General Hahn had barely 30,000 soldiers, whereas Chen Yu had 200,000, a ratio of six and a half to one. To humor their commander, they all nodded and said, "Yes!"

General Hahn deployed 10,000 troops halfway down the slope and arrayed them with their backs against the river. The Zhao forces watched from above and laughed at their manifest stupidity. Hahn's men then unfurled a series of tall red flags and hoisted them as they marched up the hill toward the Zhao barracks, accompanied by the beating of military drums. About half of the Zhao army came out, and the two sides fought.

After a while, General Hahn and Zhang Er pretended to abandon their drums and flags on the ground while ordering a retreat to the riverbank. Hoping for a quick victory, the Zhao army followed in hot pursuit, and the two sides fought again by the river.

Seeing General Hahn's drums and red flags littering the slope and expecting a rout, the rest of the Zhao army rushed out of its camp in full force to join the chase and hunt for war trophies.

As soon as General Hahn's hidden cavalrymen saw the mass exodus of the Zhao army, they galloped into the Zhao barracks and replaced the Zhao flags with 2000 red Han flags.

Noon arrived. They had fought for many hours and were at a standstill. The Zhao army was ordered to turn back. It was only then that they discovered the walls of their barracks covered with Han's red flags fluttering in the autumn breeze. The Zhao troops were greatly alarmed, suspecting that Han had somehow already won the battle and taken their leaders captive. A panic ensued, and they trampled over one another as they rushed to escape.

Taking advantage of the confusion, General Hahn ordered a massive attack, which completely routed the terror-stricken Zhao army. Chen Yu was beheaded, and King Zhao Xie was captured.

Having heard of Li's reputation for wisdom, General Hahn gave the order that Chen Yu's adviser, Li, was to be taken alive. The soldiers were told that whoever delivered Adviser Li unharmed would be given a reward of a thousand pieces of gold. Soon Li was brought in front of him.

General Hahn unbound Li's fetters himself and invited him to sit in the seat of honor facing east while he himself sat facing west. Many officers

came forward to present their captives as well as various enemies' heads. After rendering their congratulations, one of them asked, "In the *Art of War*, it states that the most advantageous position for an army is to have mountains to the right rear and rivers or marshland to the left front. Yet this time you ordered us to fight with our backs to the water. You also predicted that victory would be ours by dinnertime. Please tell us your reasoning."

General Hahn replied, "It's all written in the *Art of War*. You haven't noticed it, that's all. The book says, *Zhi zhi si di er hou sheng!* 'Confront a man with the danger of death, and he will fight to live.' I placed all of you in a life-threatening situation with your backs against the river to motivate you. If you had had an easy escape route, the temptation of flight would have been on your mind constantly and you would not have fought so valiantly."

General Hahn now turned to Li and asked, "I would like to turn north and attack Yan, then go east and conquer Qi. How should I go about it?"

Li replied, "An officer from a defeated army should no longer claim bravery. A minister from a conquered nation should not cherish high hopes. Here I am, your prisoner! How dare I discuss matters of import with you, my conqueror?"

General Hahn said, "I have heard of a man in ancient times who, while he was working as a minister in Yu, Yu was conquered. But when he became a minister in Qin, Qin prospered. This was not because the same man was stupid in Yu and suddenly turned smart in Qin. It's a question of whether he was used or not used by his king and his ideas adopted or denied. If Chen Yu had embraced the strategy that you advised, then I would probably be your captive today. It's only because he rejected your suggestions that I am given the chance to be your student. Please believe that I am entirely sincere in wishing to learn from you."

Li replied, "Although it is true that *zhi zhe qian lu, bi you yi shi*, 'the wisest among us are not always free from error,' *yu zhe qian lu, bi you yi de*, 'yet even a fool sometimes hits on a good idea.' *Kuang fu zhi yan, sheng ren ze yan*, 'learned men have said that the ranting and raving of a madman is sometimes appropriate.'

"Notwithstanding the fact that my stratagem may not be suitable, through it I wish to express to you my gratitude and loyalty.

"As for Chen Yu, I once placed in his hands a war plan that would have worked a hundred out of a hundred times. But he rejected it. The

result is that he lost the war within the short time of one single morning and paid for it with his life.

"Regarding Your Highness, today I saw you vanquish 200,000 Zhao soldiers with only 30,000 of your own. In spite of your great victory, however, your soldiers may be tired. Should you attack Yan just now, you might not be successful even after a long and protracted siege. Those who are skilled at war should never use weakness to attack strength, but always use strength to attack weakness."

General Hahn asked, "So what should I do?"

"In my opinion," Li replied, "you should give your officers and men a period of rest and relaxation. Govern Zhao benevolently. Nurture and tend to Zhao's orphans and children. When you do this, the people will welcome you with wines and meats and other sumptuous foods. Reward your soldiers liberally and console the wounded. Only when they are well rested should you turn north toward Yan.

"Instead of an army, I would send a diplomat armed with only a short letter, telling the King of Yan your true military strength. I predict that the King of Yan will submit to you. Next send your diplomat east to Qi. By then even the wisest adviser under Heaven would not be able to find a way out for Qi, and I'm sure Qi will submit as well. After that, Your Highness can draw a great plan for All Under Heaven.

"As soldiers, we should always practice *xian sheng hou shi,* 'discussion first and military force later.' This is the stratagem that I would use if I were you."

General Hahn adopted his advice and sent a messenger with a letter to the King of Yan. Sure enough, the King of Yan submitted. Hahn Xin reported the good news to Liu Bang and recommended that Zhang Er be appointed King of Zhao.

Meanwhile, Liu Bang himself was encamped at Chengkao, a small city close to Jungyang, planning to take back the Ao Granary. Xiang Yu, who held Junyang, now besieged Chengkao. Leaving behind his army, Liu Bang fled from Chengkao in his chariot toward Zhao, accompanied by only his driver, Xia. After spending the night at a guest house, Liu Bang galloped by himself at dawn into the barracks of General Hahn Xin and Zhang Er. He was told that they were still sleeping. Calling himself a messenger, Liu Bang slipped into General Hahn's tent and took the seal and tally

entitling him to the command of Hahn Xin's army. He summoned the officers and proclaimed himself as commander in chief of all of Han's armed forces. Only then did General Hahn and Zhang Er find out that Liu Bang was with them. They were greatly astonished.

Liu Bang then appointed Zhang Er as King of Zhao and ordered him to raise fresh troops in Zhao. He made General Hahn Xin his prime minister and ordered him to go east and invade the state of Qi with the surrendered army of Chen Yu.

Taking over General Hahn's original army, Liu Bang went south again. Xiang Yu had taken Chengkao and maintained control of the Ao Granary. This time Liu Bang strengthened his defenses but would not engage Xiang Yu in direct battle. Instead, Liu Bang sent troops to aid the guerrilla fighter Peng Yue, who was harassing Xiang Yu's forces in Chu and burning his food supplies.

While this was going on, Mad Master suggested that Liu Bang send him to Qi so that he might persuade the new King of Qi (Rong's son Guang) to submit to Liu Bang. Qi bordered Chu, and the King of Qi had a force of 200,000 soldiers. With Qi on their side, Liu Bang could attack Xiang Yu from the rear as well as the front and force him to fight on two fronts.

Since General Hahn was busy drilling his newly raised army with Zhang Er in Zhao, Liu Bang did not deign to inform them of his plans but merely sent Mad Master to Qi as his *shuo ke,* "persuasive talker."

Face-to-face with the King of Qi, Mad Master asked, "Does Your Majesty know what is the true inclination of the people everywhere?"

"No, I do not."

"Only if Your Majesty understood the true inclination of the people would you be able to protect and safeguard Qi."

"Tell me then," the King of Qi asked, "what *is* the true inclination of the people everywhere?"

"*Ren xin gui Han,* 'the heart of the people belongs to Han,'" Mad Master replied.

Ren xin gui Han has become a well-known proverb. It encompasses and expresses the emotion Chinese people feel toward China. In 1984, when Margaret Thatcher signed the historical agreement with Deng Xiaoping ceding Hong Kong back to China in 1997, an American friend of ours who was in the oil business was visiting

a small city in Liberia. To his delight, one day he came across a shabby but clean Chinese restaurant. Inside, there were no pictures on the walls, only two long strips of red paper with large black Chinese characters. He took a photo and showed it to us on his return to California, asking for the meaning of the words. One paper read "1997" (in Chinese), and the other paper read ren xin gui Han, *"the heart of the people belongs to Han." Our friend was astonished that a Chinese restaurant owner thousands of miles away in Liberia would care sufficiently about Hong Kong's return to China to place such a proverb on his wall.*

In 1997, when Hong Kong was ceded back to China, 155 years of British colonial rule ended. In the newspapers of Hong Kong and Taiwan, many editorials and letters discussed the pros and cons of this historic event. "When all is said and done," one paper reported, "despite the reservation many of us have regarding Communist rule, the majority of Hong Kong people still prefer to be part of China. Why? The reason is very simple. Ren xin gui Han, *'the heart of the people belongs to Han.' "*

Mad Master then analyzed the political situation for the King of Qi, comparing and contrasting the personalities of Liu Bang and Xiang Yu. By the end of the meeting, the king had agreed to submit and enter into an alliance with Liu Bang against Xiang Yu.

Meanwhile, after preparing his army for battle readiness in the state of Zhao, General Hahn was about to cross the Yellow River to Qi when he heard of Qi's submission to the Mad Master. He began to halt his troops, but his political strategist, Kuai Tung, approached him and said, "Your Highness received orders from Liu Bang to attack the state of Qi some time ago. Later, Liu Bang arranged for Mad Master to go separately and prevail upon the King of Qi. Did Liu Bang ever withdraw his order to you or command you to halt your invasion at any time? No, of course not! If he hasn't given you a direct order to stop, why should you stop?

"Besides, Mad Master is only a scholar, not a military man. Using his *san cun zhi she,* 'three inches of immortal tongue,' he weaves a spell over the King of Qi, persuades him to surrender, and secures more than seventy cities in one fell swoop! In contrast, Your Highness has spent over a year on one battlefield after another, risking your life and the lives of 30,000 soldiers, in order to conquer just fifty cities. So, is your blood and sweat then worth less than the rant of a garrulous Confucianist?"

When he heard this, General Hahn became agitated. He decided to cross the Yellow River and continue eastward toward Qi.

Back in the capital of Qi, Mad Master was being royally entertained by the King of Qi after the signing of their treaty. Garrison duty was called off, and army officers were instructed that Han troops were now their allies. Encountering no resistance whatever, General Hahn's army rolled across and easily routed the Qi army. In no time at all, they were encamped outside Qi's capital city.

Alarmed and suspecting entrapment, the king berated Mad Master vehemently for betraying his trust. Angrily, he ordered Mad Master to halt General Hahn's advance immediately. Mad Master was surprised and confused at the turn of events. Not realizing that General Hahn had ulterior motives and a separate agenda, he nevertheless refused to intervene.

"Your Majesty," Mad Master said, "I cannot do so. General Hahn and I both work for Liu Bang. Apparently, he and I were separately deployed to Qi for reasons that have not been disclosed to me. Please believe that I hardly understand what's happening myself. Far be it that I should betray Your Majesty. By refusing your request to address General Hahn, I fully recognize what is going to befall me. But for a great man like Liu Bang, who is deciding the fate of All Under Heaven, it is perhaps impossible to worry about minor details such as the life of a Confucian scholar like me. So be it."

Mad Master knew perfectly well what awaited him. The King of Qi gave the order, and Mad Master was boiled to death in a giant wok.

◆

When I was a little girl in Shanghai, one of my greatest pleasures was writing kung fu novels. I could spend an entire day crafting such stories at my desk. It thrilled me to be able to forget the horrors of my daily life in such a simple way. In my stories I was no longer the unwanted little girl who caused my mother's death. Instead, I could be anyone I wished.

I often dreamed about running away from home, going to the mythical E Mei mountains in Sichuan Province, and becoming an apprentice to a you xia, "knight-errant," skilled in martial arts. My master would resemble a monk and dress in coarse russet robes. But he was actually a prince in disguise and extraordinarily skillful, able to break stacks of bricks with a single blow of his hand or topple muscular opponents twice his size with lightning-quick tackles.

While researching the meaning of the proverb ren xin gui Han, *"the heart of the people belongs to Han," I hoped to discover the cultural essence behind the foundation of my own Chineseness. To my surprise, I found that there was a long tradition of knight-errantry in China that was first described by Sima Qian in* Shiji *and termed* jiang hu wen hua.

There is no exact equivalent for jiang hu wen hua *in English. Literally, the four words mean "culture based on rivers and lakes" or "culture based on knights-errant drifting about every corner of the world defending the weak and helping the oppressed." Skilled in martial arts, these* you xia, *"knights-errant," do not care about status, money, or power, only about ethics, freedom, and chivalry.*

Unlike my grandfather, who limited his reading to only three books for the last few years of his life, I have gone back to the Chinese literature of my childhood. Once more, my mind is being gripped by the fearless kung fu heroes of yore who were "so limber that they seemed to have no bones, so silent that their footsteps sounded like sighs, so powerful that they jumped from rooftops like tigers, so agile that they scaled the walls like flies."

Perhaps my quest for the essence of what makes me Chinese will lead me back to the place from which I came, sitting and writing by the window in the same room on the second floor that I used to share with my Aunt Baba in Shanghai so many years ago. With hindsight, I'm beginning to understand that my childhood dreams of knight-errantry were very much part of the fabric of my Chinese heritage. The truth is: like a billion or more other Chinese, I have come to know that part of my heart also belongs to Han.

The Human Heart Is Difficult to Fathom

人心難測
Ren Xin Nan Ce

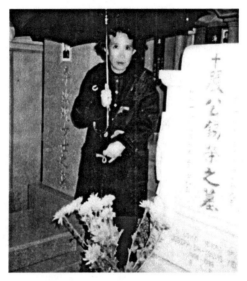

Me in front of Father's tomb in North Point
Cemetery, Hong Kong, December 1989.

*S*ince *becoming a writer, I have received many letters from readers all over the world telling me about their own family problems. I found that regardless of racial origin, religious affiliation, income level, educational background, or nationality, every family has issues of its own of one sort or another. Intrigues, betrayals, conspiracies, and jealousies simmer and abound behind closed doors in many a home. Disputes usually stem from jealousy over love, money, or control. There are incidents*

in which the entire family becomes embroiled in painful turmoil stemming from the malice of one or two members. Frequently, the instigator is someone who is middle-aged, unhappily married, saddled with financial problems, and unable to keep a job. These people compensate for their lack of self-esteem by wreaking havoc.

My sister Lydia was just such a woman. In hindsight, I now realize that she must have hated me on sight when she met my plane at Beijing Airport after a separation of thirty years. Here was I, the little sister whom she had always despised, returning to China in triumph as a respected, Western-trained physician from California. Worst of all, Lydia had to eat humble pie in front of her children and beg for my help to get them educated in America. Like a beast of prey, she marked me, made her plans, recruited Niang, swore her to secrecy, then lay in wait patiently before pouncing.

Nine months before she died, Niang invited me and my family to visit her in Hong Kong. I did not know it then, but she had already disinherited me. Her friendly gesture was a sham, tendered deliberately to torment me so that the hurt would be that much more excruciating because of the element of shock. While we were there Niang played a cat-and-mouse game with me, first agreeing to an intimate tête-à-tête with me and then canceling at the last minute. This happened four times.

The evening before our departure, Bob and I invited Niang, my brother James, and his family out for dinner at a Chinese restaurant. When James arrived he brought us Niang's apologies. She was feeling unwell and would not be coming. I expressed disappointment and told James that I would get up early the next morning to pay Niang a visit before departing for the airport. James pretended to approve. However, at the end of the meal he suddenly turned to me and said, "What do you say if I pick you up at 6 A.M. tomorrow morning and the two of us drive to North Point Cemetery to pay a visit to Father's grave?"

As I write, the memory of that gloomy, overcast morning comes back to me clearly. James picked me up at my hotel at the crack of dawn. When I got into his car, I saw with a pang that in his usual thoughtful way, he had brought along a big bouquet of flowers to be placed at Father's grave.

We stood side by side under a large black umbrella while the rain pelted down all around. I felt very close to my brother as we reminisced about our past. I reminded him of the time years ago in Shanghai when he had helped me bury my pet duckling PLT. Tears coursed down my cheeks, and I could hardly speak. Without a word, James fished around in his pockets and handed me his large white handkerchief.

I would like to believe that there was a little bit of genuine emotion on James's part that morning. What a clever move to suggest a trip to Father's grave! I was, of

course, totally taken in and diverted. By the time we got back to the hotel Bob was checking out and arranging a taxi to Kai Tak Airport.

I never saw Niang again, let alone face-to-face by ourselves. At the airport I tried repeatedly to phone her, but her line was always busy. At one point I remember asking James, who was seeing us off with his family, "Does she speak on the phone a lot?" And he answered smoothly, "Sometimes she takes the phone off the hook when she wishes to rest."

I have neither written to nor heard from James again since the publication of my autobiography. From time to time I am tempted to try to contact him. I want to tell him that I love him and that I wish him well. But I am also aware that I am the last person he wants to see because I remind him of everything he wishes to forget. In spite of this, I hope he also realizes deep down that I will always be there for him, for as long as I live, should he need me in any way.

I prefer to remember him the way he used to be, the sweet-faced gentle big brother who always understood without anything being said. The best times we spent together were probably those Sunday afternoons during our student days in England. I would take the day train from London to Cambridge and visit him in his medieval college rooms. Hour after hour we'd drink instant coffee brewed on his portable electric heater while sharing memories, exchanging jokes, learning each other's minds, and discussing every subject under the sun. In those days betrayal and duplicity were inconceivable. Our friendship was rare and true. The future was limitless. We trusted each other implicitly. Our freedom was intoxicating, and we shared a sympathy so deep that nothing needed to be explained.

Toward the end of his last year at Cambridge, I remember telling James about Karl, my professor and boyfriend, with whom I was having a very hard time. James was walking me back to the train station, looking very handsome and impressive with his Cambridge scarf around his neck and his black college gown flapping in the breeze.

"He is not the right one for you," James finally said, walking so fast on the cobblestones that I was forced to trot after him in my high heels.

"How do you know? You haven't even met him."

"I don't have to meet him to know. Besides, I know you."

"How about coming to London next Sunday so you can see for yourself?"

He stopped so suddenly that I almost ran into him. He thought for a while, then slowly shook his head no. In the silence, I could hear the church bells all around us ringing out their chimes for evensong.

"But why not?" I finally asked, so disappointed I felt like crying.

"Because it's a waste of time!" he said. "Can't you see that he is taking advan-tage of you? Get away from him. Just because you want a permanent relationship does not mean that he wants the same thing. How does that proverb go? Ren xin nan ce, *'the human heart is difficult to fathom.' "*

I found out much later that the proverb ren xin nan ce *was first written by Sima Qian to describe the demise of another relationship. I was fascinated to come across this same phrase in the well-thumbed copy of* Shiji *at the library of the Univer-sity of California, Irvine, while doing research for this book.*

◆

As soon as Xiang Yu heard that Hahn Xin had routed Qi's army and intended to invade Chu, he responded immediately to Qi's request for aid and sent 200,000 soldiers under the command of Officer Long, one of his favorite followers.

An adviser from Qi came to Officer Long and said, "General Hahn's army has traveled a long way. Moreover, we have the advantage in that this is our home territory. I recommend that you strengthen your defenses but do not fight them directly. Tell the King of Qi to link up with the minis-ters governing the enemy-occupied cities of Qi. When they learn that their own king is leading the resistance with the help of Xiang Yu's troops, they will rise up against General Hahn's rule. The Han troops are more than five hundred miles away from home. If the people of Qi should unite and revolt against Han, the invaders would not have enough food and would have to surrender without a battle."

General Long replied, "General Hahn and I are both natives of Chu. I understand him well. My lord, Xiang Yu, has ordered me to rescue the King of Qi. If I should induce General Hahn to surrender without a battle, what service would I have rendered? On the other hand, if I should defeat General Hahn on the battlefield, I would end up with half of Qi as my own personal kingdom. Why shouldn't I take him on?"

Hahn Xin and Officer Long faced each other across the River Wei (present-day Shandong Province) and set out their battle formations. Gen-eral Hahn ordered that 10,000 sandbags be made and filled with sand. In the depth of night, he secretly positioned the bags so as to block the flow of water from the upper reaches of the river. Then he picked the best

swimmers from his army, marched them halfway across the river, and launched an attack with crossbows and spears. When the enemy resisted, Hahn Xin feigned defeat and retreated hastily. Observing their withdrawal, Officer Long said happily to his adviser, "I knew that Hahn Xin is timid!"

Officer Long's troops sprinted across the semidry riverbed in hot pursuit. When they were at their most vulnerable position, General Hahn instructed that the sandbags be removed. The pent-up water came rushing down the river, trapping Officer Long's troops and drowning most of them, including Officer Long. The rest surrendered or were captured. It was again a total victory for Hahn Xin.

While General Hahn was vanquishing Officer Long in Qi, Liu Bang and Xiang Yu were fighting each other over Chengkao and the Ao Granary.

Having fortified himself with 30,000 soldiers from the original army of General Hahn after his visit to Zhao, Liu Bang felt powerful again. He returned to a site close to Chengkao, fed his soldiers with sumptuous meals, and prepared to engage Xiang Yu in battle once more. His advisers, however, cautioned him not to challenge Xiang Yu directly but instead to assist the guerrilla fighter Peng in his partisan efforts. Liu Bang, therefore, sent 20,000 soldiers and several hundred cavalrymen into Chu territory to assist Peng in destroying Xiang Yu's food stores. Their combined forces attacked and routed the Chu army just outside Yan, capturing seventeen cities in the process.

Alarmed at Peng's success, Xiang Yu left Chengkao temporarily and led his troops eastward to attack Peng. While he was gone Liu Bang advanced across the Yellow River and again took Chengkao. He encamped at Guangwu, reoccupied the Ao Granary, and guarded it with a crack regiment of his best troops.

Although Xiang Yu was winning against Peng and had subjugated over ten cities, the reports that reached him from elsewhere were all unfavorable. Chengkao and the Ao Granary had both been retaken by Liu Bang, his own troops were being besieged at Jungyang, and Officer Long had been defeated and killed by General Hahn in Qi.

Xiang Yu rushed back to Jungyang and relieved the siege, but the Ao Granary was now in the possession of Liu Bang, guarded by his best troops. Both Liu Bang and Xiang Yu camped at Guangwu, facing each other for many days but with neither side willing to initiate a battle on the precipitous

and difficult terrain. Able-bodied soldiers of both armies were exhausted from the incessant battles, while the old also suffered from transporting food and other duties. The two leaders were aware of this and one day had a dialogue, shouting to each other across a gully.

Xiang Yu wanted to fight a duel with Liu Bang, but Liu Bang refused. Instead, he rebuked Xiang Yu and listed his ten cardinal crimes. He said, "Right from the beginning you and I agreed to a covenant with the King of Chu, who proclaimed, 'Whoever first conquers the Land Within the Passes will be made its king.' You betrayed this covenant and made me King of Bashu and Han instead. This is your first crime.

"You manufactured a false order purportedly from the King of Chu for the execution of Commandant Song. Actually, it was you who arbitrarily beheaded him, and then you had the gall to name yourself commanding general of the revolutionary army in his place. This is your second crime.

"After you relieved the siege of Julu and rescued the state of Zhao, you were supposed to return to Chu and report to the King of Chu. Instead, you coerced the nobles from the other states to lead their armies and accompany you into the Land Within the Passes. This is your third crime.

"Before we set out, the King of Chu made us promise that our armies would not commit arson, rape, theft, robbery, or murder when we enter the Land Within the Passes. However, not only did you burn the Qin palaces, you also dug up the tomb of the First Emperor and took for yourself his treasures. This is your fourth crime.

"The last king of Qin, King Zi Ying, had already surrendered. Yet you chose to execute him for no reason whatsoever. This is your fifth crime.

"You lured 200,000 young Qin soldiers into surrendering to you and then betrayed them by burying them in a trench. Following this you compromised the Qin generals by giving them kingdoms and making them kings. This is your sixth crime.

"You showed discrimination in your distribution of kingships after the Battle of Julu. You rewarded the best territories to generals whom you personally favored, wantonly displacing their former rulers and exiling them to distant lands, thus inciting widespread treason, rebellion, and chaos. This is your seventh crime.

"You drove out the King of Chu (later Emperor Yi) from Pengcheng and made that city your own capital. You grabbed the best areas of Liang

and the whole state of Chu for yourself and expelled King Cheng of Haan. This is your eighth crime.

"You banished the King of Chu (Emperor Yi) to Jiangnan and then secretly arranged to have him murdered. This is your ninth crime.

"As a subject, you have murdered your king. As a general, you have executed those who have already surrendered. As a ruler, you have been unjust. As a man, you have betrayed your honor by being faithless to the covenant. Such deeds are those that cannot be endured by All Under Heaven. They constitute *da ni wu dao,* 'treason and inhuman conduct of the worst kind.' This is your tenth crime.

"I, Liu Bang, am the leader of a righteous force that, together with the armies of other nobles, are in the process of crushing a cruel and savage traitor. I should send an exconvict to fight a duel with someone like you. Why should I bother myself?"

Hearing this, Xiang Yu became very angry. He shot at him with a hidden crossbow, and the arrow wounded Liu Bang in the chest. But Liu Bang had the presence of mind to make light of his wound in front of his army. He grasped his foot and said, "The coward has hit me in the toe!"

Liu Bang retired to his bed to nurse his wound. But Strategist Zhang Liang urged him to rise, go among his soldiers, and allay their fear over his injury to prevent Xiang Yu from taking advantage of his weakness. Liu Bang did so but suffered greatly. So he went to Chengkao to recuperate.

While he was ill and in pain, a messenger came with a letter from General Hahn that said,

> *Your servant Hahn Xin wishes to report that the defeated King of Qi, Guang, is now a prisoner in my custody and Officer Long has been killed. However, the state of Qi has many bandits who are rebellious and are unhappy with the current situation. Unfortunately, my authority is slight. To the south, Qi shares a common border with the state of Chu, governed by Xiang Yu. Unless there is a strong and proactive ruler stationed in Qi, affairs here may be difficult to control. I would like to be made provisional King of Qi temporarily.*

On reading this, Liu Bang became enraged and said to General Hahn's messenger, "Here I am, stranded in this awful place and afflicted with a deadly wound! Day and night I am hoping that Hahn Xin will come and

rescue me. What do I get instead? A letter from him declaring that he would be King of Qi!"

Hearing this, both Zhang Liang and Chen Ping immediately kicked Liu Bang's foot as a warning and whispered in his ear, "Our soldiers here are not doing too well against Xiang Yu. Besides, how are you going to stop General Hahn from crowning himself King of Qi if he insists? Why not let the situation take care of itself and set him up as king in earnest? Treat him well and congratulate him. Let him rule and defend Qi for his own sake. Otherwise, he might turn on you and rebel."

By then, Liu Bang realized his error himself. Without missing a beat, he continued in the same tone of voice, "Since General Hahn has the ability to vanquish those nobles that cause trouble, then he deserves to be crowned as a proper king. Why does he even bother about wanting to be a 'provisional king temporarily'?"

Liu Bang, therefore, dispatched Strategist Zhang Liang to Qi with the appropriate seals. While officially conferring the title of King of Qi to Hahn Xin on Liu Bang's behalf, Zhang Liang tactfully instructed Hahn Xin to prepare his army for a major assault against Xiang Yu in the near future.

Xiang Yu, meanwhile, was brooding over the death of Officer Long. With him gone and many others defecting, Xiang Yu began to worry for the first time about his own prospects. He sent Diplomat Wu to Qi in an attempt to persuade the newly crowned King of Qi, Hahn Xin, to turn away from Liu Bang.

Diplomat Wu said to Hahn Xin, "The world was burdened by the harsh rule of Qin for a long time. All the nobles then came together and defeated the Second Emperor. Afterward, Xiang Yu divided the Qin Empire and awarded everyone according to his merits. Unfortunately, Liu Bang began to expand eastward to invade the kingdoms of others. After annexing the Land Within the Passes, he organized a combined force against Xiang Yu's kingdom of Chu.

"Liu Bang is an ambitious man. He will never be satisfied until he has taken exclusive possession of All Under Heaven. He is also someone who cannot be trusted. My Lord Xiang Yu held Liu Bang's life in his hands on several occasions but let him go each time out of pity. As soon as Liu Bang was freed he would betray Xiang Yu's trust and turn around to attack him. Faithless! That's what he is!

"Although you consider yourself to be an intimate friend of Liu Bang's, and try your best to fight and scheme constantly on his behalf, you will end up eventually as his captive. The reason Liu Bang treats you well is only because my Lord Xiang Yu is alive and still powerful.

"At present, the struggle for dominance between Liu Bang and Xiang Yu depends to a large extent on you. If you lean toward Liu Bang, then Liu Bang will win. If you lean toward Xiang Yu, then Xiang Yu will win. Should Xiang Yu be destroyed today, then it will be your turn next.

"You and my Lord Xiang Yu knew each other well from the past. In fact, you used to work for Xiang Yu before Liu Bang. Why not declare your independence and enter into an alliance with Xiang Yu? The three of you will control the world with each of you ruling one third.

"If you should ignore this critical moment and continue to help Liu Bang against Xiang Yu, your opportunity will pass and the consequences will not be pleasant for you."

But Hahn Xin replied to Diplomat Wu, "I used to work for Xiang Yu. At that time, I was merely one of his many security guards, holding a spear and standing watch. Xiang Yu neither listened to my advice nor adopted any of my strategies. So I left and joined the ranks of Liu Bang. Not long afterward, I was made general in chief of the Han army and authorized to command tens of thousands of troops. Liu Bang took the clothes off his back to dress me, shared his meals with me, and *yan ting ji cong,* 'listened carefully to all my suggestions.' That is how I reached my present position. Since Liu Bang trusts me so much and treats me so well, it would not be auspicious for me to betray him. I will remain loyal to him until death. Please thank your Lord Xiang Yu on my behalf for his advice."

Political Strategist Kuai independently came to the same conclusion as Diplomat Wu. He also felt that Hahn Xin held the fate of the world in his hands at that moment. Hoping to convince Hahn Xin by means of an unconventional approach, he said to him, "I am well schooled in telling a person's fortune by his physiognomy."

Hahn Xin asked, "How do you do it?"

Kuai replied, "From his bone structure, I can tell whether he is of noble or humble birth. From his expression, I can tell whether he is happy or sad. From his decisiveness or lack thereof, I can tell whether he will succeed or fail. Following these three principles, I have never been wrong."

"Good! Will you please tell me my fortune?"

"It should be done in private."

"I have sent all my attendants away and we are now alone," Hahn said. "Please begin."

"From viewing your face, I predict that you will continue to be only a noble lord. On top of that, the frontal view shows that you will soon run into grave danger. However, from viewing your back, I predict a *gui bu ke yan*, 'limitless and indescribably brilliant life.'"

"How is that?" Hahn asked.

"When the nobles from the various states first revolted against Qin, many declared themselves as kings and raised their own armies. They congregated together from all over the land with the common goal of destroying Qin. Although only two contestants are left, the power struggle between Liu Bang of Han and Xiang Yu of Chu continues to cause countless casualties and numerous deaths. The people of Chu began their rebellion in Pengcheng. After many years of bitter battles and earthshaking heroism, they advanced only as far as Jungyang. Now the Chu army has been tied down in the same area for almost three years and is still unable to advance. Liu Bang's army fights them constantly, sometimes several battles a day. Yet Liu Bang has not been able to win any spectacular victories either. In fact, when he was besieged by Xiang Yu in Jungyang recently, no one came to his rescue. After getting wounded near Chenkao, he had to withdraw west to nurse his injury. From this we can conclude that the brave and resourceful are all exhausted.

"Officers and soldiers have had their dash and drive destroyed by years of stalemate. Food is scarce, and people everywhere are tired and resentful, having been kept in a constant state of anxiety. The way I see it, unless an outstanding hero appears in our midst, there will be no way of solving the present dilemma. The fate of Liu Bang and Xiang Yu rests entirely within your hands. If you side with Han, Liu Bang will win. If you side with Chu, Xiang Yu will triumph.

"Because your decision is so very crucial, therefore, I have dared to reveal to you my innermost thoughts. My only worry is that you will not consider my strategies worthy enough.

"My opinion is that you should side with neither Liu Bang nor Xiang Yu but divide the world into three like the three legs of a tripod, with

each of you ruling a third. Of course, once that is done, you should not be the one to initiate military actions against the other two.

"At present you are known throughout the world as a hero of outstanding ability, with hundreds of thousands of troops under your command, governing the strong and rich state of Qi. You should now go north and take over the states of Yan and Zhao. Then proceed to capture the weakly defended back areas of Han and Chu while Liu Bang and Xiang Yu are occupied with each other. After that, advance westward and demand that Chu and Han cease their hostilities since that is the people's wish. By then, all the people under Heaven will rise up in support of you. Who would dare object or go against your wishes?

"Pare down the size and might of the most powerful states. Transfer some of their land into newly created kingdoms. Once the new kings are in place, they will be indebted to you and obey you. Meanwhile, you have as your base the land of Qi with which you can grace the nobles with favors, teaching them the art of kindness and courtesy. They will learn to respect and honor you as their leader. Then All Under Heaven will be at peace.

"I have heard it said that *tian yu bu qu, fan shou qi jiu,* 'when gifts from Heaven are spurned, intended recipients will be censured.' *Shi zhi bu xing, fan shou qi yang,* 'when opportunities from Heaven are rejected, calamity will occur.' I hope Your Majesty will consider my words carefully."

Hahn Xin replied, "But Liu Bang treats me so magnificently! He lets me drive around in his chariot, dresses me in his robes, shares his food with me. Would it not be wrong to be ungrateful for the sake of gain?"

Kuai said, "You are of the opinion that Liu Bang is your friend. Hence you are trying to create glorious achievements that will last ten thousand generations on his behalf. I'm afraid I don't agree and consider your thinking erroneous.

"Do you recall the two Scholar-Generals Chen Yu and Zhang Er? The friendship between them was most certainly sincere at the beginning. Yet at the end they tried to kill each other. Do you know why?

"Because *huan sheng yu duo yu,* 'calamity arises from greed,' and *ren xin nan ce,* 'the human heart is difficult to fathom.'

"At present, you are basing your relationship with Liu Bang on loyalty and trust. However close that connection may be, surely it does not exceed the intimacy that used to exist between Chen Yu and Zhang Er. But greed

increases as the stakes get higher, and the possibility of change is ever present. Hence I feel that you are wrong in thinking Liu Bang will never turn against you. When the prey gets caught and the hunt is over, the hunting dog gets cooked for supper.

"At present, although you are nominally Liu Bang's prime minister, your renown actually exceeds that of either Liu Bang or Xiang Yu. The two of them must both be feeling very much threatened by your fame. You are in a dangerous position, and I am seriously worried on your behalf."

Hahn Xin thanked him and said, "I shall think about it."

When Hahn Xin remained silent on the subject after a few days, Kuai approached him again and urged, "Accepting sound advice is the beginning of good omen. The wise are decisive at the right moment. He who vacillates accomplishes nothing.

"It has been said, 'A fierce tiger that hesitates to attack causes less damage than a direct bee sting. A thoroughbred taking stuttering steps arrives later than a plodding jade. A brave warrior full of misgivings cannot compare with a determined mediocre fighter. A wise man who is silent imparts less knowledge than the deaf and dumb using sign language.'

"Therefore, everything depends on the deed being carried out at the right moment. Great opportunities seldom arise and, if neglected, are easily lost forever. Once this particular time passes, it will never return. I beg Your Majesty to ponder my advice very carefully."

Remembering all that Liu Bang had done for him, Hahn Xin simply did not have the heart to rebel. He remained undecided and irresolute, thinking that the many services he had already rendered on Liu Bang's behalf would protect him from harm. He gave his thanks to Kuai, turned down his advice, and remained loyal.

◆

Ever since my primary school days in Shanghai, I have dreamt of becoming a writer. In later years while working as a physician, I did attempt to write my story on several occasions but invariably stopped after a few pages, unable to continue. As soon as my parents died, however, everything changed. A floodgate opened, and the words began pouring out of me.

Even today, I cringe whenever I remember those awful days in Hong Kong immediately following my stepmother's funeral. Charles Dickens once wrote, "To a

child, there is nothing worse than discrimination." No matter how old you eventually become or how wise, when you go home to attend your mother's interment and face your siblings again, you revert to the same hierarchy that you were in before the age of ten.

As events unfolded in Hong Kong and one blow followed another in quick succession, I had a sense of déjà vu. Emotionally, we were back in Shanghai and I was once more the solitary seven-year-old standing up to my stepmother and fighting against all odds. But my situation in one sense was now worse: my lone ally, James, had succumbed and gone over to their side.

For over a year afterward I had difficulty eating and sleeping. Then one night I had a dream. In the dream it was Chinese New Year, and we children were lined up to get our ya sui qian from Niang. (Ya sui qian is a traditional Chinese New Year's gift of money inserted in a red envelope.) Before receiving our present, however, we had to spit on a certain mysterious object lying on the floor of a cupboard. As usual, I was last in line.

I watched my siblings as they went around the room one by one, collecting their red packages. Niang's two children were first, followed by Lydia and my three older brothers. Finally, it was my turn. I ran eagerly to the cupboard. It was dark and filled with odds and ends. Then I saw it. Amid a pile of old books, newspapers, and magazines was the large photo of my grandfather Ye Ye that I had just retrieved from Niang's flat in Hong Kong, his face covered by streaks of spittle from the mouths of my brothers and sisters.

I bent down and picked up Ye Ye's photo. Holding it with both hands, I walked slowly toward my stepmother.

She glared at me and said, "Spit!"

I clenched my fists around the photo, gritted my teeth, and said, "No!"

"Then you will have nothing!" she shouted, and slapped me hard.

I woke up with a jerk. It was pitch black, and the clock read 4:30 A.M. Bob was snoring gently next to me, and I was safely back in California. I turned off the alarm and rose from bed. I had a long list of surgeries scheduled, and it was almost time to get ready for work, but there was something I felt compelled to do.

I ran downstairs into my study where I kept my books, found the one I wanted, and flipped through the pages. It was the same volume of Shiji that I had discovered in Niang's flat just before seeing Ye Ye's photo. There it was—the passage that I was looking for!

All these ancient writers had pain in their hearts, for they were not able to achieve
in life what they had set out to accomplish. . . . And so they felt compelled to
write about their past, in order to pass on their thoughts to posterity. . . .

I, too, have dared to venture forth and commit myself to writing. . . .

I sat there reading and rereading the Grand Historian's memorable words writ-
ten 2100 years ago, as fresh and relevant as if he were whispering them into my ear
while standing next to me. I remembered Niang's expression and the venom in her
voice as she said, "Then you will have nothing!"

"No!" I said to Niang as I drove along the dark and deserted freeway on my
way to the surgical center. "It is not nothing! In spite of yourself, you have given
me a legacy after all. Like the Grand Historian, I will also turn the anguish you
have left me into creativity."

After completing my first book I hesitated for a few months before looking for a
publisher. Writing the book had been a tremendously uplifting and cathartic expe-
rience. But from the very beginning I knew in my heart that my siblings would not
be pleased.

Since the book's publication, I have been accused of disloyalty, shamelessness,
and even greed by some of my Chinese relatives. The act of writing such a book
has been called da ni wu dao, "treason and inhuman conduct of the worst kind."
In spite of this, within the innermost reaches of my heart, I have no regrets. For
hurting my brother James, I am sorry; it was never my intention. My brother is a
decent man who got caught in a dilemma and took the easiest way out, assuaging
his conscience by giving me 10 percent of his inheritance from Niang as soon as
the probate was completed. Up to the very last, however, James clung to the party
line that my disinheritance had been caused not by Lydia's poison letters but by a
lack of gratitude on my part to Niang for my medical education.

My books are, essentially, about Chinese life. So is Shiji. Perhaps that is why I find
so much personal resonance in reading the writing of Sima Qian. The Grand Histo-
rian could have been describing my relationship with my own siblings when he wrote:

Their friendship was most certainly sincere in the beginning. Yet at the end
they tried to kill one another. Do you know why?

Because calamity arises from greed, and ren xin nan ce, "the human heart
is difficult to fathom."

Devising Strategies in a Command Tent

運籌帷幄

Yun Chou Wei Wo

Aunt Baba, Shanghai, 1991.

*I*n the summer of 1974 I asked my husband to meet my parents for the first time. Eighteen months earlier Bob and I had invited them to our wedding in California, but they could not get away. Now we were to spend three days with them at their high-rise apartment in Monte Carlo, overlooking the Mediterranean.

On the evening of our arrival, they invited us to dinner at the elegant and expensive Café de Paris. Niang was in her element, glamorously decked out in a designer suit and all her diamonds. After seating us at a table not far from one occupied by Liza Minelli, the headwaiter endeared himself to Niang forever by hovering solicitously

over her throughout the meal. Soon he and Niang were involved in animated con-versation, speaking in rapid-fire French while ignoring the famous entertainer and everyone else.

Neither Father nor we could understand what they were saying. Niang was obvi-ously enjoying herself. After a while, Father turned to Bob and asked, "As a uni-versity professor in microbiology, what do you do?"

"Research and teaching," Bob answered with a smile.

"How many hours do you teach a week?"

"You mean lecturing to the students?"

"Yes. Lecturing to them in the classroom."

"This quarter I have three lectures a week. One hour each."

Father was incredulous. "Only three hours a week!" he exclaimed. "What a fab-ulous job! That's twelve hours a month. Divide your monthly salary by twelve. That's quite a lot of money per hour! On top of that, do you get benefits too?"

"It doesn't work like that," Bob said. "Besides lecturing, I have to apply for grants to support my doctoral students, technicians, and maintain my laboratory. In addi-tion, I do research, publish papers, attend meetings, grade exams, and carry out admin-istration. Lecturing to students plays only a small part in the whole process."

"It's like your job, Father," I added. "How often do you go to one of your fac-tories to inspect the work in progress?"

Father shook his head. "No, you've got it wrong. The way I see it, lecturing to students is the essence of a university professor's job. In business, you have to be absolutely clear about what is the most important element and nurture it. I have thousands of workers on my payroll. Obviously I can't look after everything myself. How successful I become depends on how I spend my time.

"Business is like war. You can't win by yourself. In business, first you decide on a product and a clear objective. Next you make a plan. Learn to delegate responsibility. It is crucial to hire the right person for the right job. Once you've made your choice, let your employees do their work the way they see fit without interference from you.

"In the old days in China, a commanding general of an army would confer with his officers in a special tent before battle. This was where the major decisions were made—not on the battlefield but in that command tent. The strategies devised in that tent, not the bravery or skill of any particular soldier, would determine whether the battle would be won or lost. There is a well-known proverb from Shiji *known as* yun chou wei wo, *'devising strategies within a command tent,' which holds the secret to my business success. Be sure to keep that proverb in mind should you ever venture into the business world.*

"To go back to your job, Bob. How many hours did you say you teach a week?"

My whole life I had dreamed of having a heart-to-heart talk with my father, when I could ask him all the questions I dared not ask as a child and reveal to him everything buried within me. I did not realize it then, but the ten-minute conversation we had together at the Café de Paris in Monte Carlo was to be the only occasion when he opened up to me in any way at all. Two years later he started showing signs of Alzheimer's disease at the age of sixty-nine. As time went by he spoke less and less. Toward the end he stopped talking altogether and remained completely silent for the final five years of his life.

Some time later, after his death, I once mentioned to my brother James my regret at not ever having had the opportunity to really converse with him. I never forgot James's reply. He said, "I have had lots of talks with him. Believe me, it would have been a waste of time. He would not have said anything to you. You are hankering after something he simply could not have done. For him to talk to you in that way, Niang would have had to die first. Can't you see that?"

◆

After many months of stalemate, the two antagonists Liu Bang and Xiang Yu finally signed a peace treaty and divided the world in half. The Chinese at that time thought that the world, *tian xia,* or All Under Heaven, was China and nothing else. The dividing line was a site called Honggou (Wild Goose Channel). The territory west of Honggou was to belong to Liu Bang and east of it to Xiang Yu.

In November 202 B.C.E. Xiang Yu returned Liu Bang's father and wife, and both sides began preparations for retreat. Xiang Yu withdrew his army and started eastward. Liu Bang was about to head west, but Strategist Zhang Liang said, "Han already owns more than half the world. The nobles governing the other states are all allied with us. Xiang Yu is on his own. His troops are exhausted, and he has no food left. The people do not support him. This is a Heaven-sent opportunity to destroy him. If you don't finish him off now, you will be *yang hu yi huan,* 'rearing a tiger to court calamity for yourself later.'"

Liu Bang followed Zhang Liang's advice. He dispatched messengers to General Hahn Xin and the guerrilla fighter Peng summoning them to join him in a united effort to defeat Xiang Yu. He pursued Xiang Yu

all the way and finally caught up with him in Guling (present-day Henan Province). There he stopped and encamped, but neither Hahn Xin nor Peng came to join him.

Xiang Yu was furious at Liu Bang's breach of faith so soon after signing their treaty. He launched an attack and severely routed Liu Bang's army. Liu Bang was forced to retreat and defend himself behind city ramparts. He summoned his advisers and said, "Neither General Hahn nor the guerrilla fighter Peng came to join me as promised. What should I do?"

Zhang Liang said, "Although Xiang Yu's army is almost totally defeated, you have not yet conferred upon your two best generals, Hahn Xin and Peng, their own kingdoms. No wonder they didn't come as promised! Your Majesty should confer the territory from east of the district of Chen to the ocean to Hahn Xin, and the area from north of Suiyang all the way to Kecheng to Peng. This way, Hahn Xin will end up with most of the land of Chu and be King of Chu. Hahn Xin was born in Chu, and his home is still in Chu. I know that he would like nothing better than to return to his hometown as its king.

"By giving up the above territories to these two, you are effectively telling them to fight for their own as well as your interest. This way they are bound to join you, and Xiang Yu will surely be defeated."

Thereupon Liu Bang dispatched a messenger to each and promised to give them the territories as suggested by Zhang. Both came, leading their troops. They were joined by others, including former allies of Xiang Yu who had been persuaded to change sides.

In December 202 B.C.E. Liu Bang and his allies congregated and surrounded Xiang Yu. In Xiang Yu's camp, food was scarce and there were many deserters. In the middle of a bitterly cold December night in 202 B.C.E., Xiang Yu was suddenly awakened by the sound of hundreds of thousands of men *si mian Chu ge,* "singing the songs of his native state of Chu from all sides." He was not aware that this was a ploy on the part of Liu Bang to induce homesickness in his soldiers, most of whom had followed him from Chu. Liu Bang also wanted to mislead Xiang Yu about the extent of the rebellion against him. *The phrase si mian Chu Ge, "songs of Chu from all sides," has become a proverb. It describes a person who is besieged by hostile forces on all sides; someone completely isolated and cut off from outside help. I used it in my autobiography to describe my father when he came down with Alzheimer's.*

After the publication of my autobiography I received, to my astonishment, a letter of congratulation from Lydia's son, my nephew Tai Way. As my book had not painted a particularly flattering portrait of either him or his mother, I was touched by his friendly gesture and was tempted to pen him a reply. That night I had a dream: I was a child again and visiting my grandfather as he sat at his desk practicing calligraphy. I stood on tiptoes and saw from behind his shoulders the words yang hu yi huan, *"rearing a tiger to court calamity for oneself later," as my grandfather wrote them over and over with his brush. Next I saw Ye Ye sitting on a raised throne in front of a giant chessboard in an immense hall with the sign* Command Tent of Heaven *hanging on a wall behind him. He wrote the words* Yun Chou Wei Wo, *"Devising Strategies in a Command Tent," across the face of the board and said, "Don't be naive, Wu Mei (Fifth Younger Daughter)! Think and plan before you act! Lydia and her son are hatching further evil plots against you. You must be careful!"*

Suddenly I saw Lydia and Tai Way. Mounted on big black horses, they were dressed in black and galloping toward me across the enormous black and white squares forming the chessboard. I looked down and saw that I was wearing a thin white cloak. Shivering from cold and anxiety, I was poised halfway between engagement and withdrawal when Ye Ye started shouting, "Danger! Danger! Si mian Chu ge, 'You are besieged by hostile forces on all four sides'! Get away! Run!"

On awakening, I was filled with a sense of foreboding. My dream was of particular significance to me because my Ye Ye had been the calligrapher writing these proverbs. Somewhat illogically, I considered my dream to be an omen as well as an expression of my subconscious. I read and reread Tai Way's letter but finally filed it away without responding.

Xiang Yu was shocked and saddened. To him, these were melodies from his youth that were only too familiar. He rose from bed, poured himself some wine, and said wistfully to his favorite concubine, the beautiful Yu Ji, who frequently accompanied him, "Have Liu Bang's troops occupied the entire state of Chu already? Why are there so many natives of Chu in his army singing the songs of my childhood?"

He thought of his horse, Wu Zhui, the black and white steed that had carried him to so many victories. He drank more wine and started to sing along with Liu Bang's men outside. Before long, he felt the urge to compose some lyrics, then began to sing them:

My power can raise mountains,
My courage is unparalleled.
But times are unfavorable to me
Even my horse would not run.
If my horse runs not, what can I do?
Yu Ji! Yu Ji! What about you?

As he drank, he sang this song many times, while the beautiful Yu Ji sang with him. After a while he began to weep. Yu Ji and his aides-de-camp wept too, but none dared raise their eyes to look at him.

Thereupon Xiang Yu gritted his teeth and bade Yu Ji a final farewell. He mounted his horse, selected 800 of his best cavalrymen, and burst out of the encirclement after a bloody battle in the middle of the night. He fled south as fast as he could and was not discovered missing until dawn. Liu Bang immediately dispatched 5000 cavalrymen after him in hot pursuit.

Xiang Yu crossed the Huai River. By then, his cavalry had dwindled to just over a hundred men, and they ended up mired in a large patch of swampland. There Liu Bang's troops caught up with them.

Xiang Yu led his troops east and fled to Dongcheng. By then there were only twenty-eight cavalrymen left, pursued by a force of a few thousand. Knowing that he would not be able to escape, he said to his men, "From the time I started fighting Qin's Second Emperor, it has been eight long years. I have personally taken part in over seventy battles and, until now, have won them all. This is how I came to dominate the world. But things have changed, and I am pinned down here, not because of lack of fighting ability but because it is the will of Heaven.

"Since I am fated to die, I would like to fight bravely to the end for you. I'm determined to win three out of three skirmishes and force them to raise the siege so that you can escape. I will kill a few Han officers, chop down some Han flags. This way you will know that my defeat is due to Heaven's will and not to incompetence."

Xiang Yu then divided the twenty-eight men into four groups of seven each and ordered them to counterattack on four fronts. Since they were surrounded by layer upon layer of Han troops, Xiang Yu said to his men, "I will get one of them for you!" He ordered them to charge in four different directions and meet him east of the mountain. Then he let out a mighty roar and began to gallop at high speed. The Han troops scampered

in front of him, and in the confusion Xiang Yu was able to cut down one Han officer.

Liu Bang's chief cavalry officer, Yang, galloped after Xiang Yu. Xiang Yu glared at him and roared again. Yang was so startled that his horse turned around and ran away, stopping after only a couple of miles. Thus Xiang Yu was able to get away and meet his followers as scheduled. He divided them into three teams, and they went off again in three directions.

Not knowing which of the three teams included Xiang Yu, Liu Bang's troops also separated into three groups and resurrounded them. Xiang Yu whipped his horse on while wounding and killing eighty to ninety Han soldiers as he sped along. His little company congregated again, and this time there were only two casualties.

Xiang Yu fled east and came to the Wu River. The chief of that district had prepared a boat and was waiting for him. He said to Xiang Yu, "I advise Your Majesty to cross the river as soon as possible. It so happens that I have the only boat around here. When the Han army arrives, they'll be unable to cross."

But Xiang Yu laughed bitterly and said, "Since Heaven wishes to destroy me, why should I bother to cross the Wu River? Besides, when I started off in the beginning, I led an army of 8000 young men from that land east of the river. Now, not a single one is left to go home with me. Even if no one breathes a word about my losses, don't you think the dead and wounded will weigh on my conscience?"

The district chief said nothing. After a while, Xiang Yu turned to him again and said, "I know that you are a loyal and venerable elder, and I thank you. I have ridden this horse for five years. It is *suo xiang wu di,* 'invincible and breaks all enemy resistance,' and can run for long distances without tiring. I don't have the heart to kill it and would like to give it to you."

Xiang Yu dismounted and ordered his troops to do the same. They retained only their short weapons and began hand-to-hand combat. Fighting valiantly, Xiang Yu himself was able to kill a few hundred more Han soldiers. But he sustained more than ten wounds in the process.

Suddenly he recognized one of his former cavalry officers who had defected to the Han army. He said to Lu Matong, "Did you not use to fight for me at one time?"

Lu turned away and pointed out Xiang Yu to his commanding officer Wang.

Xiang Yu said, "I hear that Liu Bang has placed a price of 1000 pieces of gold and the income of 10,000 families on my head. I hereby present it to you as a gift."

He then cut his own throat and died. At that time he was thirty-one years old.

Wang cut off Xiang Yu's head. The other officers and men congregated around his headless body and fought over his remains so viciously that scores of men were killed. Finally, they agreed among themselves that the credit should be shared among five officers, including Lu, Wang, and Yang. They reassembled the body parts that each had in his possession and proved to everyone's satisfaction that it was indeed Xiang Yu's body. Liu Bang rewarded them liberally and conferred the title of marquis on them all.

Toward General Hahn Xin, Liu Bang behaved very differently. Immediately after Xiang Yu's death was confirmed, Liu Bang commandeered Hahn Xin's army for his own use. Although he did make Hahn Xin King of Chu, it was largely a ceremonial title. He remained wary of Hahn Xin's ability. Barely one year later, Liu Bang arrested him and took him to the capital. Finding no evidence of wrongdoing, Liu Bang demoted him to marquis and kept him in the capital for four years. Once, the two men had an interesting conversation.

"How many troops do you think I am capable of directing?" Liu Bang asked.

"One hundred thousand maximum," Hahn Xin replied.

"What about you?"

"The more the better. There is no limit," said Hahn Xin.

"If that is the case, why are you my captive?"

"Even though Your Majesty has little ability in directing soldiers, you have great ability in directing generals. That is why I am your captive. Your talent is not man-made but an inborn gift from Heaven."

After Xiang Yu's death was announced, the rest of the cities in Chu all surrendered to Liu Bang. He buried Xiang Yu's dismembered body in Kecheng (present-day Shandong Province), holding the ceremony as befitting the rank of a duke. Liu Bang himself attended the funeral, wearing mourning clothes and weeping in front of Xiang Yu's tomb.

As for Xiang Yu's relatives with the last name of Xiang, Liu Bang did not harm them. Instead, he conferred the title of marquis on four of them, including Xiang Yu's uncle Xiang Bo. It was Xiang Bo who had saved Liu Bang's life during the sword dance at Hongmen (Wild Goose Gate), and Liu Bang never forgot that favor. He also allowed Xiang family members to change their surnames from Xiang to Liu, his own surname.

Following his victory, Liu Bang held a celebratory banquet in his palace. He asked his ministers to compare him with Xiang Yu and offer reasons why he was the one who triumphed in the end. When no one could come up with a satisfactory answer, Liu Bang said, "This is the way I see it. *Yun chou wei wo,* in 'devising strategies in a command tent' that will assure victory while hundreds of miles away from the war, I am not as skillful as Strategist Zhang Liang. In governing a state, pacifying the people, distributing food, and paying the army on time, I am not as competent as Administrator Xiao He. In deploying millions of troops and winning battles, I am not as expert as General Hahn Xin. These three can truly be considered to be champions in their fields. But the fact that I am able not only to recognize their talents but also to have them all working for me—that is the reason I am now Ruler of All Under Heaven. Xiang Yu had only one competent adviser, Old Man Fan, but he could not even use him. That is why he lost."

Toward the end of March 201 B.C.E., at the insistence of his followers, Liu Bang was crowned First Emperor of the Han dynasty. During the early years of his reign, Liu Bang launched a series of purges against renowned generals such as General Hahn Xin and guerrilla fighter Peng, who had been instrumental in defeating Xiang Yu. In spite of their contribution, Liu Bang never trusted those high-ranking officials who had kept their own armies after he ascended the throne. He took advantage of the slightest pretext to take away their power, drove them to revolt, accused them of treason, and punished them with death. (In a similar fashion, Mao Tsetung unleashed the Cultural Revolution in 1966 to rid himself of former comrades who, in his opinion, had become too powerful.)

In 195 B.C.E. Liu Bang successfully quelled yet another rebellion. On his triumphant return to his capital of Changan (a few miles east of the Qin capital of Xianyang), he passed by his hometown, Pei. Unable to resist revisiting the landscape of his childhood, he stopped and held a big banquet in the newly constructed palace at Pei. To the banquet he summoned all

the people, young and old, whom he had known previously. He drank wine with them and asked for the children of Pei to attend. One hundred and twenty came, and he sang with them the songs of his childhood. They laughed and rejoiced together, with Liu Bang relating stories about his past. When the adults had drunk to their hearts' content, Liu Bang plucked the strings of a *se* (a twenty-five-stringed musical instrument similar to a zither) with a bamboo plectrum and sang a song he had just composed:

> *A violent wind whipped away the clouds over the sky,*
> *Impressing everyone within the four seas with my might.*
> *On returning to the village of my birth*
> *Will I find valiant men to defend my turf?*

He taught the song to the children and asked them to repeat it in concert. While they sang, he rose and danced. All sorts of feelings welled up within him, and tears of happiness rolled down his cheeks. He said to the elders of Pei, "The wanderer is sad when he thinks of his native homeland. Although I must leave and take up residence in the Land Within the Passes, my soul will always hanker after the village of Pei, even after my life is over."

The dynasty founded by Liu Bang lasted for 400 years and was one of China's greatest. From time to time, the Chinese still call themselves *Han ren,* "people of Han." The proverb *ren xin gui Han,* "the heart of the people belongs to Han," has taken on a whole range of different meanings, encompassing love of the Chinese language, fondness for the food, pride in the culture, reverence for elders, nostalgia, and hope for a better future for China.

Even outside China, the Han dynasty is remembered today. The term *kanji* in Japanese is written in the same way as the Chinese words *Han zi,* only pronounced differently. The two characters mean "Chinese writing" in both languages. But the name China itself, by which her Chinese name, *zhong guo,* or "central kingdom," is known to the rest of the world, is probably derived from the word *Qin* and originated because it was the name of the state and dynasty of the First Emperor.

By the time of the birth of China's First Emperor in 259 B.C.E., Rome had replaced Greece to become the dominant city-state in Europe. Commerce began to flow along the Silk Road between East and West during

the Han dynasty. There is archaeological evidence that Chinese silk was exchanged for Roman glass, gold ornaments, and Persian jewelry.

Approximately three hundred years after the death of the Greek historians Herodotus and Thucydides, Sima Qian wrote his *Shiji*. Factors such as ancestor worship, filial piety, respect for the elderly, Confucianism, and continuity of the Chinese language have all contributed to the importance of the study of history in China. A book such as *Shiji* is perceived by the Chinese as a repository of the wisdom and cultural traditions of our ancestors.

◆

My Aunt Baba died in 1994 in our lao jia, *"old family home," in Shanghai. Shortly before the end, she was given heavy sedation but still had short spells of lucidity. Once she said to me, "It's such a shame that the Red Guards destroyed everything in my safe deposit box during the Cultural Revolution. Otherwise I could give you back all your report cards from kindergarten and primary school, as well as your Ye Ye's letters. He used to worry about dying, not for himself but because of all of you. He regretted that he had no money or precious objects to leave to his grandchildren. He was concerned that he was going to die without bequeathing a legacy to any of you."*

She lapsed back into sleep as I mulled over her words. I thought back on my own life: my quest for approval from my family, Father's single-minded pursuit of wealth, Niang's malice, Lydia's treachery, and James's denial. Then I remembered Ye Ye telling me to study hard and daring me to compete in the most difficult examinations. "No matter what else people may steal from you," he said, "they will never be able to take away your knowledge!"

I took Aunt Baba's hand and said, "It is not true that Ye Ye died without leaving me a legacy." Just then an astounding thought occurred to me. Aunt Baba was snoring softly, but I continued, "All those proverbs Ye Ye taught me, and the stories behind those proverbs, they are all qi huo ke ju, *'precious treasure worth cherishing.' They are his legacy to me."*

Getting up at dawn in the quiet of my home in Huntington Beach to write, I hear Ye Ye's voice urging me on. I wish I could show him my work and thank him for his unwavering belief in my worth. If he could see me today, would he be proud?

Once Aunt Baba asked me, "Of course, if you had obeyed Niang and not helped Lydia and her children out of Communist China, Niang would never have disinherited you. Do you regret your actions?"

*It was an interesting hypothetical question, and my answer surprised me: "No,"
I said, "because in spite of herself, Niang did provide me with a legacy of sorts.
Deception and malice are her legacy. Her acts provided the plot and the impetus that
impelled me to write my first book. Without them, would I have had the determi-
nation to give up my medical practice and become a writer? I don't know the
answer myself."*

*Just as each of us creates her own destiny, we also bequeath specific legacies
through our conduct. The money we leave behind is but a tiny part of that legacy.
In the end, it is the essence of the person herself that exerts the deepest and most
lasting influence on her heirs.*

*In spite of being disowned, I consider myself to have been richly endowed by
the four adults who shaped my life. My Aunt Baba gave me unconditional love and
boundless self-confidence. My stepmother, Niang, stoked my determination with
her constant rejection, even from beyond the grave. My father provided me with such
sound business advice in Monte Carlo that I have never looked back since that
day. And my grandfather left me a matchless collection of proverbs that I have never
forgotten.*

*In this book I have tried to give a personalized account of the life and times of the
First Emperor of China as recorded in Shiji and seen through my eyes. When I
began, I had no idea that so many of the proverbs told to me by Ye Ye first came from
the pen of a historian who lived 2100 years ago.*

*I am approaching the age of my grandfather when he passed away fifty years
ago. At this stage I would like to hand on my legacy from him to you. I hope you
will find these proverbs entertaining as well as inspirational. By taking incidents
from my own life and inserting appropriate proverbs the way they are used every
day in China, I hope to make them come alive, thereby explaining how the Chinese
think, and why we think the way we do.*

List of Proverbs

A comment on those who lose their original self by slavishly imitating the ways of others.

Xin zhi suo wei
"Grasping the essence of what he was alluding to."

Yi yan er wan shi zhi li
"Speaking one sentence that results in ten thousand generations of gain."

CHAPTER 3
Jing xi zi zhi
"Respect and cherish written words."

Yi zi qian jin
"One written word is worth a thousand pieces of gold."
A literary masterpiece.

CHAPTER 4
Guo zu bu qian
"Binding your feet to prevent your own progress."
Nonadvancement due to self-imposed restraint.

CHAPTER 5
Gu zhang nan ming
"Clapping with one hand will produce no sound" or "It takes two hands to clap."
One cannot negotiate alone; or, it takes two to tango.

Gai guan lun ding
"Only when a person is dead and the lid of his coffin closed can final judgment be passed on him."

Han Feizi's writing has been admired by hundreds of millions of readers over the centuries. Like King Zheng, we continue to be dazzled by his brilliance and ingenuity. The titles of many of his essays have become well-known proverbs. The following are some examples:

Zi xiang mao dun
"Using one's spear to pierce one's shield."
There was a vendor at the market who sold spears and shields. Holding up a shield, he cried, "My shields are so well built that nothing can pierce them." Then he raised a spear and shouted, "My spears are so sharp that they will penetrate anything."

The crowd jeered him, and one of them asked, "What happens when you use one of your spears to pierce one of your shields?"

The vendor remained silent and could not answer.

This proverb is used to describe a person who contradicts himself in action or words. Because of its popularity, the essence of the story behind the proverb has been incorporated into the Chinese language. If the two words *mao* (spear) and *dun* (shield) are used side by side, the Chinese term *mao-dun* (spear-armor) means "contradiction." This is a typical example of the way Chinese language evolved: by using concrete objects to represent abstract concepts.

Mai du huan zhu
"Purchasing the box and returning the pearls."

A jeweler from the state of Chu went to another state to sell a strand of beautiful pearls. He made a box for the pearls with fine-grained wood from the magnolia tree, treated it with sweet-smelling perfume made from osmanthus blossoms, mounted it with white jade, decorated it with rose-colored precious stones, and lined its borders with green jadeite. The craftsmanship was so exquisite that a man bought the box and returned the pearls to the jeweler.

It can be said that the buyer made a strange decision. He was so much swayed by the beauty of the box that he never noticed the value of the pearls.

The proverb *mai du huan zhu,* "purchasing the box and returning the pearls," describes a person who grasps the image but lets go of the substance.

Zheng ren mai lu
"A man from Zheng buys shoes."

A man from the district of Zheng wanted to buy a pair of shoes. He measured his feet at home and wrote down the size. Being absent-minded, he left the measurement on his chair and rushed off. When he reached the market, he approached the shoemaker's stall but could not find the measurement he had written. Still he paid for a pair of shoes. Then he said to the shoemaker, "I've forgotten the measurement of my feet at home and don't know what size I should buy. I 'm going home to get it." When he returned to the market with the measurement, he found that it had already closed.

Someone said to him, "Don't you have a pair of feet? Why didn't you try on the shoes when you were at the shoemaker's stall?"

"I trust only the measurement of my feet but not my actual feet," replied the man.

The proverb alludes to people who rigidly follow rules regardless of actual circumstances.

Shou zhu dai tu
"Watching the tree to catch a hare."

Once there was a boy who was told by his master to catch a hare. He went into the woods and looked around. Lo and behold, at that very moment, he saw a hare running along at full speed. As he watched in astonishment, the hare ran smack into a tree and knocked itself unconscious. All he had to do was to pick it up and present it to his master. For the rest of his life, the boy spent his time waiting behind the same tree in the vain hope that more hares would drop at his feet in the same way. They never did.

The proverb describes someone who expects chance to repeat itself in exactly the same way. In fact, the only thing that does not change is that everything changes.

CHAPTER 6

Tu qiong bi xian
"When the map is unrolled, the dagger is revealed."

The Scheme is exposed; or the Game is up.

CHAPTER 7

Fen shu keng ru
"Burning books and burying scholars."

Emphasizing the present and discounting the past.

CHAPTER 8

Wang guo zhi yan
"Words that would cause a nation to perish."

Advice that leads to total disaster.

CHAPTER 9

Zhi lu wei ma
"Pointing to a deer and calling it a horse."

Deliberately confounding right and wrong.

Bu ke sheng shu
"Innumerable persons were implicated."

Ren ren zi wei
"Everyone felt threatened and feared for his own safety."

Zi yi wei huo
"Self-doubt about one's own sanity."

Qian shi bu wang, hou shi zhi shi
"Use incidents from the past as lessons for the future."

CHAPTER IO

Yan que yong you hong hu zhi
"Little sparrow with dreams of swans."

Someone with lofty ambition and high aspirations.

Shou zhu dai tu
"Watching the tree to catch the hare."

Wang hou jiang xiang ning you zhong hu
"Kings and marquises, prime ministers and generals: such men are made, not born."

Jie gan er qi
"To hoist a bamboo pole as a banner of revolt."

A popular revolt against tyranny.

CHAPTER II

Po fu chen zhou
"Destroy the cooking cauldrons and sink the boats."

To make a last, desperate gamble for victory.

Qu er dai zhi
"Step into the emperor's shoes and replace him."

Taking another person's place.

Cai qi guo ren
"Outstanding talent and ability."

Exceptionally quick-witted.

Xian fa zhi ren
"The one who strikes first will gain control of others."

The best defense is a good offense.

Huo da da du
"Generous, big-hearted, and open-minded."

Bu shi jia ren sheng chan
"Refused to do the kind of work performed by his father and brothers."

Min bu liao sheng
"People had few means of livelihood. Times were hard."

Yi bai tu di
"Smeared to the ground after a single defeat."

Chu sui san hu, wang Qin bi Chu
"Even if there are but three families left in Chu, the Qin empire will be toppled by someone from Chu."

Yu bang xiang zheng, yu wung de li
"While the snipe and mussel were fighting each other, the fisherman captured them both."
Divide and conquer.

Cheng bai zai ci yi ju
"Success or failure depends on my next move."

Zuo bi shang guan
"Watching the action from the safety of their tents."

Yi yi dang shi
"Everyone was equal to ten of the enemy."

Wei ji si fu
"Beset with danger and opportunity on four sides."

CHAPTER 12

Ru zi ke jiao
"This young man is worth educating."
Description of a youth with promise.

Yi mu pi xiang
"Judging ability by appearance."

Wu he zhi zhong
"Assortment of rough and untrained ruffians."

Zi tou hu kou
"Voluntarily stepping into the tiger's mouth."

Si tong ba da
"Many highways radiate from this hub city in all directions."

Wu zhong fu che
"Accidentally struck the wrong vehicle."

Tong xing wu zu
"Free passage without hindrance."

San cun bu lan zhi she
"Three inches of immortal tongue."

Zhong yan ni er li yu xing
"Loyal advice that sounds unpleasant must still be followed."

Liang yao ku ko li yu bing
"Effective medicine that tastes bitter must still be swallowed."

Yue fa san zhang
"A code that consists of only three laws."

Establishing clear and simple rules to be observed by all concerned.

CHAPTER 13

Hong men yan
"The banquet at Wild Goose Gate."

A celebration fraught with danger and hidden agenda.

Qiu hao wu fan
"Not disturbing the finest downy hair."

Not trespassing against anyone to the slightest extent.

Xiang Zhuang wu jian, yi zai Pei Gong
"While Xiang Zhuang ostensibly performs a sword dance, his real intention is to kill Liu Bang, Lord of Pei."

Actions with a hidden motive.

Mu zi jin lie
"Split the corners of one's own eyes open with the blazing anger in one's gaze."

Ren wei dao zu, wo wei yu rou
"They are like the knife and chopping board, whereas we are like fish and meat about to be minced."

Description of a precarious predicament.

CHAPTER 14

Yi jin ye xing
"Dressed in the finest brocades to parade in the dark of night."

Not being able to show the people at home that one has made good.

Da shi suo wang
"Greatly disappointed in their hopes."

Mu hou er guan
"Restless monkeys in tall hats."
Worthless people dressed up as dignitaries.

Guo shi wu shuang
"No comparable talent in the entire country."

Piao mu zhi en
"Kindness from a washerwoman."

Zi shi qi li
"Feed oneself by one's own effort."

Kua xia zhi ru
"Insults from under the hips."
The worst kind of humiliation: crawling under the crotch.

Chi zha feng yun
"Commanding the winds and the clouds."
All-powerful and earthshaking.

Pi fu zhi yong
"An ordinary man whose bravery is really recklessness."

Fu ren zhi ren
"Benevolence of a woman."

Tong ru gu sui
"Hatred that has gone into the marrow."

Ji feng er shi
"Using without delay as a weapon while sharp."

Yi jin huan xiang
"Returning home in silken robes after having made good."

CHAPTER 15
Fan jian ji
Plot to sow discord and create enmity.

Ming xiu zhan dao, an du Chen Cang
"Openly repairing the plank roads but secretly crossing via Chen Cang."
Outwardly pretending to advance along one path while secretly following another route.

Da ni wu dao
"Treason and heresy of the worst kind."

Min yi shi wei tian
"To the people, the essence of what is most important is food."

CHAPTER 16
Ren xin gui Han
"The heart of the people belongs to Han."

Expresses the emotion Chinese people feel toward China.

Wen jing zhi jiao
"A friendship so close they would risk having their throats cut rather than betray each other."

Zhi zhi si di er hou sheng
"Confront a man with the danger of death, and he will fight to live."

Zhi zhe qian lu, bi you yi shi
"The wisest among us are not always free from error."

Yu zhe qian lu, bi you yi de
"Even the fool sometimes hits on a good idea."

Kuang fu zhi yan, sheng ren ze yan
"The ranting and raving of a madman is occasionally approved by sages as appropriate."

Xian sheng hou shi
"Discussion first and military force later."

CHAPTER 17
Ren xin nan ce
"The human heart is difficult to fathom."

Human behavior is often irrational and unpredictable.

Yan ting ji cong
"Listened and adopted all my suggestions."

Gui bu ke yan
"Limitless and indescribably brilliant life."

Tian yu bu qu, fan shou qi jiu
"When gifts from Heaven are spurned, intended recipients will be censured."

Shi zhi bu xing, fan shou qi yang
"When opportunities from Heaven are rejected, calamity will occur."

Huan sheng yu duo yu
"Calamity arises from greed."

CHAPTER 18

Yun chou wei wo
"Devising strategies in a command tent."

Skillful at analyzing situations and laying out correct principles of operation.

Yang hu yi huan
"Rearing a tiger to court calamity later."

Si mian Chu ge
"Songs of Chu from four sides."

Besieged by hostile forces on all sides.

Suo xiang wu di
"Invincible and breaks all enemy resistance."

Bibliography

Ban Gu, *Qian Han Shi (History of the Former Han Dynasty)*.
Sima Qian, *Shiji*.
Wu Fa, *Cheng Yu Zhong De Li Shi*.
Zhan Guo Ce (Strategies of the Warring States).

Barnouin, Barbara, and Yu Changgen. *Ten Years of Turbulence: The Chinese Cultural Revolution*. London and New York: Kegan Paul International, 1993.

Bodde, Derk. *China's First Unifier*. Hong Kong: Hong Kong University Press, 1967.

Creel, Herrlee G. *Chinese Thought from Confucius to Mao Tse-tung*. Chicago: University of Chicago Press, 1953.

Gilley, Bruce. *Tiger on the Brink: Jiang Zemin and China's New Elite*. Berkeley and Los Angeles: University of California Press, 1998.

Hardy, Grant. *Worlds of Bronze and Bamboo: Sima Qian's Conquest of History*. New York: Columbia University Press, 1999.

Jin Qiu. *The Culture of Power: The Lin Biao Incident in the Cultural Revolution*. Stanford: Stanford University Press, 1999.

Li Yuning. *The First Emperor of China*. White Plains, New York: International Arts and Sciences Press, Inc., 1975.

Karnow, Stanley. *Mao and China: A Legacy of Turmoil*. New York: Penguin Books, 1990.

Ssu-ma Chien. *Records of the Grand Historian*. Translated by Burton Watson. New York: Columbia University Press, 1993.

Yao Ming-le. *The Conspiracy and Death of Lin Biao*. New York: Alfred A. Knopf, 1983.

List of Photographs

Acknowledgments

I am greatly indebted to my publisher, Steve Hanselman, for his belief in me. I also wish to thank my editor, Renee Sedliar, and Kris Ashley, for their hard work, and for coping so magnificently with all my requests during the creation of this book.

To my husband, Bob, for his love, support, and beautiful line drawings.

To Earl and Shirley Feiwell, for their friendship, encouragement, and for scanning and compiling my personal photographs.